Drawing
on Tradition

Drawing on Tradition

Manga, Anime, and Religion in Contemporary Japan

Jolyon Baraka Thomas

University of Hawai'i Press
Honolulu

17 16 15 14 6 5 4 3

Library of Congress Cataloging-in-Publication Data

Thomas, Jolyon Baraka.
 Drawing on tradition : manga, anime, and religion in contemporary Japan / Jolyon
 Baraka Thomas.
 p. cm.
 Includes bibliographical references and index.
 ISBN 978-0-8248-3589-7 (hardcover : alk. paper)
 ISBN 978-0-8248-3654-2 (pbk. : alk. paper)
 1. Comic books, strips, etc.—Japan—History and criticism. 2. Comic
books, strips, etc.—Religious aspects. 3. Animated films—Japan—History and
criticism. 4. Animated films—Religious aspects. 5. Japan—Religion—21st
century. I. Title.

PN6790.J3 2012

 2012019821

University of Hawai'i Press books are printed on acid-free
paper and meet the guidelines for permanence and durability
of the Council on Library Resources.

Designed by Publishers' Design and Production Services, Inc.
Printed by Sheridan Books, Inc.

CONTENTS

One of the most frustrating experiences of my life was that of becoming suddenly illiterate when I stepped off the plane and into Narita Airport in January of 2002. I had moved to Japan on a whim and with little linguistic preparation, having landed a teaching job via the Internet about three or four weeks prior. I took with me a newly acquired teaching license, the enthusiasm of a recent college graduate, and a pact I had made with myself that I would live in Japan for at least one year.

There are many things that could be said about that first year in Tokyo, but one feeling that stays with me is that of being almost entirely unable to decipher the written messages all around me. In addition to its rampant noise pollution (*everything* talks), Tokyo is a cacophony of printed messages. Yet because I could not yet read in Japanese, for my first few weeks I wandered in a muted version of the city. On trains—and Tokyoites spend a lot of time on trains—I was impervious to the relentless bombardment of ad campaigns, unable to catch up on the latest gossip regarding celebrities and the imperial family printed in hanging tabloid ads, indifferent to (because ignorant of) the printed admonitions to report suspicious activity. My *hiragana* reading was slow and awkward, and *katakana* still largely eluded me.[1]

During my commutes, I began to combat my illiteracy by documenting correspondences I saw between Romanized spellings of train stations and their *kanji* and *hiragana* equivalents. My sight word vocabulary grew slowly and steadily, as did my collection of flashcards and pocket notebooks. With time, I was able to navigate Tokyo's labyrinthine train system and muddle my way through a restaurant menu.

To be truly literate, however, I had to pick up a book and just start reading. When I did, I turned to Japan's illustrated serial novels called manga. In addition to supplementing text with pictures, manga often include phonetic glosses for characters that may be unfamiliar to some readers, making them ideal literacy aids for second language learners.

I began with readily comprehensible fare like *Doraemon* (a classic series about the adventures of protagonist Nobita and his robotic cat from the fu-

ture), *Crayon Shin-chan* (shorts about an eternally young and irrepressible boy with a penchant for nudity and mischief, somewhat like Calvin of *Calvin and Hobbes*), *Conan* (a brilliant teen detective trapped in the body of a prepubescent schoolboy), and *One Piece* (a story about a ragtag ship of pirates who do more do-gooding than pillaging). Within a couple of months of starting to read manga, I was regularly borrowing volumes of *One Piece* and *Conan* from my students. I was hooked.

My experience with manga changed, however, when I discovered Tezuka Osamu's *Phoenix* (*Hi no tori*). I saw that Tezuka had woven bits of Japanese religious history into his narrative, and his already compelling story gained additional intellectual appeal for me since I had majored in religious studies as an undergraduate. At around the same time as that discovery, a friend introduced me to the anime (animated films) of Studio Ghibli directors Miyazaki Hayao and Takahata Isao, both of whom similarly incorporated religious imagery and vocabulary into their works. I found Miyazaki's *Nausicaä of the Valley of the Wind* (*Kaze no Tani no Naushika*) and Takahata's *Pom Poko* (*Heisei tanuki gassen ponpoko*) particularly intriguing. Although at the time I could not articulate the role that apparently religious content played in these various works (much less how Japanese people would interpret that content), given the evident popularity of such manga and anime, I wondered if there was something particularly compelling about the ways in which these master storytellers deployed religious imagery and vocabulary in their narratives.

When I left Japan in 2004, I already had the germ of an idea for a research project related to these questions. I started to write this book to answer a question that seemed simple enough: why—in light of Japan's evident and often fervent secularism—were manga and anime with apparently religious themes so numerous and so popular?

I returned to Japan between 2005 and 2007 to pursue this question and draft most of the material on which this book is based. In the field, however, the question turned out to be maddeningly complex; as my research proceeded, the nature of the question changed. I wanted to know whether and how these evidently religious themes—which run the gamut from cavalier appropriations of formal religious imagery to pious renditions of saintly hagiographies and sententious explications of religious doctrines—came to influence people's daily lives and worldviews.

The following pages form the beginning of an answer to these intertwined questions. I found that while much of the deployment and reception of apparently religious imagery and vocabulary in manga and anime is casual

and often irreverent, some audience members have responded to particular characters or to the oeuvre of a certain author or director with fervent devotion. Some people have created new ritual traditions based on fictional worlds, and some have interpreted manga and anime in light of their lessons for daily life. Furthermore, some artists have adopted leadership roles for fan groups that have legally incorporated as religions. Manga and anime culture thus reveals aspects of religion in contemporary Japan that exist at the boundaries of formal religious institutions and their doctrines. The production and reception of these influential media provide provocative examples of the ways in which fictional settings can influence, absorb, and create religious worlds, and how fictional characters and fanciful ideas can inspire audiences and influence their worldviews.

Books are collective efforts, and this one has been immensely enriched by the following individuals' commentary and recommendations. In no particular order, they are George Tanabe, Helen Baroni, Christine Yano, Shimazono Susumu, Inoue Nobutaka, Jacqueline Stone, Hirafuji Kikuko, Hoshino Seiji, Tsukada Hotaka, Erik Schicketanz, Matthew McMullen, Levi McLaughlin, Bryan Lowe, April Hughes, Takashi Miura, Sakurai Yoshihide, Yamanaka Hiroshi, Jean-Michel Butel, Gregory Watkins, Poul Andersen, Michel Mohr, Benjamin Dorman, Ian Reader, an anonymous reviewer, Douglas Cowan, Cathy Wessinger, Rebecca Moore, Ogawa Yūkan, Matthew Mitchell, Justin Stein, Pamela Runestad, Jesse LeFebvre, Dominic Franchini, Michael Naparstek, Matthew McDonald, Ben Lewinger, Jessica Freedman, John Sweeney, Paul Gomes, Faye Higa, Joshua Irizarry, Jessica Starling, Ōtake Hiroko, Suzuki Nobuko, Erica Baffelli, Rebecca Suter, Charles T. Whipple, Ogihara Eriko, Stephen Poland, Kashimada Yuka, Shindō Kazushige, Katase Senchan, Isom Winton, Takeuchi Chinami, Ryan Loren, Patricia Crosby, Ann Ludeman, Alison Hope, and the Tsubo-Kura Crew (Kōjirō, Aika, Shibata, Shizuka, Taiichi, Nozawa, Yuri, Tattchan, Ayaka, Takamaru, Tōkai, Hide, Yōko, Rintarō, Wāko, Ikumi, and Takurō). I thank them all for their help; any errors or oversights are my own.

Kuroda Minoru, former manga artist and founder of Subikari Kōha Sekai Shindan, deserves special mention for taking time out of his busy schedule on three separate occasions to meet with me. I am also greatly indebted to the publishers and copyright holders who have graciously agreed to allow me to reproduce their proprietary images in this book. In addition to my profound gratitude to the authors and artists, I thank Kengo Monji of *Shōnen Jump Comics* (Shūeisha), Hasegawa Yōichi and Motegi Yukio of *Ultra Jump Comics* (Shūeisha), and Tange Yōko at Kōdansha for responding to my requests with alacrity and generosity.

The Crown Prince Akihito Scholarship, the Foreign Language and Area Studies Fellowship, the University of Hawai'i at Mānoa Center for Japanese Studies, and the John Fee Embree Scholarship offered financial support for

travel, research, and writing. Henry Rietz and Ed Gilday of Grinnell College, Nagashima Kay-ichi of Tamagawa Gakuen University, Kimberly Smith of Southwestern University, and Paul Narum of Yokohama City University provided valuable opportunities to give guest lectures at their institutions. I also benefited from questions and commentary at the 2005 annual meeting of the American Academy of Religion, as well as at conferences held at the University of Hawai'i (2005 and 2007) and Harvard University (2007).

An early version of Chapter 3 first appeared in *Nova Religio* in 2007, as well as in abridged form in the 2007 *Religion and Film Reader* edited by Jolyon Mitchell and S. Brent Plate. An earlier iteration of Chapter 4 appeared in Japanese in *Gendai shūkyō 2008*; an article drawing on some of the same material is forthcoming in the *Japanese Journal of Religious Studies* (2012). Additionally, several short sections in various chapters are similar to parts of an article on religion and Japanese film found in the 2009 *Routledge Companion to Religion and Film* edited by John Lyden. Equivalent sections were published in Japanese in 2010 as part of the proceedings of a research forum on "Religious Culture in Film" held at Kokugakuin University in September 2009. These articles and chapters have all been significantly revised here.

Finally, this book is far better for the influence of my family. I am grateful daily for my wife, Kimberley, a consummate interlocutor, playful companion, and adventurous partner. My brother, Akili, is a terrific and supportive friend; he also made a fine roommate (despite rather cramped quarters) during one summer of research in Japan. My father, Frank, instilled in me a love of science fiction and a relentless curiosity about human nature. My mother, Sheena, nurtured my artistic sensibilities and provided valuable lessons on the importance of maintaining an unflagging sense of wonder and joy in the world. I owe my parents more than I can ever repay, and because of that it is to them that this book is dedicated.

In an ideal world, this book would be as thoroughly illustrated as its subject matter, but the exigencies of keeping print costs down (and the difficulty of getting permission to use all of the images that might be appropriate) militate against it. I compensate for the limited number of figures I am able to use by deploying visual metaphors throughout the text. The use of words such as "draw," "frame," "illustrate," "depict," "render," "trace," "portray," and "visualize" is designed to serve as a reminder of the visual qualities of the media under consideration and to highlight recursive relationships between the literal and figurative registers of these terms. Similarly, through phrases such as "recreating religion" and "entertaining religious ideas" I am mobilizing the simultaneously subversive and allusive power of puns to bolster theoretical points about recursive relationships between religion and entertainment.

All figures included in this book either fall within the standards of fair use or are reproduced with the kind permission of the publishers and copyright holders. Photographs are by the author. Citations of manga are from paperback or hardback volumes rather than from weekly or monthly magazines, and I cite only the volumes in my personal collection. Unless I indicate otherwise, the volumes listed should not be taken as making up the entirety of the series. I only translate titles where necessary, and Japanese transliterations of English words (e.g., *Ultraheaven*, *Death Note*) have been simply rendered in the English to avoid confusion. Otherwise, I follow authors' and publishers' chosen transliterations where appropriate (e.g., *Kujakuoh* instead of *Kujakuō*).

Japanese names are given in traditional Japanese order, family name first, with the exception of Japanese authors writing in English or in the case of historical figures who are primarily known by other sobriquets. Following Japanese publishers' preferred conventions, authors and directors are listed with their family names last in copyright acknowledgments for the figures. Some Japanese authors do not follow normal rules of transliteration when rendering their names in the Roman alphabet; I have maintained fidelity to their chosen spellings (e.g., Kubo Tite would usually be written Kubo Taito).

I have retained diacritical marks on all Japanese terms, except for the most common of place names (e.g., Tokyo instead of Tōkyō). In referring to historical periods, for broad historical spans such as Heian or Edo, I have used the word "period," and for imperial reign dates I have used the term "era." Where appropriate, I designate Sanskrit with the abbreviation "Skt.," Chinese with "Ch.," and Japanese with "Jp."

With the exception of Kuroda Minoru, the names of all interviewees have been changed to preserve their anonymity. All survey respondents and interviewees were the age of majority in Japan (twenty) at the time of the survey or interview; a small number of survey responses from underage respondents were discarded. When citing posts on fan community message boards, I have listed the posts by number rather than by the handles that the posters use. This is both to grant the writers some degree of anonymity and to compensate for the fact that community members often change their online nicknames.

All Japanese translations are my own unless otherwise indicated in the text or citations, and I accept full responsibility for any mistakes in translation or transliteration, as well as for any factual errors or sins of omission.

Religious Frames of Mind

The 20 March 1995 poisonous gas attack on the Tokyo subway system perpetrated by the religious group Aum Shinrikyō irrevocably changed the Japanese religious landscape. Armed with plastic bags of liquid sarin (a deadly nerve agent) wrapped in newspaper, members of the group's inner elite boarded multiple trains that were converging on Kasumigaseki Station in central Tokyo. In the midst of the rapidly crowding trains, the Aum members punctured the bags with sharpened umbrellas, quickly debarked, and hastened to their rendezvous destination. The liquid evaporated and spread through the train cars, killing twelve, injuring hundreds, and mildly affecting thousands. Already under suspicion for other crimes, the reclusive religious group became the primary terror suspect, and a raid on Aum compounds throughout the country yielded evidence that the group had been amassing an arsenal of weaponry in anticipation of imminent apocalypse. Guilt for the atrocity had been established, but the underlying reasons for Aum's actions remained unclear.

The attack sent shockwaves through Japanese society that continue to be felt to this day.[1] In its immediate aftermath, various attempts at explanation appeared in journalism, fiction, documentary film, and academic literature.[2] Some journalists and scholars blamed the fictional media of manga (illustrated serial novels) and anime (animated films and television series that are often based on manga) for the Aum membership's alleged inability to distinguish between fiction and reality.[3] Replete with science fiction and fantasy, manga and anime became scapegoats, the sources of the putative delusion of the young intellectuals who formed the group's inner circle.

Aum doctrine certainly had the potential to appear fantastic and bizarre to the uninitiated. Its teachings were an eclectic amalgamation of doctrines

1

from many different religious traditions, its visions for the future seemingly were derived directly from science fiction, and its strict asceticism seemed foreign and extreme. Furthermore, observers noted that the membership was generally youthful and intelligent. Many of the prominent members were well-educated individuals who were graduates or students of the top-level universities that routinely produce Japan's technocratic elites. Through their membership in Aum, these promising individuals had chosen to remove themselves from slow but steady promotion in Japan's mainstream hierarchy, preferring instead to count themselves among the membership of the postapocalyptic elect. This stance was an overt and discomfiting condemnation of the mores and social norms of contemporary Japanese society.

As I demonstrate in Chapter 4 in a discussion on the complicated relationship between media, millenarianism, and religious violence, the assertion that manga and anime deluded Aum members is overly simplistic. They did affect Aum, but they were only some of the many factors that contributed to Aum's doctrinal development through the 1980s and early 1990s.[4] Nevertheless, it is clear that after the Aum incident manga and anime came to the fore in discussions of religion and public life, briefly and negatively. Although manga and anime content did not change significantly as a result, the powerful image of these media as potentially deleterious persisted in critical commentary even as it was resisted in fan apologia.[5]

This book seeks to recast these highly influential media, which are popular domestically and internationally, as vehicles for the dissemination and adulteration of existing religious vocabulary and imagery, as inspirations for the creation of innovative ritual practices, and as stimuli for the formation of novel religious movements.[6] These significant and often positive relationships between manga, anime, and religion not only predated the Aum incident, but also have continued in various forms since. Furthermore, as I show in Chapter 4, manga and anime have become important venues for artists and their fans to reflect on Aum, religious violence, and the social implications of the incident.

A prodigious and increasingly sophisticated body of scholarship on manga and anime exists across a range of disciplines such as media studies, anthropology, and sociology; this book deals exclusively with the religious aspects of manga and anime culture, however. Making explicit reference to the technical aspects of manga and anime production alongside discussions of narrative content and visual composition, this book illustrates how these elements play important and hitherto largely unexamined roles in eliciting

reverent and ritualized reception among some fans. It shows not only that religious content can be found in manga and anime (something that a few others have indicated), but also that some practices of rendition and reception can be accurately described as religious.[7] Furthermore, although it serves as a corrective for the problematic assumption that religion is an endangered species in contemporary Japan, this book avoids appraising the continued vitality of religion through a strictly denominational lens.

Manga and Anime

Manga are a specific type of comics. They are illustrated serial novels that comprise juxtaposed panels that combine artwork and text. These panels are read sequentially from right to left and top to bottom, although artists occasionally mobilize other modes of composition and sequencing, such as superimposing one panel above another or breaking the frame of a single panel to emphasize dynamic movement. Manga are usually initially published in episodic form in large weekly or monthly magazines of several hundred pages, with a single episode by a particular author occupying only a fraction of an issue. These episodes (about twenty pages apiece) are then collected into paperback (usually) or hardback books and republished in several volumes, each volume consisting of several episodes over a total of about two hundred pages. Publishers thus maximize their profits by selling manga in serialization in bulky magazines printed on cheap paper, and then again in bound compilations on slightly higher quality paper.

As of the mid-1990s, manga sales made up roughly 40 percent of the print publishing market in Japan. Although sales have declined slightly in the past decade due to the advent of entertainment media available through mobile phones, manga still occupy a large share of the print industry today.[8] A number of subsidiary businesses further reap the benefits of this lucrative market. Popular secondhand bookstores resell used copies for tremendous profit, and manga cafes (*manga kissaten*) keep large libraries of manga on hand for customers who pay a nominal hourly fee to sip cheap drinks while reading their favorite series in private booths, interspersing their browsing with Internet surfing.

When a specific manga sells particularly well or otherwise shows narrative promise, publishers profit again by animating the story for television or for the movie theater. While some anime are originally produced for the

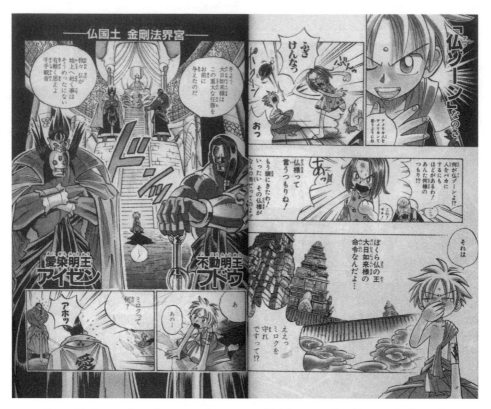

Figure I.1. A page from the manga *Butsu-zone*, which features a bodhisattva, Senju, as the protagonist. Note the changes in perspective between each panel; the switch to a black background on the left (second) page indicates a flashback scene. The second (left) panel on the right-hand page includes onomatopoetic renditions of the action of the girl throwing the bowl and the sound of it hitting Senju's head. © Hiroyuki Takei/Shūeisha.

movie theater or for television, most (some scholars say up to 90 percent) derive from manga series.[9] However, anime directors often simplify manga storylines due to time and budget limitations.[10] Some manga plots such as the popular series *Death Note* and *20th Century Boys* (*Nijū seiki shōnen*) are also turned into screenplays for live-action films featuring human actors rather than animated characters.[11] The reverse is also sometimes the case: the popular anime series *Neon Genesis Evangelion* (*Shin seiki ebuangerion*), for example, was turned into a manga series after its serialization on televi-

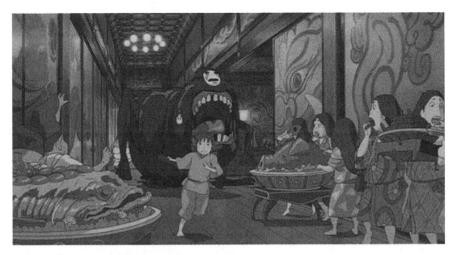

Figure I.2. Kaonashi (No Face) rampages through the bathhouse in Miyazaki Hayao's anime *Spirited Away.* © Hayao Miyazaki/Nibariki TGNDDTM

sion.[12] In general, the business model is to extract as much profit from a story and the marketing potential of its characters as possible.

Although publishers outside of Japan were slow to pick up on the booming industry of manga publication, the translation and distribution of manga and anime internationally has proven itself to be remunerative. Growing numbers of international publishers release officially authorized translated, subtitled, or overdubbed versions of popular series, although they occasionally choose to redact scenes or terminology that is deemed unsuitable for their intended (non-Japanese) audiences. A vigorous Internet-based community revolving around the creation and exchange of pirated or quasi-legal "fansubs" (anime that are given subtitles by devoted fans) and "scanlations" (scanned manga that have been given English text) also exists, although these unofficially distributed translations sometimes lack quality control. They are also increasingly subject to litigation for copyright infringement.[13] As a general trend, until around the turn of this century audiences outside East Asia tended to be exposed to anime first and to manga second, meaning that they generally encountered redacted and simplified anime storylines more frequently than they read the relatively complex manga from which most anime derive.

A new generation of Anglophone scholarship has accompanied the recent popularity of manga and anime outside Japan, however. Early and somewhat

apologetic treatments of manga and anime strove to overcome perceived biases in the popular imagination that associated illustrated fiction with frivolity or that generally disparaged comics and cartoons as puerile (or manga and anime as particularly prurient).[14] Now an increasingly sophisticated body of research approaches these media from a variety of methodological angles and critical viewpoints, the result of the development of an academic infrastructure related specifically to the study of manga and anime. The annual journal *Mechademia* is devoted to the study of manga and anime, many recent academic conferences have featured papers and panels on them, and lately there has been a wave of theses, dissertations, academic monographs, and edited volumes that deal with them in some way. Very recent publications have included significant articulations of methodology coupled with reflexive overviews of the state of the field.[15] Notable recent developments include a diminution of apologetic rhetoric, a willingness to examine the ways in which industrial dispositions affect production and consumption, and a move to supplement narratology with ethnography and examinations of aesthetics.[16]

Nevertheless, several problems remain in this nascent area of study. Many studies have focused on the most prominent artists and directors at the expense of studies of the equally stimulating oeuvres of their less famous peers. Tezuka Osamu, for example, has been given excessive credit for his influence on the development of postwar manga, and internationally acclaimed directors such as Miyazaki Hayao have received the lion's share of accolades for their anime.[17] This means that some very intriguing work by less famous artists such as Matsumoto Taiyou, Koike Keiichi, and Furuya Usamaru (all discussed in later chapters) has gone unexamined. The influential genre of girls' (*shōjo*) manga has also been understudied, although some recent publications have rectified this state of affairs.[18]

Additionally, some studies have problematically treated manga and anime as keys to understanding a quintessential—if nebulous—"Japaneseness."[19] However, even a cursory review of manga and anime history reveals the marked influence of Western comic art and films on their development. In this sense, manga and anime were never exclusively "Japanese" media, although certain facets of the Japanese industry have contributed to the creation of unique aesthetic styles that have since been exported and appropriated abroad. Like other media, manga and anime reveal mimetic qualities, simultaneously mirroring and influencing other media forms. With the progressive globalization of manga and anime production and consumption, it is

becoming increasingly difficult to describe these media as specifically "Japanese" or as embodying or transmitting "Japanese culture." Many Japanese studios ship their storyboards overseas to reduce production costs for time-consuming "in-between" animation, for example, and growing numbers of artists outside Japan describe their work as manga. Furthermore, manga and anime are targeted to specific demographics and as such are rarely representative of Japan as a whole.[20]

A number of scholars have argued that manga and anime differ drastically from other forms of illustrated fiction as a way of garnering legitimacy for their studies of "pop culture."[21] This stance has now served its purpose, and with the maturation of the field such apologetic rationalization is no longer necessary. Nevertheless, it is important to recognize that certain industrial dispositions and associated stylistic conventions do distinguish manga and anime from other combinations of image and text. Some of these techniques and dispositions are especially efficient in the representation of religious ideas and ideals, and some of them particularly contribute to religious reception among audiences.

I explore these characteristics in more detail throughout the book, but two points deserve mention here. It is true that the target demographics for manga and anime are generally more diverse than those of comic books and cartoons in the United States and Europe, which have historically been primarily marketed to and consumed by children and teens. The range of manga and anime subject matter is accordingly more varied. Alongside rather jejune stories aimed at children, manga and anime include how-to manuals, explications of economics and politics, erotic literature targeting the concupiscence of various demographics, and a large share of science fiction and fantasy.

Industrial trends also affect aesthetics. The use of inexpensive media in the production of manga encourages the creation of drawn-out narratives that can have tremendously convoluted plots. Conversely, the time- and labor-intensive practice of drawing numerous cels for anime has resulted in directors' use of simplified "banks" of cels that can be reused, creating a unique aesthetic that both mimics and distorts live motion.[22] I draw attention to these unique methods of depiction and composition because I will show later in this chapter and in Chapter 1 that some of them—when conjoined with careful analysis of audience reception—can serve as convenient analogical tools for envisioning how manga and anime influence audiences' religious lives.

Framing Religious Subjects

My emphasis on rendition and reception is designed to compensate for an excessive emphasis on narrative content that has not only characterized most studies of manga and anime to date, but also has characterized many foregoing studies on media and religion.[23] Overemphasizing narrative content can problematically lead to a similar overemphasis on formal religious doctrine, thereby downplaying the fact that religious activity is often provisional or playful and that religious content is malleable. Additionally, such an approach can place undue emphasis on denominational distinctions, which may not be important or interesting for the people involved in the production or consumption of a specific story. This focus on recognizable and venerable religions (Buddhism, Shintō) occurs at the expense of understanding religious innovation, which may include the proactive poaching of religious imagery or content, the fusion of previously discrete doctrines, and parodic or irreverent portrayals of saints and saviors.

The negative effects of these problems have manifested themselves according to the ideological commitments of the person performing the reading. Some conservative scholars, for example, pessimistically view manga and anime as incorporating bastardizations of "authentic" religion or otherwise adulterating pure religious content.[24] Conservatives that are more optimistic see these media as preserving religious information in a secular age in which most people have unfortunately lost touch with religious traditions.[25] Conversely, scholars who are less concerned with the integrity of specific religions have argued that anime directors offer modified forms of traditional religions that are more suited to a secular social environment.[26]

The thread that ties these various approaches together is a tacit but palpable presupposition that contemporary Japan is religiously deficient. This idea is paired with a concomitant assumption that manga and anime producers preserve—with varying degrees of fidelity and awareness—otherwise moribund religious traditions by smuggling traditional religious ideas and imagery into audience consciousness. Such an approach to manga and anime content does not allow for proactive audience reception, and furthermore reduces religion to a tidy collection of static doctrines and inert deities that can be catalogued according to their apparent denominational origins. The irony of this focus on the preservation of ossified religious specimens and the one-way transmission of immutable religious doctrines in a field concerned with *animated* films and *moving* pictures and stories is considerable.

Using a sufficiently nonreductive understanding of religion fructifies attempts to apprehend, sensitively and accurately, how religion may not only form part of manga and anime content, but also may be an important part of the culture of producing and consuming these media. Specifically, investigating the ways in which authors, directors, and audiences act or speak may be more illustrative of the relationship between these media and religion than simply tracing certain content and imagery onto the blueprints provided by venerable religious traditions. This means that careful delineation of the overarching category of religion and its relationship to specific religions and particular religious attitudes is indispensable.

I proceed in the next two sections by providing a brief overview of contemporary Japanese attitudes towards religion and then defining religion for the purposes of this book. By doing so, I intend to responsibly address the dilemma that poses itself to a scholar who is predisposed by his training to see the religious aspects of culture in a society that generally does not place high importance on distinguishing religion from other aspects of cultural life. I therefore explicitly acknowledge important differences in the interpretations of religion and its relationship to media favored by scholars, clerics, media producers, and audiences. For example, whereas scholars (myself included) may be primarily interested in religion and media on a historical or sociological level, clerics may be interested in transmitting religious truth, producers may be interested in the capacity of religious concepts and imagery to enhance narrative content, and audiences may just want an exciting or meaningful story. The variegated and complex picture of religion that emerges from superimposing these diverse and often incommensurable attitudes on one another is the focus of this book.

Characterizing Japanese Attitudes towards Religion

Statistically speaking, Japanese people's professions of religious belief and affiliation are exceptionally low, hovering at around 30 percent of the population for the past thirty years.[27] Although Buddhism, Shintō, and Confucianism have informed Japanese conceptions of life and death, morality, and cosmology, these ideas are often described as "common sense" (*jōshiki*) or "Japaneseness" rather than as anything explicitly religious.[28] Religious affiliation is also generally seen as familial rather than personal. Many people will acknowledge that their family has had a traditional connection to one sect

or another of Buddhism, for example, although they may not be certain as to which sect it is. The disposition of religion in contemporary Japan thus cannot be apprehended through statistical accounts of institutional participation or affiliation, especially since religious organizations regularly inflate their numbers and individuals regularly downplay their actual involvement.[29] Because of discrepancies between academic and lay definitions of religion and religiosity, the state of religion in contemporary Japanese society cannot be described solely through respondents' answers to survey questions.[30]

It would seem that this situation presents a hermeneutical impasse, but ethnographic studies of sacred sites, ritual, and associated visual and material culture have provided significant insights into the role of religion in contemporary Japanese society. When scholars examine what Japanese people do (rather than what they say they believe), it becomes clear that many people participate in rituals in a manner that can reasonably be described as religious, even if that is not the terminology most Japanese people would use. For example, trips to historic temples and shrines—including package tours that are marketed as pilgrimages—form a large part of domestic tourism, and people make seemingly casual trips to local and regional shrines and temples to petition the deities for worldly benefits (*genze riyaku*) such as academic success, luck in marriage, help in securing divorces, healing, and so forth.[31] People also may perform acts of obeisance before small domestic altars that enshrine ancestors or other deities, or may purchase sacerdotal ritual services such as having apotropaic incantations recited to ward off misfortune during inauspicious years.

Japanese laypeople, including many of my survey respondents and interviewees, generally prefer to describe these practices as customary, not religious. Custom (*dentō*) is also the term they often use to describe annual observances that take place at formal religious sites, such as New Year's shrine visits (*hatsumōde*), equinoctial visits to ancestral graves (*ohigan*), and the Obon summer festival (which is also for ancestral spirits). In addition to these overt ritual practices, in recent decades there has been a demonstrable popular intellectual interest in topics related to religion, including publications on Buddhism written for lay audiences and popular television programs on supernatural phenomena and divination.[32] Japanese people—especially the young—are more likely to admit to belief in spirits, the afterlife, or deities than they are to admit to allegiance to one tradition or another.[33]

In sum, even if attestations of religious affiliation are low, scholars still attempt to account for individuals' evident (and sometimes fervent) belief

in empirically unverifiable realities. Both Japanese and foreign scholars have generally mobilized the term "religion" (*shūkyō*) to do so.[34] This use of the term "religion" does not wholly escape the scholar's conceit that academic categories can accurately describe people's activities and what they say or think about them. Nevertheless, careful situational definition and conscientious application of the category to aspects of the lives of people who are not necessarily vocationally religious or exceptionally pious helps scholars ascertain sites, situations, and practices in contemporary Japanese society that can be fruitfully described as religious, even if they are not associated with formal religious lineages or institutions, or their clergies.[35] This is not to discount the ways that people describe their own attitudes and activities, but to interpret them with one of the best heuristic tools we have at our disposal—namely, the concept of religion.[36]

Rendering Religion

This stance reflects some basic assumptions regarding religious form and function that inform this book. I argue that fidelity to tradition, sedulity in ritual practice, and formal allegiance to a specific doctrinal lineage are not prerequisites for producing or consuming religious content. Audiences need not recognize a narrative as formally religious for it to serve an inspirational or instructive function akin to that found in conventional religious hagiographies and myths, and narrative need not be characterized as doctrine to have a hortatory or edifying effect akin to that of orthodox religious homilies and parables. Moreover, ritual activity and textual exegesis are not necessarily conducted under the auspices of formal religious institutions or through the mediation of clergies.

For the specific purposes of this study, religion is defined as a particular imaginative mode with an inherently social disposition that can be observed in overt ritual practices or in public statements of belief. It is a willing suspension of disbelief that is dependent on communicated descriptions and shared ideations of otherwise empirically unverifiable realities or personalities. These descriptions are communally deemed veridical, either temporarily or in perpetuity, by groups that may meet regularly or intermittently and may comprise individuals who never meet in person (e.g., online communities) or who are primarily aware of each other's existence as members of the same audience—as mutual recipients of specific messages. While the content

of religion is empirically unverifiable, it is still communicable. Communal interpretations of that content reinforce consensus and commitment, and rituals (which may be equally directed to supernatural or mundane ends) are reproducible and exportable to new contexts. The emphasis here on the inherently imaginative aspect of religion quite naturally points to belief as an integral part of it, but this does not mean that all belief is expressed overtly and verbally or even formally cognized.[37] Belief may be evident in embodied activity. It may also be temporary or situational.

When used with an indefinite article or in the plural ("a religion," "religions") the word refers to social groups that coalesce around shared commitments to (or belief in) empirically unverifiable realities. These groups may have articulated doctrines, canonical texts, prerequisites for membership, or requirements for advancement within established internal hierarchies. They may be (but are not necessarily) legally designated as religious juridical persons based on their provision of magic or salvation through ritual or instruction. These services can vary in the degree to which they are formalized or require special training or credentials. Alternatively, groups may be designated as religions due to their association with a particular site or edifice that is legally or popularly distinguished as sacred; they may also gather in recreational or explicitly commercial settings.

"SPIRITUALITY"

In recent decades, some scholars have used the category of "spirituality" and similar terminology to describe individuals' elective or nondenominational commitments to empirically unverifiable realities. Within this larger global academic trend, Japanese scholars have mobilized categories such as "individualized religion," "spirituality," and "new spirituality movements and culture" to describe groups and movements characterized by loose commitments to vaguely religious content and practices that lack the strictures of formal or compulsory affiliation.[38] Such practices can include various types of divination, energy healing such as Reiki, physical exercise and meditative regimes like yoga, tourism to sacred sites and "power spots," and attendance at "spirituality conventions" featuring various purveyors of magical services and goods. Many of these groups and movements provide access to their content through media and for profit, and scholars argue that practitioners prefer these relatively individualized activities precisely because they do not require allegiance or clearly articulated faith.[39] Claims to "spirituality" over and against "religion" rhetorically allow people and groups to assert the non-

coercive and elective nature of their empirically unverifiable beliefs and associated activities.

Although participants in these movements might rhetorically disavow the religious nature of their practices, I treat spirituality as a subset of religion for several reasons. First, like religions, spiritualities are usually based on perceptions of common membership in an audience or similar community.[40] It is also significant that historians and sociologists specializing in religion have conducted most studies of spirituality to date. Although some foregoing scholarly distinctions between spirituality and religion have been predicated on the perception that spirituality can be personal or individualized whereas religion as such cannot, people almost necessarily draw on concepts from existing religious traditions in the creation of their individualized spiritualities.[41] Individuals modify and amalgamate existing religious concepts and practices as they form loose affiliations of like-minded members with minimal prerequisites for membership. In my usage, the category of religion thus includes shared attitudes that may not be found within the teachings or practices of any specific group that is legally incorporated or otherwise formally designated as a religion.

Meanwhile, formalized religious groups occasionally take advantage of the tax benefits and legal protection offered to religious juridical persons while doctrinally distinguishing themselves from the category of religion as such, usually to emphasize their innovative nature or suitability for a postreligious age.[42] (In Chapter 2, I describe one such group, founded by former manga artist Kuroda Minoru.) "Spirituality" is also increasingly used in public dialogue worldwide to refer to people's commitments to empirically unverifiable phenomena (or practices based on such commitments) in a politically correct fashion, and functions as a euphemistic substitute for the term "religion." In this book, religion is therefore understood to be an imaginative and social endeavor that encompasses the category of spirituality while accounting for practices and commitments that exist both within and outside the formal confines of traditional religions such as Buddhism, Christianity, and Shintō, and their associated canons and liturgies.

VERNACULAR RELIGION

Within this broader field of religion, this book is primarily concerned with what Keller Kimbrough and Hank Glassman have recently described as "vernacular religion."[43] As they indicate, "vernacular" is an improvement over the terms "popular religion" and "folk religion," both of which problemati-

cally imply hierarchies of authenticity predicated on varying degrees of proximity to the centers of doctrinal creation and interpretation. "Vernacular," in contrast, refers specifically to the acts of interpreting and translating a given concept or practice into local languages and worldviews (which may be erudite or unschooled) or the export of formal religious ideas to quotidian (but not necessarily plebeian) contexts. "Vernacular" therefore indicates the translation of concepts into categories that the constituents of a given stratum or subculture of a society would find intelligible and meaningful.

Ecclesiastical authorities and lay entertainers all participate in the creation and use of media written in accessible language (and frequently augmented with images) to encourage familiarity with religious vocabulary, imagery, and concepts. Vernacular religion is thus simultaneously reflective of and formative for Japanese culture, providing a "storehouse" of religious concepts on which various entertainers have drawn throughout history in the process of creating compelling stories.[44] The term therefore can indicate the deployment of religious terms and iconography on the part of lay authors and artists to capture and entertain audiences as much as it can indicate clerics' use of vernacular language to translate doctrine.

"RECREATING RELIGION"

In this deployment of religious themes for diversion and the mobilization of entertainment media for religious instruction and inspiration, we find vivid examples of how religion is "re-created" while people recreate.[45] The phrase "recreating religion" forms a recurring motif in this book, referring simultaneously to producers' use of religious content in the service of creating entertaining media products and to the alteration of religious content that occurs through mediation. Throughout the text, "recreation" can and should be read both ways (recreation as entertainment and re-creation as reconstitution), but for clarity I will include the hyphen (re-create) when using the word specifically with the meaning "to create again."

When proselytizers make use of various media to present their formal doctrines, the media in question ineluctably shape the messages that are transmitted. Similarly, when authors, artists, and directors borrow from the "storehouse of religious concepts" in the service of creating an entertaining story, the primary interests of the producer (making art, making money, entertaining an audience, educating) filter the religious information involved. Unless commissioned by a specific religious group, creators of vernacular

religious media are not required to follow any specific doctrine, and they may liberally pick and mix images, concepts, and vocabulary from a variety of religions.[46]

The resulting products may be irreverent, but they are rarely iconoclastic. Storytellers would doubtless find it inconvenient to obliterate the powerful imagery and narrative tropes that religious traditions offer. Rather, vernacular religious media are "iconoplastic." They mold existing religious information and imagery to suit their narrative needs. For example, Nakamura Hikaru's manga *Saint Young Men* (*Seinto oniisan*) humorously portrays Jesus and the Buddha as roommates in modern-day Tachikawa, eliciting comedy from the incongruous juxtaposition of these venerable saintly figures with contemporary urban life.[47]

Although the plasticity of doctrine forms one crucial aspect of my discussion of the re-creation of religion that focuses on the side of production, there is an equally important aspect on the side of reception. This is a crucial difference between two aspects of entertainment—namely, a discrepancy between the apparently synonymous terms "diversion" and "recreation." In my usage, diversion refers to a temporary flight from quotidian concerns after which people return to daily life relatively unchanged. Recreation, though, refers to the process whereby viewers re-create themselves and their worldviews through mediated experience. In the case of anime, for example, viewers may watch a particular film as a way to distract themselves for ninety minutes without taking any particular messages away from it and without using the film as an impetus for changes in their behavior or lifestyle. They are temporarily diverted from their daily lives—amused, to be sure, but not changed in any significant fashion.

In other instances, however, audiences suppress their awareness of the gap between the fictional world of the film and empirical reality, reading the story as having a particular message about ideal lifestyles, viewing a character as a model to emulate, seeing a particular filmic site as a representation of a real, meaningful, and sometimes sacred place, and perceiving a filmic ritual as an activity to be reproduced in reality. The same, of course, applies to the reception of manga, and in both cases, audience members re-create their worldviews. Any religious content in such moving stories may also be re-created through the process of interpretation. Whatever the interests of the director and whatever the actual connection with formal doctrine, audiences can interpret the content in various and unexpected ways that may be more cavalier or more pious than the producer intended.

ENTERTAINING RELIGIOUS IDEAS

Media producers may mobilize entertaining religious content and audiences may entertain religious ideas through (or because of) media, but neither necessarily influences the other. Nevertheless, there are many instances when a given media product may be interpreted as both entertaining and religious, or when competing interest groups describe the same product as one or the other. As a way of theoretically highlighting this simultaneous continuity and contradiction, in an earlier publication I juxtaposed the words *shūkyō* (religion) and *asobi* (play) in the neologism *shūkyō asobi*.[48] This term elaborates on the aforementioned concept of "recreating religion" by etymologically drawing attention to the long tradition of entertainment as an integral aspect of religion in Japan through the semantically fecund verb *asobu* (to play) and its derivatives. *Shūkyō asobi* also highlights the similarly imaginative aspects of religion and recreation, helping to elucidate the ways in which a given media product can be perceived as simultaneously facetious and pious on the side of production, or as both frivolous and poignant on the side of reception. Here I will briefly recapitulate the gist of my earlier argument as a way of summarizing the approach to religion that informs this book before moving to a specific discussion of how I will address the media in question.

The verb *asobu* in modern Japanese carries connotations of play, diversion, pleasure, enjoyment, transformation, and adulteration.[49] In classical Japanese, the verb has additional connotations related to performance, including musical performance, oratory, and ritual.[50] While frequently translated into English as "to play" and accordingly associated with the activities of children or with games, the word *asobu* is more diverse in usage, covering a wider variety of activities associated with entertainment and leisure. Some examples include playing music and dancing (including *kagura*, a sacred dance), diversion, outdoor activities, hunting, strolling, gamboling (what children or animals might do), traveling, loitering, being let loose or set free (as in land lying fallow, money accumulating interest, or a tool left unused or unattended), gambling, teasing, or being teased.[51] *Asobu* is also commonly used euphemistically to refer to sex (especially of the casual variety) or related activities such as prostitution. Etymologically, *asobu* ("to play") originated in references to the entertainment that accompanied religious ritual such as music and dance.[52] To play (*asobu*) is "to liberate one's mind and body from daily life, and to entrust one's self to another reality."[53]

Asobi, the nominal form of the verb *asobu*, can be glossed as "play." *Asobi* (play) changes the form or shape of something commonplace in order to

amuse and to delight. People submit to novel rules and acknowledge imagined strictures during play. They also necessarily—albeit often temporarily—accept pretense at face value.

While at times educational or edifying, the activity of play suggests a relaxing or escapist flight from mundane concerns. Yet the experience of play often reflects those concerns by challenging and critiquing them through the artifices of pretense, humor, and manipulation. This mercurial activity therefore offers both respite from and reconciliation with the serious elements of daily life.[54] Adulteration (to play with, to play upon) takes a starring role within the broader play of diversion and recreation.

Some religious activity can be characterized by the verb *asobu* because it is instantiated in nominally entertaining activities, while some play can be described as *shūkyō* because it reveals sincere and shared belief in empirically unverifiable realities. The phrase *"shūkyō asobi"* therefore refers to religious entertainment and playful religion, pointing to instances where modifications of religious behavior and outlook occur within spaces equally devoted to entertainment or, alternatively, where religious practice and pedagogy simultaneously behave as entertainment experiences. In the sense of play as manipulation or adulteration, the term also can indicate the process of drawing on existing religious schemata while modifying them, emphasizing the plastic nature of religious doctrines and ideas (authors, artists, and directors playing with religious content).[55]

As Chapters 2 and 3 will show, there is an embodied component to *shūkyō asobi* as well, since audience members may play at being religious through role playing and ritual. Entertainment may therefore affect how people view or practice religion, but these effects are not necessarily indicated by overt changes in religious affiliation (conversion) or increased knowledge of doctrine (religious education). *Shukyo asobi* allows for oscillations between perceptions of an activity or media product as either religious or entertaining while emphasizing continuity between the similarly imaginative aspects of religion and recreation.

The aforementioned phrase "recreating religion" encapsulates these recursive relationships between religion and entertainment. This unifying phrase should be read with the aforementioned Japanese etymology in mind. That is, the very notion of recreation derives from (and is mutually imbricated with) religion. Play—like religion—often relies on the ideation of other worlds, frequently involves submission to imagined strictures and rules, and furthermore often features imputations of particular potency to certain agents and attributions of unique significance to specific events.

Religious Manga and Anime Culture

I use the foregoing understanding of religion, media, and entertainment to describe a subset of the culture of manga and anime production and consumption that I call "religious manga and anime culture." By "culture," I simply mean a collection of attitudes, behavior, materials, and media associated with a particular group; in this case the group comprises the producers and end users of manga and anime. Although some producers and consumers of manga and anime might have reservations about the use of the word "religious" to describe their relationship with these products, I maintain that it is an accurate descriptor of some emotional, intellectual, and recreational aspects of manga and anime culture. Similarly, although the leaders of some religious institutions or other religious individuals may have reservations about modifying the phrase "manga and anime culture" with the adjective "religious," I argue that the use of apparently religious themes (deities and apocalypse, for example) by producers of these products and the canonization and ritual usage of some of these works by audiences suggests that "religious" is an adequate and appropriate descriptive word for describing the processes of imagination, production, and consumption that characterize some aspects of manga and anime culture.

With the foregoing definitions in mind, I argue that, whereas we can think of religious edification and fictional entertainment separately, manga and anime sometimes provide cases—both in content and in consumption—where they are functionally conflated. These cases are important not only because they reveal the popularity of apparently religious themes in a society where many people exhibit antipathy or apathy towards religion, but also because they sometimes prove to be the origins of doctrinal and ritual innovation, including the development of novel religious groups. This is not to say, however, that a causal connection exists between authors' inclusion of apparently religious narrative content and imagery and fans' apparently religious interactions with fictional worlds. Some products will elicit seemingly religious responses despite having little content that is explicitly or even evidently religious, and some products will be greeted with apathy in spite or because of their overtly religious content.

With these caveats in mind, there are observable behaviors in manga and anime culture that can be reasonably and accurately described as religious. Clerics sometimes use stories to edify their audiences, and authors sometimes use religious concepts to captivate their readers. Both make expedient use of illustration and animation to augment their narratives. At the same

18

time, audiences of ostensibly secular entertainment media sometimes engage in apparently religious practices. To foreshadow some examples that appear in later chapters, audiences may interpret texts and apply lessons found therein to daily life (visiting the Yasukuni war memorial shrine after reading Kobayashi Yoshinori's manga), may canonize texts and films that they find particularly instructive (supplementing passages from Tezuka Osamu's *Buddha* [*Budda*, 1992–1993] with expository text about the manga's lessons for life), or ritually reproduce actions that they have learned through media (playfully emulating anime characters' interactions with fictional deities).

Taken together, these practices of production and consumption in manga and anime culture form a viewfinder through which we can take a snapshot of contemporary vernacular religious content and practice. Such a snapshot illustrates the ways in which the portrayals and practices of religion in manga and anime culture reflect producers' visions of religion and how these in turn affect local and international audiences. Furthermore, to take a page from the media under consideration here, this synchronic snapshot can be placed on a diachronic timeline to illustrate continuities in vernacular religious practices and media across history.

Outlines

The dearth of studies on the religious aspects of manga and anime culture derives in part from the immaturity of the field. More importantly, it reflects significant methodological dilemmas that have not been systematically addressed until very recently.[56] In the following sections I discuss ways to apprehend the narrative, visual, and filmic aspects of these media in conjunction with the exegetical, ritual, and pedagogical aspects of religion. I furthermore sketch ways for understanding manga and anime in light of authorial intent and audience reception while acknowledging that these media are targeted to specific demographics.

AUTHORS AND DIRECTORS

It is now common sense that authorial intent does not always match audience reception. However, the study of manga and anime has hitherto given undue preference to authors and auteur theory, emphasizing the creative genius of a particular individual while downplaying the proactive roles that audiences play in the reception and interpretation of content. Although this

tendency is problematic, it is clear that the imprimatur of a specific author or director does contribute significantly to the reception of a work. Her specific interests and intentions can influence the ways in which a particular manga or anime fulfills a religious function, be it at the stage of production (an inspired work) or consumption (liturgical use or inclusion in the canon of a religious group). For many authors, the deployment of religious vocabulary and imagery is merely an expedient means for attracting audience attention, and most authors seem quite casual in their use of religious themes. Nevertheless, a small number of authors and directors are explicit about the religious motivations behind their work.

In this book I try to balance examples of both cavalier and pious authorship. While it is impossible to determine authorial intent prior to production and publication, interviews provide a way of understanding how authors retrospectively interpret their own work. Although I experienced less success in securing interviews than I would have liked during my years of fieldwork, in the case of prominent directors such as Miyazaki Hayao and manga artists (*mangaka*) such as Kobayashi Yoshinori I was able to draw on a large body of prior conversations, both journalistic and academic. I also was able to use the memoirs of artists such as the "god of manga" (*manga no kamisama*) Tezuka Osamu. In addition, Chapter 2 includes an extended discussion of three interviews I conducted with Kuroda Minoru, a *mangaka* who founded a religion. Artists will only rarely acknowledge religious dimensions in their work, however, and even when they use apparently religious language it does not necessarily indicate firmly held beliefs. Famed *mangaka* Urasawa Naoki refers to moments of artistic inspiration as a feeling of having the "god of manga" (*manga no kamisama*) enter his right hand, for example, but there is no indication that he is an ardent devotee of this muse.[57]

AUTHORIAL AND ACTUAL AUDIENCES

Jaqueline Berndt has persuasively argued that scholars have frequently and mistakenly interpreted the fact that most Japanese people have significant exposure to manga or anime as an indication that they all read or watch them the same way.[58] As she indicates, manga and anime are usually targeted to specific demographics, and even within a target audience the reception of a particular work can vary considerably. Ethnographic methods thus become indispensable for apprehending how audiences perceive various works. This is not to discount the value of narrative analysis (a technique that I also use),

but rather to say that such readings are most persuasive when conjoined with ethnographic, sociological, or historical data.

Ethnography is not without its own difficulties.[59] The insularity of manga and anime fan culture has made it difficult for scholars to approach its end users in a way that guarantees the candor or veracity of their responses to survey questions. Furthermore, informants will generally downplay the religious nature of manga and anime content or use other adjectives to describe it. Participants in rituals based on manga or anime narratives may also be loath to describe their behavior as religious. I have compensated for these difficulties by carefully examining the religious functions that manga and anime play in people's lives while avoiding excessively mechanistic interpretations that render complex audience interactions with media as simplistic cases of narrative cause and personal or social effect. In particular, I have tried to faithfully indicate my informants' resistance to the adjective "religious" as a descriptive term for their consumption or production of manga and anime.

In addition to reporting the results of interviews with Kuroda Minoru (the aforementioned *mangaka* who founded a religion), later chapters include results of a survey of nearly one hundred college students and several interviews of young adult consumers (ages twenty to forty) of manga and anime. Portions of the work use the more anonymous but also informative realm of Internet message boards, fan sites, and blogs to capture audience reactions to religious content found in popular media. I also draw on the work of scholars who have made passing references to the observable ritual behavior of manga and anime enthusiasts in scholarship on media and religion.[60] Extending the provocative work of scholar of religion Yamanaka Hiroshi, I situate religious manga and anime on a typological continuum, supplementing his organizing criteria regarding the rendition of religious content with additional categories related to authorial intent and audience response.[61] Finally, aware of the fact that my own interpretations and experiences will undoubtedly affect my analysis of the works in question, I occasionally insert myself into the text. Anecdotes of my casual conversations with Japanese friends and acquaintances add an informal ethnographic component that supplements the formal interviews and surveys.

TELLING STORIES

The aforementioned emphasis on ethnography informs my approach to narratives. Narratology sometimes elucidates the proclivities and interests of the

scholar performing the reading while obfuscating the ways in which non-academic audiences receive a particular text. Although stories can indicate a great deal about the interests of authors and their intended audiences, excessive focus on narrative content can result in abstract portrayals of unrealistically monolithic audiences. The tales that audiences and authors tell about their relationships with texts and films provide important supplements and correctives to these caricatures. Parts of this study necessarily recapitulate manga and anime plots, but to the extent possible I have tried to provide an expert reading as a scholar of religion while making that reading consistent with the surface meaning of the stories I examine. Some of my interpretations are necessarily speculative, extrapolating authorial or audience motives and attitudes from storylines, but I have supplemented such speculation with ethnography wherever possible.

MOVING IMAGES

One tendency that has characterized foregoing scholarship on manga and anime is to read these art forms as if they are any other text, overlooking the important roles that images, frames, composition, and animation play in conveying the narrative and educing intellectual and emotional responses.[62] I compensate for this tendency by carefully describing the visual and aesthetic aspects of these media alongside my close readings of texts. I also emphasize the visual aspects of the media under consideration by mobilizing visual metaphors throughout the book. I resist the urge to grant modern manga and anime an estimable art historical pedigree by tracing them directly back to venerable premodern media such as picture scrolls (*emaki*), but I do examine the history of visual-verbal entertainment in Japanese religious contexts to set a backdrop for the study, emphasizing continuities in vernacular religious media and associated practices of production and consumption.[63]

My interpretation of the relationship between religion and images draws on David Morgan's seminal work on religious visual culture and what he describes as "the sacred gaze," although I resist the connotations of overt piety that his phrase evokes.[64] The creation of art representative of religious ideas or ideals is not necessarily reverent or devout. Deities, saints, and pilgrimage sites are convenient characters and settings to be deployed in the service of entertainment and edification, and, while they may serve as awe-inspiring figures in a given image, they may just as frequently be portrayed in satirical fashion or as mere backdrops or scenery. This does not mean, however, that they have no religious significance, nor does it mean that they are immune

to reinterpretation. Audiences sometimes appropriate images that are produced in secular settings for rituals with religious significance, and artists who are not religiously motivated may borrow, emulate, or distort images generally used for ritual veneration for the purpose of entertainment. Sacred images are often expropriated and reproduced in mundane contexts (tattoos, jewelry, television), and plebeian images sometimes become objects of religious veneration. The apparent distinctions between manifest divinity, sacred iconography, and quotidian image therefore lie in differences in rendition and intentionality. That is, they lie in the manner in which a concept or entity is depicted and the attitude presupposed or evident in its production and consumption.

Recent scholarship on religion and images has corrected for museological tendencies in earlier scholarship by situating images according to their ritual use and taking their perceived vitality seriously.[65] For example, recent studies have examined the biographies of images and statues, the pedagogical power of illustrated scrolls (*emaki*), the ritual usage of *maṇḍala* and other images, and the recursive relationships between ritual and performance in dramatic presentations of religious activity (which include not only dramatic action, but also facets of illustration, sculpture, puppetry, and so forth).[66]

Many Japanese Buddhist statues, for example, boast complex hagiographies replete with origin stories and miracle tales, and devotees frequently interact with the images as if the latter were alive. For those who produce, maintain, and worship them, religious images often serve as living entities that demand ministrations including changes of clothing, offerings of food, and privacy (seclusion when not participating in ritual performance, for example).[67] Images are thus considered ontologically indistinct from the deities or cosmologies they represent.[68] In the absence of belief—that imaginative mode in which something empirically unverifiable is treated as reality—an image is merely an inert representation.[69] However, when the imagination is exercised in an attitude of belief, casual or otherwise (what Morgan calls the sacred gaze), then a religious image ceases to be purely representative, becoming the character, deity, or cosmos itself.

In formal religious contexts such as Buddhist temples, images (e.g., statues) are brought to life through rituals such as eye-opening ceremonies (*kaigen shiki*). However, even in the absence of such ceremonial inauguration, a given image can take on a life of its own for some viewers. This cognitive process whereby inert images become imaginatively vivified can be expediently described as animation. Animating an object or an image brings it to life, literally or figuratively; of course, it is in the latter sense that the term for

the illustrative technology of juxtaposing and compositing static images to create the illusion of movement exists in modern English. For the purposes of this book, animation refers to the imaginative construal of inert images as living or otherwise real; it simultaneously refers to the technical process whereby static images are given the illusion of motion through sequencing and variation.

The imaginative animation of images is not necessarily limited to formal religious contexts. Audiences may animate renditions of fictional characters found in popular media just as easily as they may animate artistic renditions of religious characters found in scripture. Fictional characters may thus come to be perceived as "real" in the eyes of their viewers. Furthermore, audience members' exposure to illustrated depictions of a particular deity, event, or concept can greatly influence their subsequent visualization or interpretation of the figure or concept in question. Finally, moving images can animate audiences, prompting intellectual reflection, conversion, and ritual activity such as role-playing.

BUILDING CHARACTER

Literature and drama have proven their capacity to inspire and exhort (as well as to entertain) for millennia; the power of stories derives in part from audiences' imaginative identification with fictive characters and the intense verisimilitude of vicarious experience. Humans can display marked commitment to obviously fictional characters or worlds; occasionally, aspects of these worlds are made manifest and characters incarnated through ritual activity, mimicry, and material culture.[70] The bride and groom dressed as Leia and Han Solo at a Star Wars wedding, the Harry Potter fan who straddles a broomstick to play Quidditch on his college campus, and the Church of All Worlds that takes science fiction author Robert Heinlein's fictional messiah Valentine Michael Smith as its founder all demonstrate the human capacity for intense and committed (if sometimes temporary) imaginative interaction with the fictive world of a film or a novel and its similarly fictive characters and concepts.[71]

These imaginative interactions may balance play and piety in equal measure, and the aforementioned examples from the modern West are matched by examples from Asia, both premodern and modern, some of which are explicitly related to religion. For example, Meir Shahar has demonstrated that vernacular drama contributed to the dissemination of deity worship throughout areas of China, showing that purely fictional characters came to

be worshipped as deities thanks to the inspiring performances of peripatetic theater troupes.[72] Anthropologist Philip Lutgendorf has documented a similar case in India in which a devotional film dedicated to the goddess known as Santoshi Ma contributed to the spread of rituals associated with viewing the film and revitalized interest in this previously obscure deity.[73]

Japanese examples also abound. Keller Kimbrough has persuasively demonstrated that famous female novelists, poets, and diarists of the Heian period (794–1185) were transformed into fictional characters themselves in a variety of Buddhist literature and imagery in later centuries.[74] Buddhist clergies used these women as exemplars of the base nature of literature in contradistinction to the salvific power of scripture. Stories of putative *Tale of Genji* (*Genji monogatari*) novelist Murasaki Shikibu suffering in hell for the licentiousness of her text, for example, served as motivators for audiences to abandon the titillating pleasures of fiction in favor of the more abstemious edification of Buddhism. The irony of using obviously fabricated stories to denigrate fictional entertainment notwithstanding, the cultural cachet of these women—charismatic figures in the proliferating Buddhist literature on sin and salvation—seems to have served as an expedient device in Buddhist proselytizers' attempts to appeal to and capture new audiences. Kimbrough's work helpfully shows how premodern Buddhist vernacular fiction built character through these stories of figures who ostensibly deserved censure (for their sensuality) or veneration and emulation (for their eventual repentance).

In the case of manga and anime, this study will show examples of individuals developing affective relationships with certain characters and taking certain obviously fictive characters as role models. Additionally, collusion between the producers of manga and anime and the makers of toys and video games means that manga and anime provide a particularly rich context for audiences to interact with their favorite characters and fictive worlds through material culture and virtual realities.[75] Audience members get in touch with their favorite characters through the imaginative mimicry known as cosplay (costume play) and through dolls, toys, and models.

LAYERS OF FILM

Like the field of manga and anime studies, the field of film and religion studies is immature. The academic infrastructure for crossing the boundaries between the academic study of religion and film studies has begun to coalesce only in the past two decades, with the establishment of the online *Journal of Religion and Film* and the publication of a few seminal texts on the subject

since the late 1990s.[76] Recent reflexive overviews of the field have indicated that scholars are increasingly aware of the problems with "reading" films as if they were any other religious text.[77] However, opinions have diverged as to how these problems can be solved. Some scholars have advocated greater engagement with the theoretical insights of film studies, while others have advocated a cultural studies approach. Furthermore, studies of film and religion have been divided between scholars who prefer the relatively artistic work of auteurs and those who use popular film to assess how lay audiences might be exposed to religious content.[78] Theological or mythological readings characteristic of both have generally emphasized the messages imparted by a certain film without questioning whether those messages have been received as such by actual audiences.[79] Furthermore, the emphasis on transmission of content leads to a concomitant deemphasis on the ritual of watching film or the rituals that ardent viewers create in conjunction with (or based on) film.[80]

My own method for approaching film is based on three interconnected presuppositions. First, the experience of watching a film is significantly different from reading a text, and film should be assessed accordingly. Soundtracks and sound effects affect the emotional register of a given scene, camera angles focus attention on specific details and obscure others, and individuals' affective relationships with specific characters in film may be based on their prior attraction to the charismatic actors who portray them (including voice actors). Second, films are tremendously fecund as sites for ritual performance. They may be watched repetitively or used in interactive call and response; in addition, filmic actions and gestures may be imitated in the real world. Filmic sites may become pilgrimage destinations, and directors and actors may become the objects of veneration. Third, film—even when viewed in relatively private formats (DVDs, clips streamed on the Internet)—contributes to the sense of being part of an audience in a manner that is different from texts' ability to do the same. As a medium frequently experienced as part of a theater or broadcast audience, film may contribute more than print does to consumers' sense of belonging to a community with shared experiences and similarly shared ideals. While the aforementioned characteristics of film generally apply to anime, animated films are qualitatively different from live-action films in significant ways that derive from the technologies used in their production and differences in format.[81] Some of the anime to which I refer in this book, for example, are not theater films but are rather serialized television programs or direct-to-video releases. I discuss the significance of these differences between anime and live-action film more in Chapter 1.

Religious Frames of Mind

As illustrated above, approaching the religiosity of manga and anime culture solely through a denominational lens generally overlooks the fact that religions comprise multiple interest groups that include clergy and laity representing various sectarian commitments and competing visions of religious authority and authenticity. It also obfuscates the inherent diversity of authorial, directorial, artistic, and audience interpretations of content. Producers may be antipathetic to formal religions and their doctrines but open to transmitting religious ideas in an entertaining format, whereas audiences may harbor similar skepticism regarding formal religious institutions while exhibiting fervent responses to certain characters and concepts, including those derived from religions. Scrutiny of media for traces of traditional doctrines and images also occurs at the expense of acknowledging emergent ritual and exegetical practices in fandom that do not necessarily or solely derive from venerable traditions like Buddhism. My corrective for this problem is generally ethnographic, but ethnography still requires interpretation. The concept of religious frames of mind will serve as a critical apparatus for apprehending the various ways in which manga and anime mediate the recreation of religion.

I have already highlighted the importance of the imagination in religion. The reception of religion, fiction, art, and film is characterized by the willing suspension of disbelief, which can be described as the willful suppression of awareness of the gap between the imagination and empirical reality. I suggest that the same noetic process that allows individuals to view individual synchronic frames of manga and anime as meaningful parts of a diachronic story also allows viewers to frame certain events, characters, and settings with religious significance. Here I will focus on two technical aspects of manga and anime production known as closure and compositing that lend themselves to the rendition and reception of religious content by inviting and demanding the aforementioned suppression of awareness regarding the interstices between fictive and empirical worlds.

CLOSURE

Closure is the process whereby readers imaginatively fill in the space between two juxtaposed panels in a manga. *Mangaka* cannot depict the myriad minutiae of movements in real time, nor is it expedient to draw all of the little moments between significant parts of a story in the manner of a flipbook.

Artists compensate for this inability with an economy of image. By carefully choosing and juxtaposing specific moments, artists demand that viewers imaginatively do the hard work of contextualizing the intervening space between panels. I explain this in more detail in Chapter 1, but, as one example, an artist might draw a soccer player's foot cocked back to kick a ball, and in the next frame show the ball swishing into the net. The intervening time—during which the foot connects with the ball, a defender shouts a warning, the goalkeeper exhibits a surprised reaction, the crowd gasps in anticipation, and the ball travels rapidly through space—is omitted.

COMPOSITING

Similarly, in a technique known as compositing, artists draw on the viewer's ability to suppress her awareness of multiple layers of signification occurring within a single frame. In Figure I.3, for example, the onomatopoetic sound of a character chuckling, "*ku ku*," is written into blank space within the frame of the panel on the far right while dialogue between two characters is written in quotation bubbles. Different panels also show different aspects of the same scene; see, for instance, the panel in the bottom left of the page on the right, which focuses on the protagonist's clenched fist. One character's internal thoughts are shown by thought bubbles on the bottom left, while the top left emphasizes the intensity of the character's assertion with a close-up shot and lines angling outward from his face. These panels, which are read right to left and top to bottom, would be read by a native speaker in just a few seconds. In the process, the viewer stitches the panels together into a coherent narrative, even if they actually demand impressive imaginative leaps between characters' internal monologues and shared dialogue, onomatopoeia, and so forth.

In the production of anime, compositing is used to make what Thomas Lamarre describes as the "multiplanar image," and "closed" and "open" compositing vary the audience's awareness of the existence of these multiple layers.[82] By adjusting the space between transparent cels through the use of an animation stand, artists and directors create the illusion of depth in a single frame of anime. In addition to panning the camera across a composite image forming one frame, they can move single layers within it to create the illusion of movement within and across individual frames. In both instances, skillful use of the apparatus allows directors to suppress or manipulate the audience's awareness of the existence of multiple layers within a single composite image; it also suppresses awareness of the rapid transitions between frames.[83]

Figure I.3. Light decides to make himself the god of a new world in *Death Note*. © Tsugumi Ohba, Takeshi Obata/Shūeisha

Detailed analysis of the techniques of closure and compositing is largely beyond the scope of this book, and there is little point in reproducing others' stimulating and expert work. Here I mention these techniques specifically to highlight the cognitive operations on which both rely. That is, they are not merely artifices for rendition and representation, but also can be conceived as particular ways of viewing manga and anime that compress multiplanar images into composite ones and that interpret the juxtaposition of such composite images as a reasonable approximation of empirical reality. Closure and compositing are therefore inherently imaginative, demanding that audiences suppress their awareness of the interstices between frames and layers within frames. Similarly, these techniques draw audiences into stories, contributing to the creation of religious frames of mind by inviting audiences to suppress their awareness of the gaps between fictive worlds and

empirical reality. I am not suggesting, however, that this suppression is uniform—these techniques can be executed with varying degrees of skill and persuasiveness, eliciting differing degrees of audience absorption. Personal predilection also will affect interpretation and intellectual and emotional investment.

As I will show throughout this book, closure and compositing can also be used metaphorically. Some authors and directors use a relatively "open" form of compositing that invites audiences to view certain narratives as equally being of religious import and recreational promise. Tezuka Osamu's *Buddha*, for example, is obviously about religious content (the life story of the Buddha) but is marketed as an adventure story.[84] Conversely, many authors and directors use "closed" compositing to suppress awareness of the religious strata of their works. Anime director Miyazaki Hayao often has been described as incorporating "Shintō" into his films, but he strongly resists this idea even though he mobilizes concepts like deities or spirits (*kami*) in his narratives. Miyazaki prefers to depict deities rather than religious clergies or institutions, and when he does depict the latter they are inert (deities' statues in *My Neighbor Totoro* [*Tonari no Totoro*, 1988]) or corrupt (the venal monk in *Princess Mononoke* [*Mononoke Hime*], 1997), while his deities are vivacious and active. He thus bypasses formal religion by tapping directly into an imagined spiritual world. Furthermore, just as *mangaka* occasionally rupture the hermetic seal of the individual panel so that characters leap out of the frame and across the page, and just as anime directors occasionally drastically switch to open compositing to elicit a sense of disorientation or movement, prosaic stories with no overt religious messages may suddenly reveal registers of religious significance, as has been the case with the works of *mangaka* such as Yamamoto Sumika and Miuchi Suzue (described in Chapter 2).

As in the case of the composite image, a given viewer may pay a greater or lesser degree of attention to the existence of the interstices between illustration and empirical reality. Yet, just as he may be able to distinguish between layers of a composite image found in a given frame, his ability to distinguish between layers of fiction and reality is not compromised by his willingness—temporary or perpetual—to interpret these layers as collectively forming a meaningful world.[85] In this sense, the artificial line between the imagination and empirical reality—a line that I have been drawing here for heuristic purposes—ceases to be significant or even intelligible. What remains is the frame through which audience members make sense of the world.

Audience members exhibit religious frames of mind when they interact with the characters and cosmologies of manga and anime in ways that reflect an imaginative mode of compositing in which illustrated worlds are superimposed on empirical reality. A religious frame of mind is present when a given narrative animates the audience, inspiring devotional or ritual activity such as composing devotional tablets (*ema*) at shrines addressed to favorite characters rather than to deities. It is visible when a given character becomes animate in an audience's shared imaginary as a model to emulate, as in the case of the women I describe in Chapter 3 who take the fictional character Nausicaä as a role model. We can trace religious frames of mind when audience members project an illustrated place onto physical topography as a pilgrimage destination (such as *Sailor Moon* fans patronizing Hikawa Shrine in the Azabu Jūban district of Tokyo). We can visualize them when a specific geographic location takes on sacred significance in fan discussions as the alleged inspiration for an animated world—a place that is simultaneously fictional and real, inspired and inspiring (the island of Yakushima as the putative model for the sacred forest featured in *Princess Mononoke*).[86]

Focus

The basic stance that ties the aforementioned approaches together is my insistence that manga and anime not be treated as museums preserving ossified specimens of assorted denominational species. They are vehicles for religious creation and re-creation, for the imaginative animation of fictive characters.[87] Authors and directors proactively mobilize religious concepts, characters, and images for a variety of reasons ranging from piety to profit. Lay artists may attempt to inculcate moral lessons in their audiences while criticizing formal religious institutions, and leaders of religious institutions may make executive decisions to proselytize through manga and anime, but in neither case are these media mere containers for the smuggling of cloaked religious content into the minds of unsuspecting audiences. This is because audiences play a similarly proactive role in interpreting manga and anime content in ways that often diverge from authorial and directorial intentions. Audience reception may include the canonization of certain works (treating them as sacred literature), ritual reading or viewing, and the associated development of affective and devotional relationships with fictional characters.

In short, this book is not about the incidence of Buddhism, Shintō, or Christianity in manga and anime as much as it is about the creative and

sundry ways in which the constituents of manga and anime culture deploy, receive, interpret, and mentally and physically interact with narrative and visual content. Moreover, it is explicitly about how they do so in ways that reflect religious frames of mind. In addition to the stories and images that compose its direct objects of study, authorial and directorial analysis, fan message board discussions, personal interviews, surveys, exegetical commentaries, critical reviews, and observable ritual practices devoted to fictive sites and characters serve as its subject matter. The frames of mind evident in these sources of data can be juxtaposed with one another; although they may not always be perfectly contiguous or complementary, through the imaginative process of closure we can suture them together to visualize the endlessly changing subset of contemporary Japanese vernacular religion that I call religious manga and anime culture.

The case studies in the following chapters strike a balance between examples derived from manga and from anime, but they demonstrate a slight bias towards manga for pragmatic reasons. Manga are easier than films to review, and in most cases manga are produced prior to anime and therefore have a narrative richness that anime sometimes lack. Nevertheless, anime have their own strengths and I have accordingly included many salient examples from anime, including those in Chapter 3 that focus in particular on the reception of acclaimed director Miyazaki Hayao's oeuvre. To the extent possible, I have indicated whether a particular story exists in both formats, and I have tried to include detailed discussions of anime such as those of directors Miyazaki and Kon Satoshi that are not based on manga.

Many of the works to which I refer are now available in translation and can be found in large bookstores or through online retailers. Some of them, unfortunately, have not yet been translated and may never be. Readers who are concerned about plot spoilers should beware that portions of the book necessarily provide synopses of their subject matter. I have tried to write these so as not to detract from the richness of their storylines, and have left some surprising plot twists unspoiled. For readers who are unfamiliar with them, no amount of description and discussion can compare with the actual experience of reading manga or watching anime. I leave it to the reader to decide which products among those discussed seem appealing.

Although I hope to provide a somewhat comprehensive overview of religious manga and anime culture in this book, there are works that I have necessarily omitted. The heavy emphasis on young adult (*seinen*) and boys' (*shōnen*) manga and associated anime reflects personal predilection more than a programmatic delineation of research parameters. This accidental em-

phasis is both unintentional and unfortunate, and is only partially redeemed by the fact that these categories of manga and anime are more widely consumed than girls' manga or ladies' comics. (While girls are likely to read and be familiar with boys' manga and anime, the reverse is less common.)

My neglect of girls' and women's manga and anime is inexcusable, but I hope that readers will supplement this study with further examinations of other types of manga and anime in coming years. Although I refer to a few works that fall into the girls' manga category, with considerable chagrin I leave the study of religion in the culture surrounding girls' manga and ladies' comics to others, hoping that this book provides helpful groundwork and research methodology that fructifies these future endeavors. Furthermore, although there are obvious connections between manga, anime, and video games, I happily relinquish study of the latter to those with greater affinity for them. Finally, while I do discuss the international reception of these media (including academic reception) in passing, for the most part my study focuses on their creation and consumption in Japan. This reflects my training in Japanese studies, the emphasis on Japanese-language sources in my work, and my years of fieldwork in that country (2005–2007). Hopefully future studies on this subject will take a more international and interactional perspective than I have taken.

Chapter 1 briefly traces the history of vernacular religious media and explores the stylistic conventions specific to manga and anime that make them amenable to conveying religious content. Chapter 2 plots manga and anime along a continuum ranging from casual diversion to explicitly religious recreation. One the one hand, I provide a typology of religious manga and anime based on criteria related to the attitudes that characterize their production, allowing for differences in intentionality while examining the rhetorical techniques ranging from satire to sententiousness that manga artists and anime directors use in the service of amusing, educating, and persuading their audiences. On the other hand, I examine the side of reception, highlighting the different ways in which audiences interpret products with apparently religious content and plotting those responses on a continuum from apathy to reverence. I examine the exegetical commentary of fan groups, ritualized activity derived from fictive manga and anime worlds, and the emergence of formal religions (groups that are legally incorporated as religious juridical persons, with clearly delineated hierarchies and doctrines) out of fan groups. This chapter includes the majority of the results of my interviews and surveys, including references to an informant who underwent Buddhist

initiation due to the influence of manga, a casual reader who recalled dis-traught fans holding an actual funeral for a fictional character of a favorite manga, and a lengthy section on former manga artist Kuroda Minoru, who founded the religious corporation known as Subikari Kōha Sekai Shindan. Chapter 3 examines the production and reception of famed director Mi-yazaki Hayao's animated films while conducting a critique of foregoing aca-demic interpretations that have treated Miyazaki's work as essentially or in-herently religious. Chapter 4 addresses the complicated issue of manga (and, to a lesser extent, anime) narratives' role in the story of Aum Shinrikyō, and provides close readings of three manga that were published in the aftermath of the gas attack and how they reflect authors' and audiences' perceptions of marginal religious movements. The conclusion summarizes the main argu-ments of the book and offers suggestions for future study. As a whole, this book demonstrates that the verisimilitude of fictive and illustrated worlds can influence audiences' perceptions of empirical reality, contributing to the concomitant development of convictions and practices that can be fruitfully described as religious.

Visualizing Religion

Just as a *mangaka* juxtaposes a series of discrete panels to create a comprehensive story, in the first half of this chapter I juxtapose several brief sketches of notable technological innovations in Japanese illustrated media to narrate the history of some stylistic, topical, and industrial tendencies that have come to characterize contemporary manga and anime culture. While I resist the presentist urge to equate earlier illustrated narrative media like premodern *emaki* and early modern illustrated novels (*kibyōshi*) with modern manga and anime, I argue that there are important similarities in the ways in which contemporary producers and premodern proselytizers and performers have used combinations of image, text, and script in didactic and recreational settings related to religion.[1] In the second half of the chapter, I examine some common compositional techniques to show some of the ways in which producers of manga and anime visualize religious ideas and ideals. Specifically, I show how artists' and directors' decisions about how to manage the ratio between text and image, how to approximate real-time motion, where and how to provide or omit background (literal and figurative), and how to expediently convey and elicit emotion all contribute to the capacity of a given work to invite vicarious experience and to take on religious significance through the creation of religious frames of mind. I furthermore show how marketing serves as another layer of rendition, determining the target audience and thereby expanding or circumscribing a given product's reach.

Pedagogical Pictures and Proselytizing Priests

Considering their prodigious production of *emaki* and statuary, it seems that premodern Buddhists embraced the old adage that a picture is worth a thou-

sand words, treating images as expedient means to pedagogical—and ultimately soteriological—ends.[2] Pictures, however, are only worth any number of words if they are comprehensible, and their intended audiences must be fluent in the visual and verbal vocabulary that informs them to serve as reasonable proselytizing media. In the absence of such fluency, translation is indispensable.[3] This pragmatic consideration contributed to the development of a class of specialist preachers who used images to amuse their audiences while simultaneously using the same images to explain religious content. With their ability to orally animate the images found in *emaki* depictions of hell, the six realms of existence (*rokudō*), and various foundation stories of temples and shrines, these raconteurs (called *etoki*) proved through their office that there are times when a word may very well be worth a thousand pictures. Their practice, which went by the same name (*etoki*), entertained audiences while simultaneously encouraging audiences to entertain religious ideas.

EMAKI

The modern categories of "art" and "religion" were not discrete in the *emaki* of premodern Japan. For example, *emaki* were often used to advertise the particular benefits that could accrue from the patronage of a particular deity or temple, simultaneously providing entertainment and salvation.[4] Many *emaki* also depicted the lives of important historical figures, serving the function of being aesthetically pleasing, mapping the area where a person lived or traveled, providing instruction on the exemplary life of the person in question, and sharing an entertaining story.[5]

Emaki depictions of Shōtoku Taishi (574–622) are one example. Like other ancient period religious figures such as Kōbō Daishi (a common epithet for Kūkai, the formulator of Japanese Esoteric Buddhism), Shōtoku Taishi has been fully turned into a figure of legend. He is famous for introducing Buddhism to Japan and for establishing a seventeen-article constitution; his hagiography includes miraculous feats such as flying over mountains. There are a number of extant pictorial biographies (*eden*) of Shōtoku Taishi, including some in the collection of the Tokyo National Museum, and also in the collections of some temples such as the hanging *emaki* at Hōryūji (allegedly founded by Shōtoku Taishi himself).[6] Similar, if less reverent, illustrated hagiographies also have appeared in recent years. *Mangaka* Yamagishi Ryōko, for example, portrays the prince as a conniving and cross-dressing wizard who

has a clandestine love affair with Soga no Emishi (son of Soga no Umako) in her manga *Prince of the Place of the Rising Sun* (*Hi izuru tokoro no tenshi*).[7]

Other *emaki* images of the Japanese ancient and medieval periods were hortatory pictures of hells, the six realms of existence, and the Pure Land. Popular images of hells, for example, showed the various tortures that awaited people who were cruel or unjust. These images sometimes included text in the vernacular, describing the torment that sinners would face in gruesome detail. People were skewered, burned alive, reconstituted, and burned again. They were drowned in pools of blood, forced to endlessly climb trees of knives, infused with molten copper through various orifices, and so forth, for many millions of years on end.[8]

In addition to the admonitory nature of the hell scrolls, some *emaki* may have contributed to the rapid spread of Pure Land belief in the fourteenth and fifteenth centuries.[9] For example, many *emaki* depicted Amida's Pure Land, or Western Paradise, or portrayed Amida and his retinue appearing to greet the deceased at the moment of death (this image has been reproduced with some fidelity in modern anime such as Takahata Isao's *Pom Poko*; see Figure 1.1).[10] Similarly, Kumano nuns used *emaki* to disseminate faith in the Heart Sutra (*Hannya shingyō*) and the Blood Pool Hell Sutra (*Ketsubonkyō*).[11]

Another popular style of *emaki* is the *engi emaki*, or foundation story *emaki*. One example is that of Kitano Tenmangū, the shrine complex dedi-

Figure 1.1. Director Takahata Isao reproduces a *raigō* scene of Amida arriving to greet the deceased in *Pom Poko*. © Isao Takahata/Studio Ghibli

cated to Tenman Tenjin. Sugawara no Michizane, a scholar and government official of the Heian period (794–1185), was enshrined as Tenman Tenjin to pacify his spirit after he was unjustly demoted and persecuted before dying an unhappy death. Shortly after Michizane's death, several calamities befell the capital, including the illness of the emperor and an epidemic. According to the story, theories began to proliferate that it was the work of Michizane's angry spirit (*onryō*), and eventually an oracle suggested that it was indeed Michizane who was responsible for the calamities. Thereafter he was enshrined at Kitano, which became one of the major shrines of Japan, and branch shrines now exist all over the country. As Tenman Tenjin, Michizane became an object of devotion in Shintō and Buddhist contexts, and is now generally regarded as the patron deity of academics due to his reputation as a great scholar and his association with the Edo period (1603–1868) temple schools (*terakoya*). The *Kitano Tenmangū engi* is a famous example of a foundation story, and the use of images to relate the story seems to have helped to spread Tenman Tenjin belief.[12]

Scholars have documented similar examples of *emaki* used as advertisements for other pilgrimage sites or as didactic expositions of hagiography. In a compelling attestation to the effectiveness of the method, some contemporary scholars have relied on the same essential technology to make their historical arguments. D. Max Moerman's book on the Kumano shrines, for example, uses a famous *emaki* as the basis for a thematic discussion of the various practices associated with those sites in premodern Japan.[13] Similarly, in a recent public lecture at Princeton University, historian of Buddhism Martin Collcutt gave a public lecture on the hagiography of the peripatetic Buddhist proselytizer Ippen. Aided by PowerPoint, Collcutt pointed to a slide of a section of the *Ippen hijiri-e* (the illustrated hagiography of Ippen, a didactic scroll) that depicted Ippen using a painting to explicate his Buddhist insight to a guest in an otherwise bare hut.[14] These three levels of pictorial exposition suggest that although the technology has become more sophisticated, the basic practice of juxtaposing the display of images with didactic explanation has been historically durable.

ETOKI

This durability originally derived from a dilemma. Although *emaki* have served as useful tools in the dissemination of religious information, originally the organization of their images was haphazard at best, and when they included text it was often similarly disorganized. Stories would not neces-

sarily move from top to bottom or right to left, but would skip from one part of the painting to another, often without any sort of boundary drawn to separate the elements of the painting. Or, if there were boundaries, they tended to be drawn as part of the landscape, so that a tree, mountain, or house actually served as a dividing line between two separate episodes in a story. Even though the images themselves might contribute to an easier understanding of the content, the (dis)organization of the painting would actually (and ironically) make it more difficult. Many *emaki* thus seem to be a bewildering array of images even if they are actually conveying a story.[15] Incidentally, although some types of *maṇḍala* do include clearly delineated panels or cartouches, it is similarly difficult to decipher their representations of cosmology and doctrine without knowledge of the tradition in question.

Stories are not immediately self-evident through image alone, but necessarily are conjoined with text, monologue, or dialogue (or if only image, very clear juxtaposition and sequencing) to achieve their narrative aims. As time went on, the organization of paintings became clearer, and some scrolls were gradually unrolled as a story was recited in order to give the impression of movement from right to left (an early form of technical animation).[16] Even with these technical innovations, however, understanding *emaki* required the explanation of a specialist versed in the story, in the doctrines of the religion involved, or in the history of the shrine or temple in question. This specialist was called an *etoki*, and the sermons given based on pictures went by the same name.

Etoki is a practice in which temple priests and itinerant preachers have used pictures to expound on religious doctrine, both for semiliterate or illiterate commoners and for the edification of literate elites (who would still have had difficulty with Buddhist scriptures, which are written in classical Chinese that is replete with idiosyncratic readings of characters that are transliterations of Sanskrit terms). *Etoki* practice treated the picture not only as a work of art, but also (even primarily) as a technology for helping to introduce audiences to religious concepts with which they may not have been familiar, simultaneously serving ritualistic, pedagogical, devotional, and entertaining functions.[17] The practice of *etoki* therefore brought the distant concepts of a largely inscrutable Buddhism to the people, serving not only as a medium for religious propagandizing and fundraising on the part of priests and nuns, but also as a ritual device for the accumulation of merit among their audiences. Thus, the practice of *etoki* combined the leisurely and supererogatory elements of popular religious practice with a "visual literacy" regarding Buddhist cosmological and soteriological concepts, origin and miracle tales of

shrines and temples, and *honji suijaku* theories of indigenous *kami* as manifestations of buddhas or bodhisattvas.

Etoki sermons were and are (for they are still practiced today at some temples) simultaneously edifying and entertaining, combining religious instruction and image-oriented entertainment in one practice. Significantly, Ikumi Kaminishi ties *etoki* practice to modern media: "Historical evidence substantiates that since the twelfth century Japanese Buddhists have been using paintings to edify lay audiences with Buddhist knowledge, morals, and way of life. [The] *etoki* tradition, now a millennium old, continues to entice and entertain people even in this television age, although to some extent movies, TV, and the Internet have replaced *etoki*. In essence, *etoki* and modern audiovisual entertainment are not so different in the way they use visual images to draw the viewer's attention while verbal texts—whether written or spoken—supply propagandizing messages."[18]

Although I agree with Kaminishi that there is observable continuity between modern and premodern media in light of their use in religious contexts, I offer the caveat that the portrayal of *etoki* preachers as shrewd propagandists who necessarily and successfully influenced passive and credulous audiences is a caricature that is not sustainable in premodern or modern contexts. While Kaminishi does not explicitly include manga and anime in her list of modern media that inherit the tradition in the quote above, other scholars' uncritical celebration of them as modern manifestations of premodern *emaki* is only uncomfortably supported by historical evidence.[19] Arguments suggesting that the two forms of media are identical generally reveal excessive zeal in the quest to secure a venerable pedigree for popular media that have often been dismissed as pulp fiction.[20] It is true, however, that similarities exist in the combination of proselytizing and entertainment in a single format. Like the *emaki* of old, various religious groups (and occasionally lay artists) use manga and anime to introduce or to reinforce religious attitudes in their audiences.[21]

The manga format, however, is clearly different from that of *emaki*, and manga has its own particular stylistic conventions. *Emaki* composition demands the role of the *etoki* preacher—it lacks the panels and clearly established viewing conventions found in modern manga. While there are certain aspects of *emaki* scenes that functionally serve as panels (trees or buildings serving as boundaries between two scenes, for example), *emaki* composition lacks the right-to-left, top-to-bottom reading style that is standard to almost all manga.[22] The genre of modern manga benefited from the stylistic conventions that emerged from the advent of mass printing, bound books,

the import of European and American comics, and the emergence of film technology. In the following sections I take up some of these developments to show how they have perpetuated images of religions and transmitted religious ideals while also indicating the ways in which they have influenced manga and anime on formal and topical levels.

Kibyōshi

One important part of the development of these conventions is the role played by popular illustrated fiction of the Edo period. Japanese today are used to being surrounded by a large amount of printed material, but for the citizens of the early Edo period it was still relatively novel to have access to literature in large quantities (a reflection of innovations in printing technology).[23] As Japan moved into the middle Edo period, the growth of urban centers and the growing power of the merchant class contributed to the development of literature that was primarily read for leisure.[24] Edo society also saw the development of book-lending services, many of which seem to have specialized in *kibyōshi* (literally, "yellow-cover books"). These were bound books that often included pictures and that were made from low-quality paper; like modern manga, they were read rapidly and then passed on or discarded.[25] Although they had initially begun as books for children, gradually the content became more adult in orientation and tended to include jokes, puns, or satire.

Humor, however, does not preclude the existence of religious themes, nor does the focus on the "floating world" of brothels and other places of leisure commonly described in *kibyōshi* suggest diminished ability to deal with the religious or other ostensibly "serious" material.[26] These media drew on traditions like *etoki* and street oration (*dangi*) that had traditionally been associated with religion, and used religion as a focal point for satire as well as for belief.[27] For example, *dangibon* were books that mocked the hortatory sermonizing common to the Nichiren, Ritsu, and Jōdo Buddhist sects of the period.[28] Similarly, *kibyōshi* used travel narratives and guidebook literature to simultaneously entertain and instruct audiences about nominally religious destinations (pilgrimage routes in particular) while providing titillation and hilarity as well.[29]

Kibyōshi and modern manga are not synonymous, although they are related.[30] Like modern manga, *kibyōshi* include combinations of image and text. Unlike *mangaka*, however, *kibyōshi* authors distributed text in relation to image in a limited number of ways—later developments such as the use

and placement of speech bubbles, thought balloons, and onomatopoeia existed only in rudimentary form in the earlier medium. *Kibyōshi* images also tended to be static—few authors seem to have used frames within pages to show temporal transitions and changes in perspective, and there was minimal use of dynamic lines and onomatopoetic sound effects to indicate action. The introduction of European and American comics and film in the late nineteenth and early twentieth century catalyzed a paradigm shift in picture-based storytelling, providing a new rhetorical vocabulary that was gradually integrated into domestic products and unified over the course of the twentieth century. During this period, illustrated fiction evolved from static pictures supplemented with text to manga, which juxtaposes images and text in a fluid and interpenetrating fashion, and ultimately to anime, which—aided by sound effects and soundtracks—not only juxtaposes static images, but also does so in such rapid succession that it is able to approximate (and productively exaggerate) real-time motion.

Comics and Film

By the turn of the twentieth century American and European comic art (known as *ponchi* or *ponchi-e*) had entered Japan, and newspapers and other serials began running satirical political cartoons and serialized comic strips.[31] These early comics generally matched the model still common in newspapers worldwide today. They involved three or four panels that concluded with a humorous denouement or an ongoing adventure story featuring a charismatic protagonist. Gradually, however, some artists pushed the boundaries of the medium, stretching their stories over more panels and making the plots more involved. This emergent genre of "story manga" would mature in the postwar period.[32]

Silent film technology had also been imported from Europe around the turn of the twentieth century, and audiences were increasingly exposed to foreign and domestic films. Like the *emaki* of earlier periods, the silent films of the early twentieth century were generally augmented by the dramatic performance of a storyteller known as a *benshi*, who matched his narration to the projected images on the screen.[33] In fact, these storytellers apparently enjoyed star power to rival that of the actors and actresses who appeared on screen. Although few examples of the silent films from this era remain, there is evidence that film was used in religious contexts. For example, historian Nancy Stalker has indicated that the charismatic second-generation leader of

Ōmotokyō, Deguchi Onisaburō, successfully used film to reach out to new audiences.[34]

Kamishibai

Film technology is expensive, however, and other media were probably more likely to form significant parts of daily life in the early and middle twentieth century. One such medium was known as *kamishibai* (literally, "paper plays"). Kata Kōji's autobiographical history of *kamishibai* illustrates some connections between religion, art, and performance in this modern art form that developed alongside manga and that foreshadowed animation technology.[35] *Kamishibai* are oral performances of stories that are accompanied by large illustrated cards slotted into a wooden frame in succession; each illustration accompanies a different scene in the story. Originally the stories were produced by individual artists who maintained a monopoly on the images and scripts of their stories, but gradually the cards (particularly those of successful stories) came to be produced en masse, and the stories would be written on the back of each card so that storytellers could memorize and perform new stories relatively quickly. Peripatetic performers of *kamishibai* were especially active in the Taishō (1912–1926) and early Shōwa (1926–1989) eras, and a thriving entertainment industry arose associated with the production of *kamishibai* stories and illustrations, including long-running serializations focused on a particular lovable protagonist (which is also a staple of modern manga).

Kata traces the rise of *kamishibai* in the late Meiji era (1868–1912) to adaptations in *sokkyōbushi*, which were moralistic Buddhist stories that were often augmented with visual aids, particularly rudimentary projected images (called *utsushi-e*) or paper puppets (*ritsu-e*).[36] Many of these stories also included ghost stories (*yōkaidan*), which necessarily drew on ideas of the supernatural and the afterlife. The content of *kamishibai* seems to have developed primarily in a fashion similar to American comic books, with superhuman protagonists fighting evil villains in the name of justice (e.g., "Golden Bat," a superhero named after the tobacco brand). Because of their origin in dramatic presentation, although they used static images, *kamishibai* developed a more interactive and dynamic style of image-based storytelling. The oratory skills of the performers were enhanced by multiple images shown in succession, as opposed to one large image serving as the source of the story (*emaki*) or several smaller images accompanied by descriptive text and dialogue (*kibyōshi*). The transitions between frames of the story allowed for

kamishibai artists to build dramatic tension in their stories, and the relatively high number of frames contributed to the sense of action and movement. *Kamishibai* formed a booming entertainment industry in the first half of the twentieth century, although they were gradually supplanted by television and the rise in mass-produced manga magazines in the postwar period.

Many of the *kamishibai* artists took up work after the war writing manga (or the darker, more adult genre, *gekiga*) for book-lending shops. Some highly successful *kamishibai* artists such as Shirato Sanpei and Mizuki Shigeru transitioned to creating serialized manga stories.[37] Mizuki, for example, developed his unique style of occult manga over several decades, and continued to touch on occult, spiritual, and religious themes in his works, which have been recently examined in a series of book chapters and articles.[38] Mizuki is best known for his stories of ghouls and ghosts like *Creepy Kitarō* (*Ge Ge Ge no Kitarō*), but as one example of his other work, in a relatively recent series called *Biographies of Mystics* (*Shinpika retsuden*), Mizuki details the hagiographies of religious figures such as Swedenborg, Milarepa, and Myōe.[39]

As Mizuki's story demonstrates, *kamishibai* could not compete with television and the newly booming manga and anime industry, especially as increasing numbers of households developed the means to acquire television sets, and as children and young adults came to be able to afford splurges on weekly manga magazines to keep up with installments of their favorite series. By the 1970s, manga and *gekiga* artists had cornered the market on printed visual-verbal entertainment, and anime—often based on manga—was increasingly being broadcast on television and screened in movie theatres.

Although *kamishibai* faded into obscurity, it left significant technological legacies for the postwar manga and anime industries. The apparatus used in *kamishibai* performance was somewhat similar to the stand used to film layered cels of anime, and just as *kamishibai* artists reused picture cards to tell their stories, anime directors began to create banks of cels that they could expediently reuse rather than drawing new images afresh. In addition to this technological connection, the practices of creating and viewing *kamishibai* performance, drawing and reading manga, and filming and viewing anime all rely on the principle of closure. In all of these media, audiences imaginatively connect one image to another, filling in the contextual space between juxtaposed images and suppressing awareness of the composite nature of certain individual images. The remainder of this chapter addresses these technical aspects of creation and the associated cognitive and visual aspects of reception.

Composition

Like Japanese novels, manga are read from right to left. Usually readers start at the top and then work right to left, then down the page. Manga generally juxtapose clearly defined frames of various sizes and shapes with speech bubbles containing dialogue. Mimetic words are built into the image.[40] Third-person omniscient narrative is often contained in boxes with clearly delineated angles, while footnotes supplement text with historical information or explications of potentially unfamiliar vocabulary. The margins of most manga are white, although some authors switch to black when showing a flashback scene (see Figure I.1 on p. 4). Patterned backgrounds indicate powerful emotional tension or magical or supernatural action, while changes between types of ink and drawing utensils—combined with the sparing use of (expensive) color—contribute to the emotional impact of certain scenes.

In part due to the effectiveness of these artistic and stylistic conventions, the paper medium of a well-written manga disappears in the same way that a reader can forget that she is holding the paper medium of a well-written novel.[41] Ideally, the power of the narrative and of the image draws the reader's attention into the imaginary world of the manga, so that the reader temporarily forgets that she is holding the manga as a physical object. This quality is directly connected to the stylistic conventions that *mangaka* use and modify in their art and their storytelling—conventions that in turn came to be essential in anime as well.

Late twentieth-century manga, while clearly influenced by American and European comic works, developed into a unique genre that differs from Western comic art in some significant ways.[42] In part this is related to the processes of production—*mangaka* have traditionally been less constrained than their American and European peers in terms of the length or content of their stories, and have generally taken a "high-context, low-content" approach to the art form by emphasizing images over text.[43] Modern *mangaka*, encouraged by a relatively sympathetic publishing industry and the use of low-grade paper, were able to expand the range of their stories over several thousands of pages, largely due to their extensive use of dialogue-free panels to demonstrate mood, the passage of time, and otherwise verbally inexpressible aspects of their plots.[44] In part, it is this quality of manga combinations of image and text, along with the general conventions of the comics art form itself, that lends modern manga to the treatment and dissemination of religious themes.

Theorist Scott McCloud's groundbreaking work on the art form of comics, while exhibiting some problematic essentialist assumptions regarding the approaches to art of East and West, provides excellent tools for apprehending the conventions of the genre (following McCloud, I include manga within the category of comics here). McCloud's work illustrates (literally— the book is in comic format) the ways this medium differs from other forms of art, literature, and film. With the base definition of comics as "sequential art," further nuanced by the working definition of comics as "juxtaposed pictorial and other images in deliberate sequence, intended to convey information and/or to produce an aesthetic response in the viewer," McCloud moves the discussion of the medium beyond the generally pejorative tendency to look at comics as something less than authentic art and as somehow inferior to estimable literature.[45]

There are several characteristics of comics that deserve attention in light of the discussion of manga and religion. One of these is iconic representation. McCloud argues that the further away from reality an image gets, the closer it gets to an idea or an ideal. He suggests that the iconic hero thus takes on more persuasive power than the photorealistic hero, because it allows for a higher level of reader identification with the protagonist (and sometimes depicting antagonists in more realistic fashion makes them emotionally further from the reader, thus subtly emphasizing the initial affective bond with the more iconic protagonist). Japanese artists in particular have often combined detailed backgrounds with iconic protagonists and realistic or otherwise "othered" antagonists, thus leading to high levels of affinity between reader and hero.[46] One Japanese artist who uses this tactic to great rhetorical effect is Kobayashi Yoshinori, whose depictions of himself are always iconic, but who depicts perceived antagonists in a relatively, sometimes highly, realistic fashion. In a slightly different mode, Urasawa Naoki provides distance from the antagonist of *20th Century Boys* by always depicting him masked.

Another important element of comics is the function of the "gutter," or the space between panels. The existence of panels minimizes the problem of *how* to read the manga; young readers quickly absorb the right-left, top-down pattern of reading. While premodern *emaki* tended to jumble the chronological events of a person's hagiography or of a miracle tale in a bewildering array of images without clear distinctions or progression, comics art uses very clearly defined conventions so that any person with a basic knowledge of where to begin can understand how to read the story.[47]

Relying on the concept of "closure," where the mind of the viewer fills in the temporal or contextual space between panels, artists have used a variety of transitions in order to move their stories forward.[48] McCloud categorizes these transitions as follows: (1) moment-to-moment (imagine a flip book, where each frame shows a successive instant); (2) action-to-action (in one frame a baseball is thrown; in the next frame the batter hits the ball); (3) subject-to-subject (the same scene, but shown by focusing on two or more different subjects in successive panels); (4) scene-to-scene (generally used to show distance in time or place); (5) aspect-to-aspect (used to show several interrelated aspects of the same moment or scene in separate panels); and (6) non sequitur. McCloud claims that whereas the vast majority of comics worldwide use types (2) through (4) to relate the entirety of a story, Japanese manga uses the entire range of the six (although the non sequitur, predictably, is only rarely thrown in for gag effect).

Although his influence has sometimes been overestimated in this regard, a major pioneer in this process was Tezuka Osamu, whose popularization of cinematic effects (close-ups, panning, cutaways, montage) within manga created new ways of envisioning transitions between panels.[49] Many successful *mangaka* since have relied on his stylistic vocabulary at least to some degree.[50] Tezuka's cinematic style of illustration significantly contributed to the development of the genre of "story manga" (works that extend over hundreds or thousands of pages).[51] He also helped to develop experimental forums, such as his magazine *COM*, for manga with more adult themes.[52] A number of Tezuka's works have dealt explicitly with religious themes, some of which have been addressed by other scholars.[53]

Comic stylistic conventions developed by Tezuka and earlier generations of *gekiga* artists can give the illusion of the passage of time and occurrence of motion and action. Frames and panels help artists to illustrate the passage of time, while the use of action lines allows them to depict motion within individual frames.[54] Japanese artists also developed what McCloud calls "subjective motion," where they place the audience's viewpoint in a place synchronous or identical with the active object (as in a viewpoint of one's own hands gripping the handlebars of a motorcycle traveling at high speed as opposed to a static viewpoint watching a motorcycle move by at high speed).[55] Combined with realistic backgrounds and iconic representations of protagonists, this conflation of the reader's viewpoint and that of the protagonist further enhances the vicarious impression of "being there" in the story. The cinematic style of illustration allows *mangaka* to develop their

stories with high levels of complexity and emotional depth; they may invite strong emotional responses as a result.[56]

Incidentally, authors of girls' manga follow a somewhat different set of compositional criteria. They are more likely to depict characters' internal emotional states through patterned backgrounds or facial close-ups, and tend to present protagonists' bodies in a way that invites reader-viewers to vicariously experience the plot. Such portrayals may show, for example, a protagonist in a full-page, full-body shot to emphasize her attire or accoutrement as well as the mood of a scene.[57]

While some might argue that the use of images serves as a crutch for the imagination, the process of closure (visualizing the contextual links between frames) still demands readers' imaginative involvement. Furthermore, static images as used in manga (to set the scene for a story, for example) combined with onomatopoeia, synecdochic representation, and a shared vocabulary of stylized depictions of intangible qualia (three wavy lines indicate odor, patterned backgrounds indicate emotional tension, a bead of sweat indicates frustration or anxiety, a nosebleed indicates erotic arousal, and so forth) create a world that is rich in sensory information.[58] This information is delivered with fewer words than one would find in a novel.

Like novelists, *mangaka* mobilize third-person omniscient commentary, dialogue, and internal monologues and asides to create multiple layers of signification. Yet *mangaka* can substitute images for the lengthy verbal descriptions novelists need in order to depict mood, setting, or internal states. Manga are therefore extremely efficient in conveying (and evoking) emotion. They also have an advantage over novels in expressing supposedly ineffable moments in their stories. Novelists need to make language break down—or alternatively need to engage in descriptive frenzy—to describe such moments. *Mangaka*, in contrast, can abandon language altogether and simply resort to image. While images are also a form of expression, the lack of text in such scenes rhetorically suggests an ineffable moment.

In Tezuka Osamu's *Buddha*, for example, the young Siddhārtha realizes at the moment of his enlightenment that all things are interconnected. This summation of his enlightenment precedes a full-page dialogue-free spread depicting a web of interconnected organisms.[59] The content of the Buddha's enlightenment is therefore not expressed in a verbal articulation of the Four Noble Truths, the most common doctrinal codification of the event (and a convenient mnemonic device). Instead, Tezuka visually presents the doctrine of dependent origination (Skt. *pratītyasamutpāda*, Jp. *engi*, an integral part of the Buddha's sudden insight), and therefore implicitly suggests that the

entirety of the foundational event can be reduced to this doctrine. Visual presentation of religious experience can thus both simplify and distort, but it is inarguably efficient at conveying rather complicated information (the specific content of the realizations accompanying the Buddha's awakening, in this case).

Intimately connected to this rhetorically effective use of image is the use of iconic representation in manga works. As McCloud argues, iconic representations of the real world and real people, precisely because of their level of distortion (in the sense of ideated—rather than realistic—figuration), pull the reader vicariously into the text. He rather enthusiastically writes, "The cartoon is a vacuum into which our identity and awareness are pulled . . . an empty shell that we inhabit which enables us to travel in another realm. We don't just observe the cartoon, we become it!"[60]

The distortion inherent in iconic representation is similar to the distortion inherent in art in general. Its value lies as much in its ability to represent ideals as it does in its ability to represent reality. Similarly, the cartoon style of depiction, replete with exaggeration and hyperbole, can be quite effective in conveying and educing emotion, resulting in a relatively high level of sympathy with protagonists and the story content in general. While vicarious experience is inherent in most forms of fiction, in manga it is sometimes enhanced through the iconic protagonist.

Not only do iconic protagonists have the potential to pull in readers' awareness and identities, but also illustration allows artists to put readers into a first-person perspective to a degree that is rare in novels (a convention perhaps borrowed from films; novels written in the second person, for example, are extremely rare). While most literature and film involves some degree of vicarious experience, the iconic nature of the illustrated protagonist—his or her visual representation of pure emotion or experience, characterized by the efficient and effective use of exaggeration and hyperbole—helps to dissolve the boundaries between the character's personality and that of the viewer. In similar fashion, the rapid changes between first- and third-person perspectives in many manga heighten the sensation of being part of the story. Readers can therefore be drawn into the story on multiple levels, sometimes resulting in strong feelings of identification with protagonists and their missions.

To be clear, usage of the manga medium is not a guarantee of narrative success. When cinematic effects and iconic representation are unskillfully executed, or when stories are overly formulaic, manga may be perceived as uninspired, insipid, and clichéd. The inelegant use of images may stifle read-

ers' imaginative involvement, and prosaic storylines might invite boredom more than pathos. Narrative success, measured here by audience involvement in the story, relies on masterful execution of manga stylistic conventions as well as similarly masterful storytelling. In other words, the use of images does not necessarily make story content more fun or interesting, and artwork, like text, requires skill to be intellectually intriguing or emotionally appealing. There are qualitative differences in the ways *mangaka* choose to render their stories, and some artists' work will naturally speak to broader audiences than others.

Furthermore, marketing decisions serve as another level of rendition. When stories are only targeted to audiences who are already actively interested in religion, for example, they often lose their ability to reach other demographics, even if portraying doctrine through the manga format ostensibly makes it more attractive to broader audiences. A manga will be most likely to gain popular attention if it initially appears in a magazine with broad distribution, if the story is turned into an anime to capture a wider audience through television serialization, and if it is actively marketed in bookstores alongside similar products in which potential audience members might already have an interest. Narrative and artistic rendition can only be commercially successful—and therefore potentially broadly influential—if audiences are made aware of a particular product and if the way it is marketed is enticing. The contrasts in rendition and marketing between two manga hagiographies of historical Buddhist figures are illustrative.

DŌGEN

Dōgen (Dōgen-sama) is a hagiography of Japanese Sōtō sect founder Dōgen that can be found on the Sōtō website.[61] Presumably designed to invite faith or inspire practice, this pedantic manga, like many products created primarily for didactic purposes, lacks extensive character development (the weight of Dōgen's historic personality as a famous denominational founder is apparently intended to serve as a substitute). The story also struggles to generate the narrative tension provided by conflict and its resolution that one often finds in more commercially successful manga. To my untrained eye, the characters seem artistically flat, and the truncated number of panels results in abrupt temporal transitions that minimize the audience's ability to develop an affective relationship with the protagonist through prolonged vicarious experience. In this case, fidelity to the extant sources comprising the historical record compromises the artist's ability to create an engaging story

through narrative license. Furthermore, the relatively high degree of third-person omniscient expository text creates a sense of distance from the actual events of the story. Most importantly, unless a person is already motivated enough to learn about Sōtō by going to the sect's website or by visiting the religion section of a bookstore, it is unlikely that a reader will encounter this story at all.

BUDDHA

In contrast, however, Tezuka Osamu's hagiography of the historical Buddha, mentioned above, has enjoyed long-lasting commercial success (it has been reprinted multiple times). His story is an adventure tale that loosely recapitulates the Buddha's life while introducing fictional characters and spicing up the traditional story with subplots and humor.[62] Tezuka takes time setting the stage for his hero, creating a vivid picture of life in what is now northern India and Nepal and drawing on the *Jātaka* tales (stories of the Buddha's former lives) over the course of one and a half volumes before he even introduces his hero. He portrays the young Siddhārtha's sensitivity and intelligence through extended, albeit fabricated, depictions of his childhood experiences, making him a character with which the audience can more easily identify.[63] Although Tezuka explicitly states that he ardently believes Buddhism is the hope for humanity's future, his depiction of the Buddha's life avoids overly pedantic discussions of doctrine and excessively pious adulation of his chosen subject, and he denies that he is a "pious Buddhist" (*keiken na Bukkyōto*), preferring to think of the Buddha as an inspiring philosopher.[64]

The treatment of didactic and overtly religious themes such as the hagiography of Siddhārtha or Dōgen does not necessarily result in insipid or sententious narrative. Rather, it is the quality of artists' deployment of manga stylistic conventions in addition to their ability to tell compelling stories that determines success in capturing audience attention. Marketing also plays a significant role. Although Ushio Press, the publishing arm of the religion Sōka Gakkai, is responsible for the publication of *Buddha*, Tezuka's story is marketed alongside other adventure stories and found shelved in the manga section of bookstores, not in the religion section. There is also little evidence of excessive Sōka Gakkai influence on the content.[65] *Dōgen*, by contrast, is not marketed as an entertaining adventure story, but rather as an edifying hagiography.

The contrast between *Dōgen* and *Buddha* also illustrates a general tendency that will be drawn out more in the following chapter. Whereas the

traditional sects of Buddhism have attempted to capture the youth market through media such as manga, their marketing strategies have generally reflected a lack of fluency in young people's protean interests. Religions of more recent provenance such as Sōka Gakkai and Kōfuku no Kagaku (a group now known internationally as "Happy Science," formerly, the Institute for Research in Human Happiness, or IRH) have demonstrated greater flexibility in their approaches to marketing and disseminating religious content.[66]

Anime

Like manga, anime could be said to juxtapose text with image, if text in this case means the script of the work. Anime directors also strategically use dialogue and image in conjunction to convey their stories. Like *mangaka*, anime directors tactically use scenes devoid of dialogue (or dialogue over static scenes) to convey mood.

Unlike manga, however, anime benefit from the additional sensory stimulus of sound. The script of anime comes alive through the timbre and timing of actors' voices, and the charismatic elocutions of famous voice actors are recognizable across different products. Soundtracks elevate tension and augment climax, and sound effects give the sensation of motion even when scenes are static. Adding emphasis to certain lines of dialogue through the use of reverb (echo) lends them particular weight, as in the case of *The Laws of Eternity* (*Eien no hō*), an anime created by Kōfuku no Kagaku. In one notable scene, angels (Mother Teresa, Florence Nightingale, and Helen Keller) explain the meaning of "becoming happy" to protagonist Yūko; the phrase *kōfuku ni naru* (to become happy) is given particular emphasis through the heavy application of reverb (see Figure 1.2).

Anime also have unique stylistic conventions that reflect the influence of manga on anime and that derive from the apparatus used to make and film the cels that comprise individual frames. Modern *mangaka* created a cinematic grammar of depiction in attempts to mimic film. Anime directors inherited that grammar (and its attendant distortions) and reinserted it into the medium of film, resulting in a unique cinematic style. The apparatus used in the production of anime—the animation stand—also invites different ways of portraying and perceiving motion and depth.[67]

Anime directors use a wide variety of perspectives, tracking shots, pans, and close-ups.[68] To audiences unfamiliar with anime, techniques such as slow panning over characters' faces between lines of dialogue can seem

Figure 1.2. Pious and earnest Yūko in *The Laws of Eternity.* © Ryūhō Ōkawa/Kōfuku no Kagaku

jarring or excruciatingly slow, but these serve a dual purpose. On the one hand, they expediently limit the number of cels that artists have to draw and film.[69] On the other, they provide dramatic pauses similar to those found in traditional Japanese drama, heightening emotional tension in the story.

Anime can also move at lightning pace, barraging viewers with a series of images in rapid succession that is equally effective in expressing mood. By varying the number of cels used to approximate real motion, anime directors create a unique aesthetic. In a technique called "limited animation," using fewer cels creates a "jerkier" surreal feel, while "full animation" uses more cels to accurately approximate real motion, animating at a rate of twenty-four frames per second (three frames per drawing, eight drawings a second).[70] Directors may also use "rotoscoping"—filming real actors or scenery and then using that film as a template for creating believable animation.[71] Increasing use of computer graphics also affects directors' abilities to approximate empirical reality. While some directors aim for a synthetic aesthetic by composing their films entirely in computer graphics (such as Aramaki Shinji's anime rendition of Shirow Masamune's manga *Appleseed*), others use computer graphics to artfully expand the limits of two-dimensional depiction (such as Kon Satoshi's anime rendition of Tsutsui Yasutaka's novel *Paprika* [*Papurika*]).[72]

Although images alone may be insufficient for telling a story, within a story they can serve to express emotion, and dialogue-free scenes in anime

(as in manga) can heighten the sense of powerful emotion or nearly ineffable experience. In the same way that the tangible manga medium (the paper) disappears as readers are absorbed into the plot of a masterfully created manga, the physical technology of the screen dissolves in the case of well-made anime. Like manga, anime heightens vicarious experience, and similarly benefits from iconic protagonists and "othered" antagonists.

Anime exist at the boundary of static image and motion by virtue of their technical execution (static frames shown in rapid succession in order to give the appearance of motion), and the aesthetic draw of animated film is precisely that it creates the illusion of movement and action by juxtaposing a series of synchronic illustrations on a diachronic timeline, creating an approximation—albeit a distorted one—of reality. Films capture reality (actors and sets creating representations of reality) in the nature of a photograph; they mimic reality in exact correlation. In contrast, anime create simulacra of reality through the medium of illustration (one step removed from photorealistic portrayal) and the stylistic conventions that anime shares with (and inherited from) manga. Additionally, through rotoscoping, directors create actions and settings that are simultaneously realistic and exaggerated.[73] Anime representations of near-reality are iconic, hyperbolic, and synecdochic.

Such techniques allow directors to create images that ordinary live-action films produce only with great difficulty. Directors play with physically distorting characters and backgrounds, and can give the impression of ordinary people performing superhuman feats without the limitations of using human actors and their physical abilities or inabilities, or material sets hampered by the laws of physics. Anime also can depict internal states in a way that is virtually impossible (or at least very difficult) for ordinary film by virtue of their ability to illustrate (rather than emote or explain) the intangible internal landscape.

For example, directors may mobilize sound effects in an action scene where the only action is a relatively small number of static images with "action lines" drawn in the background to convey the impression of rapid motion (an inheritance from manga). In these scenes, where the background disappears in order to draw attention to the emotional duress or intensity experienced by the protagonist, directors do not depict action on the virtual filmic "stage," but rather depict the protagonist's emotional state.[74] Notably, similar effects are probably only produced on stage and screen through vigorous emoting on the part of actors, or through the more efficient but potentially jarring use of asides or monologues.

Some recent films have portrayed characters' internal states in vivid detail. For example, in his adaptation of Matsumoto Taiyou's manga *Tekkon Kinkreet*, director Michael Arias switches to watercolor when depicting the daydream of amiable protagonist Shiro. Biting into an apple, Shiro is suddenly transported to a world where apple trees bloom as he rides on a star-emblazoned elephant and penguins and whales frolic in the grass nearby. Suddenly switching back to the "real" world and his normal palette, the director shows the shadow of Shiro's pachyderm mount crossing the faces of other characters as he joyfully rides around in circles in the center of a bathhouse, although these others are clearly not privy to Shiro's reverie. Later in the film, when Shiro's compatriot Kuro confronts his inner demons, his world literally melts.[75]

In *Paprika*, animation allows director Kon Satoshi to seamlessly meld the worlds of dream and reality as he visually depicts the insanity that erupts as these normally discrete worlds collide through the misuse of powerful technology. When a terrorist uses a powerful psychotherapy machine called the DC Mini to invade the collective unconscious, a giant parade featuring kitchen appliances, the Statue of Liberty, the distinctive gates that mark the entrances to Shintō shrines (*torii*), bodhisattvas, and the Seven Gods of Good Fortune (Shichifukujin, an amalgamation of Indian, Chinese, and Japanese deities) marches from the desert into the cosmopolitan center of Tokyo, wreaking havoc along the way by ensnaring increasing numbers of innocent victims in collective delusion. As pandemonium ensues, the terrorist proclaims that he will "become the god of a new world," using the dream machine to re-create reality according to his liking. However, the protagonist—a woman capable of skipping between dreams and reality through her dual persona of clinical psychiatrist Chiba Atsuko and playful dream nymph Paprika—intervenes to restore order. Kon's film both depicts and relies on the unique capacity of technology to cross the porous boundary between fantasy and reality. Like the movie's eponymous oneironaut, Kon invites his audience to tack back and forth between dream and waking life, tracing the influence of each on the other. In *Paprika*, imagination and reality become intertwined.[76]

Segue

Relying on the imaginative processes of closure and compositing, manga and anime function through the illusion of juxtaposed and superimposed static

images as images in motion. This illusion makes these media particularly appropriate for representing magic, apotheosis, transfiguration, enlightenment, and other experiences or events that might be related to the imaginative qualities of religion. The willing suspension of disbelief inherent in fiction and art—and thus integral to the imaginative participation in closure on which the viewing of manga and anime is predicated—is, conversely, the voluntary (if temporary) assumption of credulity. Readiness to participate in a narrative through belief is common to both fiction and religion, as is the readiness to interpret illustrated images as reality.[77]

The particular power of these media to convey religious content and to evoke religious responses is also tied to their artists' ability to depict—and therefore to elicit—emotion through illustration and to thereby surpass the boundaries of spoken and written language. The visceral impact of pictures can create affective responses in ways that printed text or spoken dialogue alone cannot.[78] Furthermore, because illustration is simultaneously removed from and akin to empirical reality—because it both depicts and distorts—*mangaka* and anime directors can imagine, exaggerate, and stretch the limits of plausibility in the service of their storytelling. At the same time, text and script play important roles in eliciting audiences' affective and intellectual responses to story content. The combination of static images with text or a script and the calculated adjustment of the ratio of text or dialogue to each particular image can heighten the emotional impact of specific scenes, and particular lines of dialogue may resonate with certain readers, lingering in memory long after the story ends.

Although they differ significantly from premodern media, manga and anime inherit the legacy of vernacular illustrated fiction in Japan, much of which has been historically related to religion. The retrospective that opened this chapter suggests that producers of vernacular fiction have long found it expedient to fulfill audiences' desire for religious content, and it is important to note that such content has been satirical or casual as often as it has been devout. The popular success of products with themes related to magic and miracles has also nurtured authors' tendency to include religious content in stories designed to entertain as well as in those designed to instruct or convert. It remains to be seen, however, how the motives of authors and artists influence content, and much more can (and should) be said about how audience members' interests shape interpretation. These plural perspectives on the visualization of religion through manga and anime are the subjects of the next chapter.

Recreating Religion

When I traveled back to Japan on a research trip in 2009 after two years away, two manga were prominently displayed in bookstores around Tokyo and Kyoto. One of these was the third volume of *Saint Young Men* (*Seinto oniisan*), a comical depiction of Jesus and Śākyamuni (the historical Buddha) living as roommates in Tachikawa, a suburb west of Tokyo.[1] The other was *On the Emperor* (*Tennōron*) by Kobayashi Yoshinori, the cover of which featured the prominent statement: "Even today, the emperor is praying for your sake."[2] Both manga were clearly selling many copies. There were diminishing stacks conveniently located by registers in many stores for last-minute impulse buys, and whole shelves were devoted to these recent releases in larger bookstores. Both could be reasonably described as religious in content, since the former clearly dealt with historical figures who are revered worldwide as the saintly founders of major religious traditions, while the latter highlighted the specifically religious role of Japan's emperor. Yet there were obvious differences in how the two portrayed that content—the former was parodic while the latter was pious.

The purpose of this chapter is to parse such differences. Ecclesiastical authorities may mobilize entertainment media as a way to capture audiences' attention, while lay entertainers may borrow from the storehouse of religious concepts and imagery to do the same. In both cases, the body of existing religious vocabulary, iconography, and cosmology creates a fecund source of entertaining narrative and visual material. As the examples of *Saint Young Men* and *On the Emperor* suggest, however, there are significant differences in how media producers render religious content. There is also marked variation in how audiences respond to that content.

This chapter builds on some earlier studies that have classified religious manga and anime according to differences in the extent to which the products demonstrate fidelity to religious doctrine or the degree to which the author seems to have intended her product to be received religiously. Scholar of religion Yamanaka Hiroshi, for example, divides "religious manga" (*shūkyō manga*) into the categories "religious community manga," "psychic and occult manga," "religious vocabulary manga," and "manga that acts as religious text," describing the content of the genre, the successes and failures of each subgenre, and the liberties producers take in using religious content.[3] Yumiyama Tatsuya duplicates this approach, albeit with slightly different categories, in a short encyclopedic entry on anime and religion.[4]

However, this categorical approach to religious content easily avoids the issue of how audiences perceive that content, whether they demonstrate increased intellectual interest in religions after being exposed to it, or whether they act in observably religious ways in response to it. While this chapter follows Yamanaka's pioneering study by focusing on the apparent motivations behind the creation of a particular work in light of thematic content and style, it also describes the significant differences in audience reception evident in fan discourse and ritual activity.[5] While the categories I propose are admittedly artificial ideal types, they serve the interpretive purpose of apprehending significant differences in authorial rendition and audience reception. After all, authors have minimal control over the reception of their works, and audiences, not authors, are ultimately responsible for the canonization or liturgical use of manga and anime material.

Perspectives

I plot manga and anime along a continuum ranging between aesthetic and didactic types, which respectively focus on the "show" and "tell" of religion. On the one hand, authors of aesthetic products use religious vocabulary and imagery cosmetically. Their primary aim is to mobilize religious concepts, characters, and images in the service of entertaining their audiences, although their products can elicit increased intellectual interest in (and affective responses to) that content. They can also incidentally give rise to religious sentiment or practice. Examples of such products include adventure stories featuring sacerdotal or divine protagonists, ghost stories, and horror tales. Authors of didactic products, on the other hand, use a pedagogical mode to introduce audiences to information about religions or a hortatory mode to

persuade and convert. These may include hagiographies, sectarian histories, or conversion stories designed to introduce or reinforce specific cosmological worldviews or soteriological aims. Although their primary aim may be to instruct, they may successfully entertain audiences as well. Near the end of the chapter I discuss a few products by authors who use a homiletic or parabolic narrative mode to fuse these aesthetic and didactic tendencies.

I also plot audience responses to manga and anime on a corresponding continuum that ranges from a lower level of religious commitment (boredom or temporary diversion with no lasting effect) to a higher level (belief, ritual practice, or significant changes in lifestyle or behavior). Even if apparently religious content is rendered in a pious mode, audiences may read it casually, ignoring the sententious or sanctimonious aspects of a product initially designed to inculcate a religious response. Fervency on the side of production is not necessarily matched by fervent reception, and one side of the reception continuum can thus be marked by apathetic response. Casual responses may also be limited to increased familiarity with religious concepts and characters with no overt changes in lifestyle or behavior otherwise.

Conversely, some audiences respond to certain products—including those with no particular religious message—with religious frames of mind. Exhibiting affective connections to characters and intellectual fascination with narrative content, some audience members interpret certain products in light of their lessons for life. The stories, characters, and images in question thereby become meaningful outside of their fictive universe, affecting the ways in which audience members perceive their relationships to (and in) empirical reality.

Authorial rendition therefore ranges from cosmetic use of religious vocabulary and imagery, through parody, and ultimately to piety. Audience reception ranges from apathy, through casual interest or passing familiarity, to the creation of religious frames of mind. These continuums of authorial rendition and audience reception form two lines of perspective that orient my portrait of religious manga and anime culture, throwing its depth into relief while illuminating its horizons.

Survey

Elucidating the religious aspects of manga and anime culture is potentially illustrative of the general state of religion in contemporary Japan, but I do not want to frame my informants as particularly pious. My survey of col-

lege students, for example, confirmed that most people are casually diverted, not converted, by the majority of manga and anime. In June 2007, I visited Tamagawa Gakuen University at the kind invitation of Nagashima Kay-ichi and gave short lectures in two of his classes. Nagashima and I had arranged ahead of time that I would be able to conclude each of my lectures with a survey of his students regarding their attitudes towards manga, anime, and religion.[6] I wanted to ascertain, first, if students' attestations of religiosity were indeed as low as earlier surveys conducted by others had suggested and, second, to juxtapose students' claims to religiosity or lack thereof with their habits for reading manga and watching anime. While the survey instrument was admittedly imperfectly designed (and the problem of the researcher influencing informants' responses immediately apparent), it nevertheless provided some basic information about students' attitudes towards religion and the ways in which students' use of manga and anime revealed the role of these media as forms of vernacular religious entertainment.[7]

The results suggested that professions of religious belief were indeed low (some students suggested, for example, that their families had some tenuous connection with a religious institution, but that nobody in their immediate families was particularly devout).[8] However, students' responses to the second half of the survey suggested that many—but certainly not all—had had significant exposure to manga and anime. More than half (55.1 percent) of the survey respondents said that they had had inspiring, fulfilling, or transcendent experiences reading manga or watching anime, and among the products they named as examples were Miyazaki Hayao's oeuvre, *Akira*, *Dragonball*, *Nana*, and *Slam Dunk*.[9] Admittedly, the ambiguous phrasing of the question leaves some question as to whether these reported experiences were similar. It furthermore does not indicate how such inspiring experiences may have sponsored changes in ritual practices or religious affiliation. My personal interviews with individuals, conducted on other occasions, turned out to be more revealing in that regard.[10]

A small minority of my survey respondents—between 7 and 8 percent—claimed that reading manga or watching anime contributed to their interest in religion or in a specific deity or religious figure, and some of these people named works like *Neon Genesis Evangelion*, *On Yasukuni* (*Yasukuniron*), and *Shaman King* as examples.[11] Considering the fact that few people admit to interest in religion, however, I find it significant that many respondents—nearly 75 percent—reacted positively to the idea of lay artists using religious themes in their stories: 32.2 percent of respondents said such usage was "a

good thing" (*ii to omou*), and 41.4 percent of respondents said that "given the choice, I would say it's a good thing" (*dochira ka to ieba ii to omou*). I interpret these positive responses as affirmations of the appeal of religious information outside of dogmatic contexts, particularly when contrasting these answers with responses to the question about whether students thought that religious groups should proselytize through manga: 47.1 percent said the prospect made them somewhat or rather uncomfortable (*warui to omou, dochira ka to ieba warui to omou*), and only 10.3 percent of the respondents believe that such proselytizing was definitely a good thing (*ii to omou*).[12] While a slim majority took an accommodating stance on this issue, the fact that nearly half found the prospect discomfiting is noteworthy.

Free responses to lectures I had given at the same institution a year prior (June 2006) provided further insight into how individual students perceived the relationship between manga, anime, religion, and their personal recreational practices. Whereas one student enthusiastically wrote, "Through [Tezuka Osamu's] *Phoenix*, I was able to learn about various ways of thinking about religion," another student in the same class wrote, "I have read *Phoenix*, but I did not take anything religious out of it at all."[13] Another student drew connections to religious aspects of the work of contemporary novelists such as Murakami Haruki and Murakami Ryū, and then concluded as follows: "We are often told that in Japan the two [religions of] Buddhism and Shintō are amalgamated, but to me the truly *essential* [the student used the English word] thing that is deeply ingrained in Japanese people is a kind of nature worship akin to animism, I think. I think that what especially illustrated that [nature worship] was Miyazaki Hayao's [anime] *Princess Mononoke*."[14]

Clearly, opinions were diverse, and these significant differences of opinion and interpretation among the students on that occasion were mirrored among my interviewees and survey respondents. Nevertheless, at the very minimum many of the survey respondents acknowledged that they had become familiar with religious concepts through the influence of manga and anime.

Exposure

The proverb "*Monzen no kozō narawanu kyō o yomu*" literally means "The child in front of the temple gate recites sutras without having been taught." It is used in contemporary Japan to refer to people picking things up by being

in the right environment, and no longer has any particular religious associa-
tion. In the present discussion, however, it seems appropriate for describing
people's casual absorption of religious terms from entertainment media.[15]

For example, Hirafuji Kikuko has demonstrated that young Japanese
people who have experience with video games that deploy mythological con-
tent tend to have higher levels of familiarity with mythological terms (such
as deities' names) than those who do not play such games. Yet these terms
are certainly not unadulterated. Hirafuji argues that makers of video games
create eclectic new "hyper-mythologies" that the game players absorb, con-
tributing to young people's knowledge of traditional religious information
even as they change traditional mythologies for playful and pecuniary pur-
poses.[16] As Hirafuji suggests, the same process occurs in the cases of manga
and anime.[17]

Although a certain degree of adulteration occurs when traditional con-
cepts are deployed in these media, casual uses of religious terminology and
imagery in manga and anime can teach new audiences old information. The
base of existing mythological and religious information, rich in characters,
concepts, and narrative structures that attract audiences, forms a palimpsest
on which new articulations of myths or their characters are inscribed and
reinscribed. This does not necessarily mean that audiences exhibit religious
behavior in response, but they may at the very least be introduced to hitherto
unfamiliar religious concepts.

Consider, for example, the following two passages. The first is an entry
from the *Encyclopedia of Shinto*, a peer-reviewed reference text produced by
the Institute for the Study of Japanese Culture and Classics at Kokugakuin
University describing a rather obscure element of Shintō doctrine: "Accord-
ing to Shintō doctrine, the spirit (*reikon*) of both *kami* [deities] and human
beings is made up of one spirit and four souls (*ichirei shikon*). The spirit is
called *naobi*, and the four souls are the turbulent (*aramitama*), the tranquil
(*nigimitama*), the propitious (*sakimitama*) and the wondrous, miraculous, or
salubrious (*kushimitama*)."[18] In contrast, the following passage taken from
a fan website (in English) of the manga and anime series *Inuyasha* indicates
how concepts removed from their original contexts can be shifted to match
authors' and consumers' desires even as they maintain religious information:

> The reason this jewel is called the *sheikon* [probably a misreading of *shikon*,
> or four souls] jewel is that *sheikon* means four souls and along time ago
> there was a priestess battling all sorts of demons at once and she had the
> power to purify demon souls rendering them harmless, but then one de-

mon got its fang in her chest out of there came the jewel of four souls and
the names of the four souls are aramitama, nigimitama, kushimitama, and
sakimitama, aramitama was courage, nigimitama was friendship, kushimi-
tama was wisdom, and sakimitama was love, when combined as one soul
they are called *nyobi* and there is still a battle going on inside the jewel of
four souls.[19]

The transition of turbulent to courageous, tranquil to friendly, propitious
or felicitous to loving, and miraculous or salubrious to wise—as well as the
shifts in pronunciation and orthography—suggests a substantial difference
in the ways the audience of the *Encyclopedia of Shinto* and the audience of
Inuyasha understand these concepts. Yet whatever the motivations of the
producers or consumers of these manga and anime (profit, entertainment,
education, titillation), these terms seep into consumers' consciousness.

I am not saying, however, that traditional religions are thereby "pre-
served" in contemporary media that casually deploy religious content for
cosmetic purposes. Theological or mythic content may appear in media
without audiences paying much attention. Unless audience members expe-
rience significant changes in worldview thanks to the affective or intellec-
tual appeal of a given story, we cannot say that the content has had much
long-lasting effect. Furthermore, audiences may be introduced to potentially
misleading information. In Shirow Masamune's manga *Senjutsu chōkōkaku
orion* (*Orion*), for example, a number of religious terms (e.g., Tendai, Susa-
noo) are deployed in a manner decidedly different from their original con-
texts.[20] Being made familiar with this vocabulary through the manga is no
guarantee that readers understand these terms in the context of traditional
religion, while readers who *are* familiar with the terms might derive en-
joyment or displeasure from Shirow's rather irreverent depiction of a sci-
ence fiction future in which religious spells are used in the same way that
people today use technological apparatuses. *Orion* thus serves as a fitting
introduction to the first major subgenre of religious manga and anime dis-
cussed here—products that deploy religious content for primarily cosmetic
purposes.

Show

On the aesthetic end of the rendition continuum, I include manga and anime
that use religious vocabulary and imagery for cosmetic purposes, and oc-

cult products such as horror manga. Many of these products make playful or irreverent use of religious cosmology or mythology without necessarily displaying any commitment to a particular religion. While the casual deployment of religious material for aesthetic purposes may seem cavalier, it also comes at a price. The entertainment value of that material diminishes in correlation to the amount of explication required for it to make sense, and overly pedantic explications of doctrine or cosmology may discourage readers from continuing to devote time and attention to a story.

However, there are compelling reasons to include religious themes in adventure stories. For example, Hagazono Masaya writes in his afterword to the fourth volume of his manga *Dog God* (*Inugami*) that his son's encounter with a stray inspired him to write an adventure story about a boy and his dog. To make this rather bland plot device exciting, Hagazono says he included the "essence" of boys' manga in the story. Although he does not specify what he means by this statement, this "essence" seems to refer to the canine protagonist's magical abilities, the psychic abilities of a female love interest who happens to be the daughter of a (similarly psychic) Shintō priest, and an apocalyptic setting that allows for several scenes of violence and destruction.[21] Hagazono's implication is that he deployed these miraculous and magical themes in order to heighten audience interest.

COSMETICALLY RELIGIOUS MANGA AND ANIME

One genre that enjoys a wide audience but that seems to have relatively low levels of transformative experience uses religious vocabulary and imagery without being explicitly pious or scriptural in orientation. These products tend to casually use themes from various religious traditions, removing religions like Buddhism from their institutional and doctrinal contexts in the service of adventure stories. They also may take sacrosanct religious characters as their protagonists. Several examples follow.

Saint Young Men

Saint Young Men, a manga by Nakamura Hikaru, began serialization in *Morning Two* magazine in 2006; its first volume was published early in 2008. The series traces the lives of Jesus and Buddha (that is, the historical Buddha Śākyamuni) as they share an apartment in Tachikawa (a suburb west of

Tokyo). The two have traveled there for an extended vacation from heaven (*tenkai*) after successfully making it through the turn of the century.

The story is based on exaggerated caricatures of the canonical characters of the two religious founders. Both are compassionate to a fault, are occasionally dismayed when recognized in public by their devotees, and generally just want to spend their time fitting in to contemporary Japanese society. Both demonstrate extreme naïveté about everyday social situations, but at the same time they enjoy twenty-first-century pleasures such as blogging. Of course they have their differences: Buddha is parsimonious whereas Jesus is a carefree shopaholic. Neighborhood children tease the former incessantly for the knobby protuberance on his head, while the latter is regularly mistaken for Johnny Depp. Their adventures in twenty-first-century Japan revolve around reconciling their saintly tendencies with the minutiae of everyday life.

The appeal of the series derives from its irreverent deployment of these two seemingly sacrosanct characters as protagonists, and is replete with associated comic relief, visual gags, and puns. The first scene, for example, shows Buddha lying on tatami mats in the apartment with a number of animals gathering around in a manner reminiscent of classic artistic depictions of the Buddha's *parinirvāṇa*, or deathbed scene (see Figure 2.1). The semblance is shattered, however, when the dozing Buddha suddenly springs up and chases the animals away, saying, "Scram!" (*Hottoke!*). Just then, Jesus walks in the door with lunch from the convenience store, cracking a joke at the irritable Buddha's expense: "Especially because you're the Buddha?" (*Hotoke na dake ni?*).[22]

At the end of the first volume, the two agonize over and then succumb to the temptation to shoulder the portable shrine (*mikoshi*) at a local Shintō festival. Although it would be unseemly for either to be seen by their heavenly acquaintances in such a milieu, Jesus' devil-may-care attitude eventually leads both of them to participate energetically. Jesus even gets so carried away that he begins chanting "Amen, A~men." Afterward, the roommates share a beer on the shrine steps under a shrine gate while watching fireworks, an image that might shock or dismay those more pious than Nakamura and her intended audience. The incorrigible author irreverently puns at the end of the first volume much in the same way that she opened it. As the two discover that their prizes from the festival stalls were gimmicky imitations of hand-held video games, she quips, "The two were enlightened as to the true flavor of Japanese festivals" (*Karera wa Nihon no matsuri no daigomi o shiru no de atta*).[23]

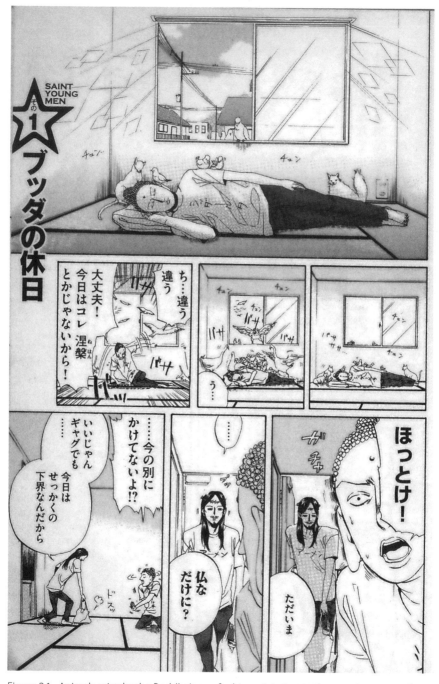

Figure 2.1. Animals mistake the Buddha's nap for his *parinirvāṇa* in the opening scene of *Saint Young Men*. © Hikaru Nakamura/Kōdansha

Garden

Garden, a manga of short, loosely related chapters by Furuya Usamaru, also irreverently uses Christian imagery and content.[24] In one chapter entitled *"Angels' Fellatio (Tenshi no felachio),"* a beautiful young woman named Maria attempts to seduce a nervous and obviously virginal male acquaintance, Yuda (Judas). Just as they are about to have sex, cherubs swoop down from heaven and separate the two. Although the girl tries as hard as possible to resist them, they fellate the boy, bringing him to orgasm and thereby rendering him catatonic. Thus thwarted, Maria ultimately has to resign herself to her fate as the mother of God's child. Although she has tried with twelve different boys (named Simon, Thomas, Matthew, and so forth), ultimately none of them can resist the powerful "Fellatio Technique" (*fera teku*) of the angels. The last scene shows her walking down a Japanese shopping street called Nazareth Center Street as a ray of light from heaven enters her uterus.[25]

Buddha Zone

Another example is Takei Hiroyuki's *Buddha Zone (Butsuzōn)*.[26] The cover says, "When you see a Buddhist statue, think hero!" Senju, an avatar of the bodhisattva Kannon (Skt. Avalokiteśvara), is dispatched to Earth to look after Miroku (Skt. Maitreya) by "the king of the Buddhas," Dainichi Nyorai (Skt. Mahāvairocana; see Figure I.1 on p. 4). The series incorporates numerous figures from the Buddhist pantheon. Kannon is a popular bodhisattva who is particularly associated with compassion in East Asian Buddhism. Miroku is the future Buddha predicted to once again preach the dharma under a dragon flower tree approximately 5.7 million years in the future. Dainichi is the personification of the ubiquitous dharma-body, which forms the ground from which all individual phenomena arise in some variants of Mahāyāna Buddhist cosmology. Jizō (Skt. Kṣitigarbha, a Buddhist deity known for his assistance for people suffering in hells), the Seven Gods of Good Fortune, and several other deities also have cameos.

In the manga, Senju and other deities appear on Earth in the guise of Buddhist statues that can move around at will. Miroku is on Earth living as an ordinary human girl, and Senju is on Earth to protect humans from injustice while guiding Miroku towards enlightenment. Tension in the narrative primarily comes through Senju's battles with increasingly powerful foes, including battles with beings such as warlike power-seeking deities (*asura*) and other bodhisattvas such as Horse-head Kannon (Batō Kannon).

Takei puts the Buddhist pantheon to work in his creation of an adventure story, but there is little in *Buddha Zone* that is strictly doctrinally accurate, and little indication that Takei intended the work to be a primer on Buddhism. Nevertheless, he cannot assume that his audience is familiar with Buddhism, and parts of the manga somewhat pedantically expound on Buddhist cosmology and mythology (perhaps the reason for its cancellation by the publisher after a short run of only three volumes).[27] Although *Buddha Zone* apparently had a committed fan base, and more than one thousand people petitioned the publisher for its continuation, ultimately the publisher seems to have decided that the series was too redolent of formal religion, and canceled it.[28]

Death Note

Many products display references to religion that are less overt. In the exceptionally popular manga and anime *Death Note*, for example, a god of death (*shinigami*) leaves in the phenomenal world a notebook that spells death for anyone whose name is written therein.[29] Light, an incredibly intelligent and attractive teenager, finds the notebook and decides to use it to rectify the world's ills. Acting on his extremely strong sense of justice (his father is a high-ranking police detective), Light sets about secretly using the notebook to kill off criminals. Crime plummets worldwide as a result, although as people come closer to discovering his identity, Light finds it necessary to kill even innocent people who might stand in the way of his mission. His nemesis, known only as "L," is a socially awkward but similarly brilliant teenaged detective who quickly determines that Light might be the person known to the public only as "Killer" (Kira). In an ironic twist, the two become friends and coworkers after a fashion, and both work diligently to catch the mysterious murderer. Light is therefore hard-pressed to devise ingenious ways to deflect L's suspicion while appearing intent on tracking down Killer.

Light's motives, of course, are not entirely pure. Behind his magnanimous decision to rid the world of crime lies a self-aggrandizing desire to make himself a god with his newfound power (see Figure I.3 on p. 29).[30] Indeed, through his manipulation of public opinion thanks to the capital punishment of criminals and evildoers, Light achieves a sort of apotheosis. Although he must keep his identity secret, Light enjoys the obsequious adulation of people around the world eager to ingratiate themselves with the

seemingly omnipotent and omniscient Killer. However, the power to command life and death comes at a price.

Characters Interacting with Deities

One of the appealing aspects of *Death Note* is the relationship of mutual dependence that develops between Light and the god of death, Ryūku, who cannot be seen by anybody who has not directly touched the "Death Note." There are many other examples of this type of product that features a character interacting with a deity who is either invisible to others or who masquerades as a human. *Hikaru's Go* (*Hikaru no go*), for instance, is the story of a young boy who touches an accursed Go board and is possessed by the vengeful spirit of a Heian period Go master.[31] With her help, he becomes an increasingly powerful Go player. In *Ah, My Goddess!* (*Aa, megamisama!*), a young man is inadvertently blessed with the continuous presence of a goddess named Belldandy in a sort of *I Dream of Jeannie* plot. Posing as an exchange student, she magically fulfills his various wishes and helps him to overcome any number of mundane problems while the two of them deal with increasingly obvious sexual tension.[32] In *Deity Dolls* (*Kamisama doruzu*), siblings who have moved to Tokyo from the countryside have a family secret: they are from a family of shrine officiants who can control "scarecrows" (*kakashi*) that are actually large mechanical deities that protect them in dangerous situations.[33] They of course immediately find themselves in a situation in which the ability to wield these supernatural entities is necessary for the protection of the innocent. The first volume of the manga includes a brief didactic afterword that draws connections between the characters in the story and terminology found in the Japanese myths of the *Kojiki*.[34]

Apotheosis

Apotheosis is also a recurring trope. In the anime *Serial Experiments: Lain*, for example, the eponymous protagonist gradually discovers that the boundaries between the collective unconscious and the global communication network known as "The Wired" are dissolving, and she alone has the ability to live in both the real and the online worlds.[35] Lain realizes that she has a brash online alter ego whose audacious personality is diametrically opposed to her everyday demure self. The embodied Lain gradually spends increasing amounts of time logged on to the Wired world, trying to figure out how it is

possible that she alone can be present in both places at once. Meanwhile, the Wired Lain performs miraculous feats such as appearing in the sky above Tokyo. A community of people who venerate her emerges, yet the embodied Lain finds this discomfiting, and she feels increasingly estranged from her family and friends in direct opposition to her increased online connectivity.

Late in the story a deceased computer programmer who has fashioned himself as a god in the Wired informs Lain that she is "software"—a program that does not need a body in the new world in which the Wired and the collective unconscious have fused. Lain's formidable powers derive from her liminal state, however, and she obliterates this would-be deity who, lacking a body, is capable of living only in the Wired. Despite this seeming triumph, Lain decides that her newfound omnipresence and omniscience are not worth her increasing ennui. Anxious about her ability to relate to others, especially her schoolmate Arisu, and fearful that her online personality will break the trust of her loved ones, Lain resigns herself to a lonely existence, wandering as pure consciousness in the Wired.[36]

Apocalypse

Apocalyptic and postapocalyptic themes that may be related to religion are also common.[37] Exceptionally notable among the manga and anime with apocalyptic themes is the famous televised anime *Neon Genesis Evangelion*, which aired between 1995 and 1996 and featured an obscure plot that compounded revelation on a postcataclysmic setting.[38] In the story, teenagers pilot gigantic robotic suits called Evas, defending Tokyo III against the periodic incursions of "Angels" (*shito*). In a feature film conclusion to the series entitled *The End of Evangelion*, the significance of the Kabbalistic imagery and escalating angelic assaults is revealed—if impartially—in a dramatic denouement that features a sudden covering of the Earth with millions of gigantic crosses.[39] As Tada Iori has observed, the compelling mystique of the abstruse plot generated a flurry of fan commentary and exegesis, and seems to have prompted some fans to seek out additional information about Kabbalah, Christianity, and the Dead Sea Scrolls.[40] All of these religious ideas, traditions, and texts are referenced overtly or obliquely in the story, but apparently they were included more for cosmetic effect than to impart any particular religious message.[41]

Many apocalyptic manga, such as *Godsider Second*, also include epigraphic quotations from the book of Revelation in the Christian Bible.[42] The

author's foreword on the inner cover of that particular work is also indicative of the motivations behind the casual usage of religious vocabulary and imagery. It reads,

> When a civilization shows itself to be at a dead end, it seems that people demonstrate a tendency to escape into pointless acts as if they wanted to forget such things.
>
> Not doing things one dislikes. Locking oneself in one's room. Delving into a delusory world. It is certainly not a good thing, but to me these things cannot help but seem inevitable.
>
> If that is so, why not be soothed by idly (?) [sic] sinking into delusion?
>
> At the end of the Edo period [that is, in the mid-nineteenth century], monster and ghost stories were apparently exceptionally popular.
>
> So today at this time near the end of postwar civilization, I think that it might be fun, perhaps, to try to delve into a story of gods and demons.[43]

For author Maki Kōji, stories about supernatural entities set against an apocalyptic backdrop are merely diversion, expedient ways to fulfill escapist tendencies. (I explore apocalyptic settings more in Chapter 4.)

In general, manga and anime that cosmetically feature religious vocabulary and imagery as narrative frames for a story walk a fine line between cavalier (and therefore entertaining) use of religious themes and dogmatic (and therefore potentially boring) explications of religious history or doctrine. Overall, most cosmetically religious manga and anime seem to prompt experiences of diversion without promoting lasting religious conviction or belief. Their portrayals of religious content are casual, although as the example of *Neon Genesis Evangelion* suggests, compelling content can spark intellectual interest in religions.

The foregoing discussion should make it clear that the cosmetic usage of religious imagery should not necessarily be taken as an indication that an author has a commitment to a specific religion. For example, reading the scene in the manga and anime *Tekkon Kinkreet* that takes place at "Takara Shrine" as somehow representing author Matsumoto Taiyou's interest or belief in Shintō would be both inappropriate and misleading (see Figure 2.2). Although a visit to the shrine forms the setting for the scene, the characters' dialogue refers not to any constituent of the pantheon of Japanese *kami* (deities), but rather to a single, omnipotent (yet fallible) creator—a theology that is only uncomfortably reconciled with mainstream Shintō doctrine.[44] Matsumoto (and director Michael Arias, following the author's

Figure 2.2. A shrine forms the background for a scene in Michael Arias' anime rendition of Matsumoto Taiyou's manga *Tekkon Kinkreet*. © Michael Arias/Shogakukan, Aniplex, Asmik Ace, Beyond C, DENTSU, TOKYO MX

lead) uses traditional religious imagery as a backdrop while subverting formal doctrine.

OCCULT MANGA AND ANIME

Some manga and anime can be classified as occult, dealing with psychic powers, ghosts, the afterlife, horror themes, and eerie phenomena. Their authors may make overt references to existing religious traditions, but they often treat religious data as fungible, liberally using information from various religions to create thrilling tales. Stories of the afterlife and spirit possession often require some sort of exploration of religious views on the nature of the soul, ghosts, vengeful spirits, heaven, and hell, even if the stories themselves are not performed in a pious mode. Authors also may borrow mythological characters in the service of adventure stories, such as Morohoshi Daijirō's manga *Dark Myth* (*Ankoku shinwa*), or the rendition of the *Ṛg Veda* authored by the CLAMP collective.[45]

Occult products also frequently include critiques of "commonsense" rational attitudes. These critiques are usually exemplified by protagonists' verbal exchanges with foils who represent scientific skepticism and who are thus ignorant of the truth regarding supernatural phenomena.[46] Rhetorically, therefore, occult products implicitly suggest that science alone is insufficient for explaining the myriad mysteries of the universe.

Vulgar Spirit Daydream

One example of a manga and anime in the occult genre is *Vulgar Spirit Daydream* (*Teizokurei DAYDREAM*), by Okuse Saki and Meguro Sankichi.[47] In the story, a teenage girl works as a spirit medium (*kuchiyoseya*) when not working as a dominatrix at a sadomasochistic sex club in Tokyo. Her shamanic abilities help her to solve mysteries surrounding innocent people's deaths, and her personal daemon (an autonomous rope named Kinui that wraps itself around her body, looking like a piece of her professional gear) protects her in dangerous situations. With its protagonist regularly depicted in all forms of undress or bondage gear, and with the repetition of various themes regarding the undead, the series uses the perfect blend of sex, occultism, mystery stories, and violence to capture its audience.

There is a long tradition of shamanistic practice in Japan and East Asia, and a number of Japanese religions incorporate practices related to trance and spirit possession. In *Vulgar Spirit Daydream*, however, spirit mediumship serves as a conduit for introducing eerie phenomena. The thrill of the undead combines with sexual titillation and mystery, but the relationship to religion remains casual. An episode may take place at a shrine, but there is little indication that by using such a setting the authors are intentionally making statements of any sort regarding Shintō per se or religion as such. They are merely making use of the data at hand in the process of creating entertaining stories.

Left Hand of God, Right Hand of the Devil

Another example is Umezu Kazuo's manga *Left Hand of God, Right Hand of the Devil* (*Kami no hidarite, akuma no migite*), a horror story about a young boy who develops shocking powers after coming into contact with a possessed pair of scissors found by his sister on a midnight adventure.[48] His sister murders the family cat with the scissors and then begins vomiting mud, children's skeletons, and toys. Eventually the protagonist, Sō, realizes that his sister has fallen victim to a curse: three decades before, a woman had murdered several neighborhood children with the same rusty scissors. Although he tries to convince his parents of this truth, their no-nonsense attitudes prevent them from hearing him. His father, a doctor, is particularly uninterested in his son's fantastic explanations for the obviously supernatural events happening around them.

Eventually overcome with lassitude after struggling to save his sister from further injury, the boy falls into a deep sleep. In the ensuing dream, he confronts the murderer and kills her and her disfigured son with his right (devil) hand, then cures her victims (including his sister and the cat) with his left. When he awakes he discovers that his dream was real. The first volume ends with his family blithely indifferent to the horrific trauma they had just experienced while the protagonist privately realizes that he has a special gift.

Ultraheaven

Ultraheaven, a short manga series by Koike Keiichi, is less popular than the aforementioned works, but is worth mentioning because of the unique demographic to which it is marketed.[49] In a near future world where drugs have been fully decriminalized, humanity adjusts its moods through the use of various chemical cocktails. Between highs and drug-induced sleep, people wrestle with themselves existentially, and some even seek suicide through a final "super high." Featuring overwhelming, intense depictions of near-death experiences and hallucinations, the manga is (as the store where I purchased it crowed) "an exploration of the world of the spirit [*seishin sekai*]!"[50]

The existential brooding, combined with wordless depictions of internal landscapes, makes for a dark but compelling read. The second volume shifts the focus from drugs to technologically induced hallucinations. The protagonist, Cabu, and his female friend manage to discover a hidden recording in the machine they are using to psychically link to one another. Having reached the limits of the machine after a shared near-death experience, the two are invited to join a meditation center in order to learn how to further manipulate their own—and others'—perceptions of reality.[51] Resorting largely to images alone for expression, Koike's incredibly detailed work is delightfully trippy, and its focus on hallucinogenic drugs as a tool for perceiving other dimensions puts it in the realm of the occult.

However, this particular series cannot be said to have a wide readership, and the store where I purchased the first two volumes is apparently one of just a few that will actually carry the manga since it seems to glorify drug abuse.[52] Nevertheless, a cursory visit to a fan page on the popular social networking website MIXI suggests that Koike's series has a devoted underground following; in late September 2011 there were 1,211 members (about two hundred more than had existed two years prior, in July 2009). Message board topics have included speculation about reasons for the slow and sporadic serialization of the manga (some members wondered if Koike's

alleged drug use was a factor), as well as reflection on the most recent volume (Volume 3, published in November 2009).[53] Notably, one fan claiming to be studying Indian philosophy and Buddhism at college highlighted what he or she saw as a rise in the incidence of Buddhist imagery and vocabulary in the third volume.[54] The person concludes by saying "Man, it was really interesting. Perhaps [the most interesting] since [Tezuka Osamu's] *Phoenix* [*Hi no tori*, on which more below]."[55]

Although *Ultraheaven* is not widely distributed, occult products in general are widely consumed, and may subtly influence people's views on the nature of ghosts and other dimensions. Dominated by the subgenre of horror, occult manga and anime tend to have heavy doses of irrationalism, and serve as sources of information about the supernatural, other dimensions, and eerie phenomena, inviting casual interest associated with the thrill of horrific or spooky content. However, although occult manga and anime frequently draw on religions for narrative purposes, they rarely seem to invite strong emotional responses of the sort that lead to heightened religiosity.

ROLE MODELS AND ROLE PLAYING

There are, however, examples of manga and anime that casually deploy religious content contributing to significant changes in individuals' lifestyles, including religious conversion or the decision to take some sort of religious initiation. Even without formal conversion, some stories serve as opportunities for reflection on the best way to conduct a moral or fulfilling life. As my male informant Satō Kenji mentioned to me in an interview, some manga can provide guidance on how to lead one's life, or at least opportunities for reflection. Satō mentioned that Inoue Takehiko's long-running and widely read manga *Vagabond*, the story of legendary swordsman Miyamoto Musashi, has served such a function for him, a sentiment echoed by another male informant (Kurosawa Shin, a friend of Satō's).[56]

Manga and anime may also directly or indirectly influence some people to join religious groups. Apparently some people who have read manga that valorize the thaumaturgical abilities of Shingon priests have consequently decided to take the tonsure based on the visions of esoteric Buddhism they have absorbed from these works. In a 2003 roundtable discussion on the religiosity of anime, for example, editor of the Buddhist magazine *Daihōrin* Sasaki Ryūtomo mentions that he knows several people who became Shingon priests due to the influence of *Peacock King* (*Kujakuoh*), the story of a priest who performs exorcisms and takes the side of humanity in grandi-

ose battles against the demonic forces of evil.[57] While his statement is anecdotal and not corroborated with specific evidence, one Shingon priest and manga enthusiast sheepishly confessed to me—without any prompting on my part—that manga had influenced his decision to enter the priesthood, saying, "I thought that if I studied esoteric Buddhism I could obtain supernatural powers."[58] This individual's situation is rare since he was not born into a family of priests (leadership of Japanese Buddhist temples is generally conferred through patrilineal succession). Rather, he decided to become a priest because—at least in part—manga had provided him with an idealized image of Shingon priests as powerful wizards.

Even without formal conversion, some fans demonstrate ritual responses to content that they perceive to be particularly entertaining or inspiring. The vicarious experience of the manga or anime world achieves a new dimension in *cosupure* (a Japanese abbreviation of the English phrase "costume play": cosplay) practice, in which fans temporarily don the personality of a favorite manga or anime character through costuming and reenactment.[59] While I hesitate to say that cosplay is a specifically religious act (many cosplayers would probably take affront at such an assertion), I do suggest that it is a ritualized act through which fans get in touch with their favorite characters. The process of mediating religion and sanctifying media includes instances where gestures in fictional media become models for ritual activity.[60]

One example of the intersection between fictional worlds and embodied religious practice is an *ema* tablet found by a colleague at Meiji Jingū, a famous shrine near the trendy Harajuku district of Tokyo.[61] *Ema* are small wooden tablets that can be purchased at shrines for a small fee. Shrine patrons use them to write propitiatory messages to the *kami*, and also occasionally to report on the outcomes of previous requests.[62] The tablet my colleague read and photographed stated simply, "Thank you, Sailor Moon." The anonymous author of this tablet hung it at an established religious institution, but the message of thanks is directed towards the eponymous protagonist of a fictional manga and anime series rather than towards an enshrined deity.

In fact, Hikawa Jinja, a tiny shrine in Tokyo that is the model for a homophonous shrine (Hikawa Jinja) featured in the *Sailor Moon* series has become the focus of fans' religious devotion. Ishii Kenji reports that fans have increased the number of religious visits to the shrine, which previously only drew a few hundred worshippers during the New Year shrine-visiting season (*hatsumōde*). These new worshippers include male fans dressed as their favorite female protagonists, and fans have also taken to providing their own

specialized *Sailor Moon ema* to record their petitions to the enshrined deities (see Figure 2.3).[63]

Describing a similar ritual response to fictional worlds, my informant Satō Kenji recalled how the death of a major character during the serialization of *Tomorrow's Joe* (*Ashita no Jō*) led distraught fans to hold an actual funeral in his honor.[64] *Onmyōji*, a manga series by Okano Reiko based on a historical novel by Yumemakura Baku, has spawned heightened interest in Onmyōdō (the Japanese term for Yin-yang divination and geomancy), especially among girls and young women.[65] The popularity of the manga and the two live-action films that followed it has led to increased visits to Seimei Shrine (Kyoto) and other shrines associated with the historical thaumaturge Abe no Seimei (the protagonist of the series).[66] As Laura Miller has recently indicated, this newfound popularity has spawned a proliferation of *Onmyōji* products, including *ema* and amulets associated with the series.[67]

Some people also talk about a particular manga as having changed their outlook on the world to the point of prompting ritual action. For example, in

Figure 2.3. An *ema* featuring a character from *Sailor Moon*. Photo taken by the author at Hikawa Shrine (Tokyo), June 2010.

a 2004 article on growing nationalistic sentiment among Japan's youth, jour-
nalists Uchiyama Hiroki and Fukui Yōhei document the case of a young man
who chose to worship at the controversial Yasukuni Shrine (where several
Class A war criminals along with thousands of other war dead are deified)
after reading Kobayashi Yoshinori's manga, a response also exhibited by one
of my survey respondents.[68] In these ways, the boundary between the fic-
tional world of manga and the real world of fans' shared experience come to
overlap through ritualized activities such as shrine visits. It is precisely this
sort of ritualized, reverent response that didactic manga and anime aim to
elicit from their audiences.

Tell

As the following examples show, on the didactic end of the spectrum I place
products that serve as textbooks or primers on religious doctrine and history
through fictional and nonfictional approaches. I also include propaedeutic
manga and anime that are designed to elicit the interest of potential consumer-
adherents, propagandistic products designed to convert potential believers,
and catechistic or pedantic products designed to instruct current members of
a particular tradition. I furthermore include polemical products that aim to
inculcate in their audiences a certain attitude (including skepticism) towards
specific religions. I also describe products that are designed to engender an-
tisecular attitudes such as religious nationalism in their audiences.

TEXTBOOKS

This category, almost always printed as manga rather than produced as an-
ime, deals with religion from a perspective similar to that of the academic
study of religion. Manga textbooks that take religion as their subject intro-
duce their audiences to religious history and doctrine in an accessible format.
These products tend to be found in the religion section of bookstores and are
generally not shelved alongside fictional manga. For example, some manga
describe the historical reasons for the differences between the various Bud-
dhist sects in an irenic mode, providing in-depth descriptions of the history
and doctrine of each individual sect. Audience responses to these works are
presumably primarily intellectual (that is, the audience members use manga
to study about religion), but certainly some of these works might invite or
deepen faith or lead to more fervent ritual practice.

One example is the primer *Japanese Buddhism and Its Founders* (*Nihon no Bukkyō to kaisotachi*).[69] The book begins with a short chapter entitled "Common [or Basic] Knowledge about Buddhism in Fifteen Minutes," and then launches into seven chapters: "The Tendai Sect and Saichō," "The Shingon Sect and Kūkai," "The Jōdo (Pure Land) Sect and Hōnen," "The Jōdo Shin (True Pure Land) Sect and Shinran," "The Rinzai Sect and Yōsai (or Eisai)," "The Sōtō Sect and Dōgen," and "The Nichren Sect and Nichiren." As may be expected from these titles, each story is fairly formulaic, repeating the details of each founder's life as historical fiction. Although the technical execution of the artwork is sufficient for the didactic purposes of the narrative, it lacks variety in the types of transitions used between panels, and many of the panels are merely the texts of founders' letters or other writings reproduced as if they were calligraphy. There is little in the text that seems capable of appealing to an audience on aesthetic grounds alone, and its intended audience is clearly curious enough about Buddhism to seek out such a text in a bookstore.

In contrast, Mizuki Shigeru's *Biographies of Mystics* (*Shinpika retsuden*), while not his most famous work, presumably enjoys more popularity because of the author's fame as a creator of occult manga such as *Creepy Kitarō*. In addition to tracing the biographies of historical figures, Mizuki also seems interested in encouraging casual belief in supernatural phenomena. In an explanatory afterword, for example, he explains that, while he has always had an interest in mystical subjects, with age he has come to believe in such mystical subjects to a certain degree, and definitely more than before.[70]

PROPAEDEUTIC MANGA AND ANIME

Some products are designed to introduce audiences to religious information as a way of educing curiosity and, presumably, greater commitment in practice or belief. Among these manga, some products demonstrate more commitment to the artistic license inherent in historical fiction than others. For example, Buddhist commentator Yamaori Tetsuo authored the text of a manga about Jōdo Shinshū founder Shinran (drawn by Baron Yoshimoto).[71] In the introduction to that text, Yamaori admits that there is little that can be known about Shinran's early life, and that his depiction is a fabrication.[72] Nevertheless, like earlier popular renditions of Shinran's life such as the early twentieth-century play and novel *The Renunciant and His Disciples* (*Shukke to sono deshi*), *Shinran* exposes a new audience to the unabashedly embellished hagiography of the venerable founder.[73]

Bodhisattva Stars in Hiro Sachiya's Comic Universe

Likewise, Hiro Sachiya, a prolific author on Buddhism, has also produced a manga series on various bodhisattvas.[74] As Michael Pye and Katja Triplett have argued, each book in the series serves as a self-help guide for its audience.[75] Using stereotyped protagonists undergoing everyday problems, the 108 volumes in the series demonstrate to their readership that there are valid reasons to incorporate Buddhism into daily life. Doing so, they presumably hope to counteract the "dark" image many people have of Buddhism.[76] While it is unclear to what extent the manga are effective in this endeavor, the sheer number of volumes suggests that the publisher saw a market value in the subject matter.

One example of Hiro Sachiya's manga is *Bodhisattva Miroku: The Buddha of the Future* (*Miroku Bosatsu: Mirai no hotoke*). At the beginning of the story, protagonist Shōhei discovers that he has failed the entrance examinations for elite universities for the third year in a row. Dejected and forlorn, he contemplates suicide as a way of evading the harsh criticism of his family members, who have all successfully matriculated at or graduated from top schools. Unable to go through with the suicide, Shōhei stumbles along the street dejected, runs afoul of some gangsters, and ultimately runs away to hide in a park, where a young nurse in training listens to his sob story. Fed up with his self-pity, she slaps him and scolds him for being so selfish.

Wallowing after this shameful incident, Shōhei spends some of the last of his money on alcohol, and as he drinks away his sorrows on a swing in the chilly park, the bodhisattva Miroku (Skt. Maitreya) suddenly appears. Miroku lectures Shōhei over the course of several chapters on his (Miroku's) role in guaranteeing salvation for all living beings several millions of years in the future. Shōhei is skeptical, then gradually convinced, of the salvific power of Miroku's ongoing discipline (*shugyō*) in the Tosotsu (Skt. Tuṣita) Heaven. Suddenly returned to reality, Shōhei accepts his lot as part of natural human suffering. He finds comfort in the fact that his experiences of the trials and tribulations of daily life are mirrored by Miroku, concurrently undergoing various austerities and acts of compassionate contemplation (*kan*) in Tosotsu Heaven. Shōhei swallows his pride and borrows money from his older brother so that he can return home to face his parents. Although his mundane problems have not been entirely solved, his encounter with Miroku gives him a new outlook and the courage to do what is right.

As Pye and Triplett's chapter suggests, Hiro Sachiya's stories are rather formulaic. They are designed to make Buddhism palatable to a broad audi-

ence, but they, too, are found in the religion section of large bookstores. In this sense, these works are preaching to the converted, for it is only by going out of one's way to seek out knowledge about Buddhism specifically that one might encounter these manga. The casual consumer browsing the shelves of the manga section of a store would almost certainly never encounter these titles.

SELLING SECTS

Various established denominations have recognized the instructional and inspirational power of manga and anime, and have accordingly created manga and anime hagiographies and other renditions of scripture. However, this kind of manga and anime, with its doctrinal focus, tends to be sententious.[77] The artists who are commissioned to produce the work may not be particularly inspired by the material, resulting in lackluster products. Furthermore, in some cases doctrinal restrictions lead to an inability to create products that are exciting to watch or read.[78] As a result, manga and anime created by religious institutions can have difficulty capturing broad audiences. Many of the manga featured in Kitahara Naohiko's book Manga *That Are Not in Bookstores* (*Hon'ya ni wa nai manga*), for example, are those created by (more precisely, commissioned by and created for) religious groups.[79] The book devotes one chapter to "religious manga" in general, another chapter to manga created by the group Cosmomate (Worldmate), and a section of another chapter to apologetic manga published by Sōka Gakkai, a lay religion in the Nichiren Buddhist tradition.

Despite these obvious problems, many religious groups have commissioned manga and anime in order to reach a broader audience, especially the young. Clearly these products represent the considerable effort on the part of these religions to reach young readers, although there is often a vast gulf between their didactic content and the relatively entertaining products that line bookstore shelves. For example, the afterword to a manga about Saichō that I found displayed next to apotropaic amulets in the Yokawa area of Mt. Hiei (the headquarters of the Tendai Sect) in 2009 includes the following statement:

> This year [1979] marks exactly 1200 years since Dengyō Daishi Saichō took the precepts [*tokudo*] at the young age of fourteen and became an official priest. To commemorate these 1200 years, various anniversary events such as the building of the Tōdōin [Eastern Pagoda Hall], the copying of

1,000 copies of the *Lotus Sutra*, and the revival of the administration of the Mahāyāna bodhisattva precepts are taking place. As one of those anniversary events, in honor of the young Saichō taking the tonsure, it came to be planned that Dengyō Daishi [Saichō's] life would be created in *gekiga* [i.e., manga] format in a manner easily understandable and easily acceptable by the youth of today, and thanks to the cooperation of various parties, we were able to see its completion and publication.

It is my sincere and ongoing hope that through these pictures even one more person might encounter Dengyō Daishi Saichō's estimable merit. (1 March 1979, Mt. Hiei Enryaku-ji, Honda Genshō)[80]

Unfortunately for the author of this text, despite the manga's long print run, its narrative and aesthetic appeal seems rather limited. Competing with mass-marketed products aimed specifically at the mercurial interests of target demographics, this single volume has remained unchanged for thirty years. It is also highly unlikely that it would be found anyplace but Tendai temples and a few specialty bookstores. As a strategy for gaining new converts, then, the manga *Dengyō Daishi* cannot be deemed a success. It is far too overtly pious to attract the serious attention of people without preexisting commitments to Tendai such as faith or academic interest.

The Laws of Eternity

Buddhist sects boasting historical longevity and a corresponding degree of clout have turned to manga to gain new converts, but the groups that have been most proactive in creating manga and anime have been groups that developed in the 1970s and since that decade, many of which exhibit considerable doctrinal eclecticism.[81] One notable example is Kōfuku no Kagaku, which has produced numerous volumes of manga and anime explicating the group's doctrine. These include an anime film called *The Laws of Eternity* (*Eien no hō*), which debuted in Japan under heavy media promotion in 2006 and used the highest standards of production and famous voice actors. In the story, Ryūta, Yūko, Roberto, and Patrick receive a mysterious message through a spirit medium from the spirit of Thomas Edison. They then build a "spirit phone" to contact the world of the spirits (*reikai*) and embark on an adventure through several dimensions. They tour through various heavens (where they meet Edison and Helen Keller, among others) and hells where Nietzsche and Hitler reside. The movie explains Kōfuku no Kagaku cosmology and moralizes as Ryūta and the others discover the "truth" of the existence of the spirit world and reincarnation (see Figure 1.2 on p. 53).

The movie includes Ryūta's heroic battles with the forces of evil, Yūko's unwavering devotion to Ryūta, and Roberto and Patrick as foils for the two.[82] Patrick plays the role of the scientific skeptic who is gradually persuaded that the "spirit world" exists; Roberto's bumbling enthusiasm and attachment to success highlight his spiritual immaturity. Eventually the jealousy these two harbor for Ryūta and Yūko lands them in hell. After Ryūta and Yūko heroically save their blundering companions, they travel to the ninth dimension and realize that they are "soulmates" who have been bonded throughout generations, from the lost continent of Atlantis to the present. Notably, the version that I picked up at Kōfuku no Kagaku headquarters in Honolulu in 2008 included a booklet with the complete script of the film, presumably so that viewers can read along (in Japanese, anyway) with the characters as they make their discoveries about the spirit world.

It is difficult to determine the extent to which films such as *The Laws of Eternity* have contributed to the popularity or growth in membership of Kōfuku no Kagaku domestically or abroad. Like other didactic films, *The Laws of Eternity* waxes pedantic, and it may therefore invite boredom or apathy as easily as curiosity or belief. The usage of the anime medium alone is not a guarantee of narrative success, nor will the creation of anime necessarily attract new adherents to a religion. Nevertheless, the superb technical execution of this film reflects the group's investment in the film and its message. Since it first turned to the production of manga in 1992, nearly 20 percent of the group's prodigious publications have been manga or anime, although it is difficult to determine whether this has contributed to growing membership in the group or increased public sympathy for its teachings.[83]

POLEMICAL MANGA AND ANIME

Some manga blend stories about fictive or actual religious groups with social commentary, including satire and critique. Since the Aum Shinrikyō sarin gas attacks in 1995, when religion as a social problem came to the fore in popular thought, many quite interesting works have been published dealing with the problem of marginal religious groups and violence. While the criticism leveled at religion or religions varies, these manga share the quality of arguing forcefully for taking negative stances vis-à-vis specific religions and their adherents. Several of these fictional manga are the subject of Chapter 4, so I will mention just a few brief examples here.

Matsumoto Taiyou's manga *Tekkon Kinkreet* (made into an anime by director Michael Arias), for example, tacitly shows (that is, through image more

than through actual dialogue) that the local mob boss runs his operation from the offices of the "Great Spirit Association" (Daiseishinkai), an obvious front.[84] Here the commentary on religion is oblique but palpable. If religions are not fraudulent organizations headed by charlatans, criminals shrewdly use their tax-exempt status and legal immunity for personal benefit. Some manga also include passing references to avaricious Buddhist priests, reinforcing a common stereotype that has been present in vernacular literature for centuries. As one example, there is a scene early in Urasawa Naoki's *20th Century Boys* in which a gluttonous priest draws the ire of protagonist Kenji as he gorges himself on food and alcohol after giving a perfunctory memorial service for an exorbitant fee.[85]

Nonfiction manga that are highly critical of religions also exist. Famed *mangaka* Kobayashi Yoshinori sharply critiqued the intellectuals who defended Aum Shinrikyō's rights in the months following the sarin gas attack.[86] Mocking the group through caricature and parodying Aum's own manga, Kobayashi portrays himself as a bearded guru engaged in sophomoric Socratic dialogue with disciples who serve as obvious foils for his opinions. He takes a utilitarian stance on the problems presented by Aum's terror—it does not matter what the legal ramifications are—for the time being Aum's rights must be suppressed for the good of Japanese society as a whole. Kobayashi criticizes the "Aum-ish" intellectuals who ignore popular opinion in favor of asserting lofty ideals about religions' rights to legal protection, caustically dismissing such attitudes as elitist and contrary to common sense.

RELIGIOUSLY NATIONALISTIC MANGA

This does not mean that all of Kobayashi's manga are necessarily antipathetic to religion. Kobayashi was raised in a Buddhist temple, and in many of his manga he has advocated religious stances, arguing for the importance of venerating (*sanpai*) Japan's war dead at the controversial Yasukuni Shrine and emphasizing the specifically religious role of the emperor. *On War* (*Sensōron*) strongly asserts parity in the guilt of the various combatants in World War II and defends the Japanese mission to "liberate Asia" (from colonialist Western powers, a euphemism for Japan's own project of colonization) while emphasizing the pure selflessness of the soldiers who fought for the empire based on the assumption that they would be enshrined as gods at Yasukuni.[87] The aforementioned *On Yasukuni* especially argues for Japanese citizens' right and duty to visit that controversial shrine.[88] Finally, *On*

the Emperor (2009), mentioned at the opening of this chapter, is Kobayashi's recent attempt to encourage attitudes of piety and reverence toward the imperial line.

Kobayashi makes full use of manga stylistic conventions to promote sympathy with his views. Depicting himself in the foreground of the frame with trademark spikes of hair floating above his forehead like antennae, he shows that he is reasonable, contemplative, and frequently exasperated by the fatuousness and mendacity he sees around him. He makes his arguments by taking a piece of commonsense knowledge and saying that he "used to think that way," then describes his change of heart, progressing to the end of each chapter where he exclaims his newfound revelations about the problems in Japanese society. Naturally, Kobayashi's antagonists are depicted in a less flattering fashion.

In the first chapter of *On the Emperor*, for example, Kobayashi complains about people's ignorant, unthinking reverence for the emperor. However, he explains that what he finds even more exasperating is the obvious indifference that many people feel towards the emperor and empress. He is not totally unsympathetic—Kobayashi himself has only recently realized that all Japanese people are religiously connected to the emperor, whether they admit it or not. Although many people say that Japanese religiosity is meager if not lacking, at the time of the New Year, for example, almost all Japanese households celebrate the calendrical and seasonal change in a ritual manner. In fact, Kobayashi asserts, all of these rituals associated with the New Year are Shintō religious rituals. Although they conduct these rituals almost unconsciously, Japanese people must have an extremely religious nature after all, he decides.

In the past, Kobayashi continues, Japanese people believed in "animism," the idea that there is a spirit in all things. Thus, when a person dies, his spirit goes to another realm, and after a set time has passed the person's individuality disappears, and the person becomes a part of the large collective known as "the ancestors" (*sorei*). In spring these ancestors become deities of the fields (*ta no kami*), and in autumn they return to the mountains and become mountain deities, and all the while they continue looking after their descendants. Furthermore, at the New Year they enter people's homes and promise to ensure a good harvest and good health for the family. The various customs and rituals that Japanese people perform at the turn of the year (such as year-end cleaning) are all tied to this ancient religion. What is more, the highest authority that oversees this religion that resides in all Japanese people is precisely the emperor![89]

This synopsis of a few pages of a chapter of the text should be sufficient to give a sense of Kobayashi's rhetoric. Although I do not have sufficient evidence to gauge the audience response to *On the Emperor*, I suspect that—like Kobayashi's earlier publications—it may be successful in sponsoring some changes in outlook or behavior in his audience. As a public intellectual, Kobayashi's oeuvre has had a demonstrable impact on discourse about Yasukuni Shrine and Japanese history. Although scholars with more centrist or liberal political views disagree with Kobayashi on several points, they have granted his work a certain degree of legitimacy by responding to it critically rather than ignoring it. No doubt this is because Kobayashi has obviously been successful at captivating readers' attention—his manga have sold well despite (or more likely, because of) their controversial content.

Kobayashi sees his work as providing Japanese people with a moral basis for living in a morally vacuous society, and he seems to have been successful in sponsoring certain moral dispositions and eliciting religious behavior.[90] As mentioned above, some of his readers have decided to worship at Yasukuni after reading his work, and one of my survey respondents claimed to have developed interest in religion due to his influence. Another friend mentioned in casual conversation that he considers himself politically conservative in part due to Kobayashi's influence, saying that he sees Kobayashi's work as a good corrective to the leftist tendencies that have pervaded the Japanese educational system for the past several decades.[91]

God Hand

Not all religiously nationalistic manga are as commercially successful, however. Nōjō Jun'ichi's obscure manga *God Hand* is the story of a boy named Jin (written with the same character as that used for a deity, or *kami*), who effects a drastic political change in Japan through a mysterious charisma that derives in part from the supernatural powers he wields with his right hand. At the end of the series, although protagonist Jin has disappeared, his loyal followers have created a new militaristic political order in Japan, guaranteeing Japanese military autonomy by removing Japan from under the United States' umbrella. Each volume bears a swastika on the cover and includes detailed information about Hitler in an afterword, and Jin's raised right hand is eerily reminiscent of the Nazi salute.

Nōjō's motives in writing the manga are not at all clear, and the manga seems to have had limited commercial success.[92] Although I did find a fan

site designed for those who "take Nōjō Jun'ichi's works as their Bible," the site manager indicated that Nōjō's work is generally unknown. The site, which was started in 2001 (ten years after the completion of *God Hand*), had not been updated since 2004, and by the summer of 2011 the site had been discontinued entirely.[93] Thus, although Nōjō's work carries disturbing implications about the author's reverence for Nazis or his celebration of fascist modes of governance, there is no indication that his message has been widely received, let alone accepted at face value. Indeed, the fan site's listing of Nōjō's works indicates that many were out of print as of 2004; some cannot even be found in used bookstores.[94]

Nōjō can be profitably contrasted with Kobayashi, because while both can be said to have drawn religiously nationalistic manga, the former's work languished in obscurity and its political message may have been too radical to be palatable to many readers. Rhetorically it is opaque, leaving readers unclear as to whether Nōjō is a Nazi sympathizer, a militant nationalist, or simply an artist who happened to use stark imagery to create his story. Kobayashi, by contrast, is quite clear in his rhetoric, and—given his commercial success and his status as a public intellectual—more persuasive. Although a tiny minority of people may have taken Nōjō's work as their "Bible" (and it is unclear what this phrasing means), some of Kobayashi's readers have actually acted on his exhortations to visit Yasukuni Shrine to pray for the war dead.[95]

Homilies and Parables

Finally, some products strike a middle position between didactic and aesthetic stances by using the parabolic mode to relate moral and religious positions through easily accessible language and allegory. In addition to inculcating faith or at least inviting casual interest in religion, apparently religious content also can be used rhetorically in the support of moral causes such as environmental preservation. Manga and anime may also reflect an author's reflections on the nature of the soul, the afterlife, or the cosmos in a way designed to encourage reflection but not necessarily conversion.

POM POKO

In director Takahata Isao's anime *Pom Poko* (*Heisei tanuki gassen ponpoko*), a group of raccoon-dogs (*tanuki*, a mammalian species endemic to East

Asia) band together to fight against humans' encroachment on their beloved mountain, which is being bulldozed in preparation for a new housing development on the outskirts of Tokyo.[96] Like foxes, *tanuki* are famed in Japanese folklore for their abilities in transformation and illusion; through a variety of magical feats they manage to disturb, but not stop, the development. Eventually they stage a massive demonstration of magical power with the help of *tanuki* priests that they have brought in from various far-flung parts of Japan, but even this is not enough to stop the building.[97] Faced with no real alternatives, the *tanuki* must eventually decide to blend into human society using their shape-shifting ability, or to make a living as wild animals in the city, foraging on human refuse.

In the film, religious imagery is regularly deployed in conjunction with the older *tanuki* protectors of the mountain (see Figure 1.1 on p. 37). The oldest *tanuki* dress in priests' robes and strategize for the magical campaign in a deserted mountain temple called Manpuku-ji. This overtly religious imagery, representing a pristine (if endangered) nature, is contrasted with the inexorable voraciousness of the bulldozers and steam shovels that progressively level the mountain, and the sterile housing developments that spring up in their wake. Furthermore, the humans who witness the magical display are blasé. Deciding the parading *tanuki* must be performing for some kind of commercial promotion, they return to their uniform high-rise apartment dwellings, mildly perplexed at its vividness but too reasonable, in most cases, to recognize it as a genuine miracle.

While Takahata's film does not use the hortatory mode to encourage increased religiosity per se, he subtly links religious reverence with an attitude of respect for nature. He condemns the wanton destruction of beautiful natural habitats through the experiences of his *tanuki* protagonists without being excessively polemical. Nevertheless, to ensure that his audience receives his intended message, at the very end of the film Takahata has one *tanuki* turn to the camera to encourage the audience to preserve natural spaces for the benefit of animals.

PHOENIX

Another homiletic product is Tezuka Osamu's manga *Phoenix* (*Hi no tori*).[98] A sprawling masterpiece spanning millennia, *Phoenix* uses the theme of the human quest for immortality to present a compound philosophical and cosmological picture of the interconnectedness of organisms, karmic cause and

effect, and a corresponding cyclical view of history. The work balances skepticism towards established religious institutions with presentations of religious ideas as solutions to the perennial problems of life and death. For example, although Tezuka criticizes the institutional aspects of Buddhism, his portrayal of Mahāyāna Buddhist concepts such as an immanent life-source from which all life emerges is sympathetic. He furthermore draws heavily on both Buddhist and Shintō mythology in the story, while at the same time putting the science fiction genre to work in describing the history of future human civilizations.

Phoenix is the story of an immortal bird that watches the development of human and other civilizations over eons. The bird is divine, in a sense—she has the ability to give life and take it, and she can communicate with people telepathically. Tezuka's story depicts human foolishness and wisdom throughout history, from the most ancient times to the farthest future, in a cyclical view of existence that relies heavily on the concept of reincarnation. Certain characters appear time and again in different epochs, identifiable by their facial features even if their costume and demeanor changes significantly. Tezuka's presentation of reincarnation is predicated on the notion that underlying and manifesting the entire universe is a fundamental life force (called *cosmozōn*, and written *uchū seimei*, literally, "universal life") to which people return when they die and from which all life springs. The Phoenix herself is actually a sort of eternal manifestation of this life force, capable of traveling between stars and between the dimensions of atoms and quarks to galaxies and universes.

The humans in *Phoenix* are complex characters who often have narrow, self-serving perspectives (many of them seek to kill the Phoenix and drink her blood in order to gain immortality). However, these selfish individuals play significant roles in light of the grander scheme that Tezuka draws. He is ultimately concerned with the problems of life and death faced by all humans, and, in his own words, the underlying theme of the work is a reverence for life.[99] Some of his characters appear time and again in different incarnations throughout human history; the most ancient of these are stand-ins for the *kami* and divine humans of the *Kojiki* mythology and the *Nihon shoki* mythological history (Amaterasu, Izanagi, Sarutahiko, Himiko). On the other end of the historical scale, Tezuka uses the science fiction genre to write a sort of "future history" by allowing his characters to deal with the limits of science and technology and the meaning of being human in a technologically advanced civilization.

In his autobiography, Tezuka explains his mission to express his reverence for life. Writing about the impetus for *Phoenix* and other works that hold this theme in common, he states,

> [When I saw that person die I wondered] if death might not be something that surpasses the pain we imagine in our heads. There might be some sort of huge life force, and the thing that resides in the fleshly bodies known as humans is just a tiny part of that, nothing more than an infinitesimal span of time. Call it a soul or whatever, when this life entity leaves the human body doesn't it go someplace? Does it begin a new life? I really thought about it at that time. I don't know if it's correct or not. However, from then on I felt the mystical nature of life directly, more than before. And from that point on especially I came to draw manga that dealt with [this] life force.[100]

Phoenix thus reflects Tezuka's philosophy and pedagogical intent. One interviewee mentioned that *Phoenix* did not initially appeal to him in his adolescence, but that when he rediscovered it in his early adulthood he found that the manga held many worthwhile lessons for him, including Tezuka's statement (delivered through the mouth of the Phoenix) near the end of the series that all religions are essentially oriented towards the same goals.[101] The religiosity of *Phoenix* has also been the subject of some academic attention.[102]

Due to his ability to create such inspiring stories, Tezuka has been revered as the "god of manga" both in life and posthumously. The canonization of works like *Phoenix*, however, remains at the level of critical acclaim. To my knowledge it has not been included in the scriptural or liturgical canon of any religious group, although commentator Kageyama Tamio, a prominent member of Kōfuku no Kagaku, called Tezuka a "bodhisattva" in his commentary on one of the volumes.[103] However, some Buddhist groups have apparently semiofficially canonized another of Tezuka's works (*Buddha*), making the manga available to their parishioners. One of my interviewees, for example, mentioned that the temple to which her family belonged kept copies of the manga around, and that this was her introduction to Tezuka's work as a child.[104]

The Tezuka estate has also published a volume entitled *The* Buddha *of Tezuka Osamu: Words of Salvation* (*Tezuka Osamu no "Budda": Sukuwareru kotoba*).[105] The book cites short scenes from the series and accompanies them with platitudinous exposition. For example, one page includes the following quote from the final volume of *Buddha*: "God . . . Did I say God!? I got it! Yeah, just now, I got it! Precisely within human beings' hearts . . . God is there . . . God is residing right in there!!"[106] This is accompanied by an ex-

pository phrase in smaller font: "Everybody has his own personalized god in his heart. If he lives life to the fullest, that god will always help him."[107] The facing page includes an appropriate scene from the manga and an expository paragraph. Here, Tezuka's work is treated as a sacred text in its own right, since citation of scripture accompanied with exposition is a feature of a great deal of religious writing worldwide. Indeed, the subtitle ("Words of Salvation") suggests that Tezuka's work boasts soteriological efficacy similar to that of Buddhist sutras.

Canonization

There is historical precedent for popular fiction leading to the creation of new forms of religious belief and practice. When they are particularly emotively and rhetorically effective (attracting and inspiring a wide audience), or as they gradually acquire the mystique and charisma of hoary tradition over time (impressing themselves upon younger generations), popular literature, drama, and film move from their position as "mere pop" to "high culture."[108] Along the way, the characters and themes within these works come to take on a life of their own, sometimes becoming objects of devotion or models to be emulated. There is, in other words, most definitely a reason why certain films and books are called "cult classics."

As fans gather around works that they find particularly appealing or inspiring, they may make reading these manga or watching these anime a ritualized endeavor for fan clubs. They may also perform exegetical readings of these products in the fashion of scriptural study groups. As these products—presumably created solely for entertainment—gradually become the objects of this exegetical practice, they take on a greater scriptural character. In the rare cases where the producer of the work also has interest in being a religious leader, the transition from an ostensibly secular piece of entertainment to a scriptural work is accompanied by the formal canonization of the work in question. Indeed, there are examples of manga and anime serving as a gathering point for like-minded individuals, transforming into scripture or liturgy, and giving birth to novel religions.

I use canonization here in the sense of treating something as sacred or inducting it into a preexisting set of ecclesiastic compositions. Some manga or anime do indeed become treated as part of the formal canon of a particular religion. Others become the primary sacred or otherwise authoritative texts for religions that emerge from audiences. In a few cases, this happens when the

mangaka him- or herself capitalizes on (or capitulates to) celebrity and takes on the role of a religious leader. The power of literature and media to inspire and instruct comes to be tied to the charismatic authority of the creator of that media—*mangaka* thus effectively or actually become leaders of religions.

One example is Miuchi Suzue, who is famed for her manga *Glass Mask* (*Garasu no kamen*), and whose work *Tale of the Demonic Princess* (*Yōkihi den*) won a prestigious award in 1982.[109] Miuchi's profile on her website states, "In *Amaterasu*, a spectacular romance of light and dark published by Kadokawa Shoten, [Miuchi] included her own mystical experiences; as a piece of literature with a powerful message this work boasts a large number of devoted fans from all walks of life. Also learned in the spiritual world [*seishin sekai*], . . . Miuchi is vigorously active [in that world]."[110] Miuchi's fan groups are not formally religious, but the author's incorporation of mystical themes in her works and her "spiritual world" activities such as tours to "power spots" like Tenkawa Benzaiten Shrine bring them close.[111]

Yamamoto Sumika, perhaps best known for her tennis manga, *Aim for the Ace!* (*Eesu o nerae!*), is another example.[112] There are rumors that Yamamoto established a religious community called Shinzankai (Holy Mountain Society), the membership of which is ostensibly drawn largely from her fan base.[113] While I was not able to secure an interview with Yamamoto, rather skeptical exposés have suggested that she acts in a shamanic capacity, performing semi-regular meetings wherein she is temporarily possessed and delivers oracles.[114] However, in a blog post dated 15 March 2004 Yamamoto herself dismisses the allegations that she is affiliated with "religion" (*shūkyō*) or that she acts as a "religious leader" (*kyōso*) as misguided.[115] Indeed, as of 2011 there is no group registered as a religious juridical person with the Japanese government under the name Shinzankai, although there are still a few scattered online Web listings for a cooperative of that name in part of Yamanashi prefecture where Yamamoto's group was reportedly active. While the veracity of the reports that Yamamoto serves as a religious leader cannot be fully verified, her case suggests that the manga medium sometimes transforms imagined communities (both the intended audience and the actual audience's perception of itself as a community of people with shared ideals) into actual religious communities.

SUBIKARI KŌHA SEKAI SHINDAN

While the case of the "Holy Mountain Society" is inconclusive, the final case examined in this chapter showcases a *mangaka* who did indeed found

a group that is registered as a religious juridical person (although, like Ya-mamoto, he resists the idea that his group is a "religion"). Former *mangaka* Kuroda Minoru is founder of Subikari Kōha Sekai Shindan (Divine Corps of the World of the Lightwaves of Su, SKSS hereafter). Kuroda's occult manga gradually took on the character of scripture as his fan community displayed strong attraction to the ideas within his works and as the author himself experimented with information from the extant religious traditions around him. Eventually, Kuroda founded SKSS, which is based on the reading of his works as well as practices derived from the Mahikari lineage.[116] Tsushiro Hi-rofumi suggests that the SKSS membership is largely derived from Kuroda's fan base, and that the usage of manga, as well as of video and other technol-ogy, has led to the group's success in gaining converts, particularly young people who are steeped in the manga medium.[117]

I met with Kuroda three times: once in April of 2007 at his home in Kobe, once during one of his regular visits to Honolulu in December of the same year, and again in Honolulu in March 2008. I asked a number of ques-tions about his teachings and about how his career as a *mangaka* had influ-enced and reflected his outlook on the nature of the soul and the afterlife. Kuroda exhibited strong antipathy to the word "religion" and seemed simi-larly disappointed in science. He was also skeptical of the word "spirituality" as a substitute for "religion." Nevertheless, his group is legally incorporated as a religion and provides services and teachings that can reasonably be de-scribed as religious. Kuroda seemed excited to talk with me largely because of the opportunity to elaborate on his ideas to a young person, an academic, and a foreigner. After each of our meetings he insisted that we meet again, but I had no impression that he was attempting to recruit.

Kuroda was born in Tokyo in 1928, and spent the first several years of his life moving from town to town because his father was a military officer. When he was young, he had several mystical or otherwise mysterious experi-ences.[118] These experiences prompted an intellectual interest in ghosts and the afterlife, and while he was still quite young Kuroda became fascinated with the writings of Asano Wasaburō, an early twentieth-century intellec-tual who conducted experiments involving communication with the dead.[119] Asano's writings reinforced Kuroda's own belief that scientific rationalism was inherently limited; Kuroda claims that he had no particular attraction to religion since his youth.

Asano had been friends with Deguchi Onisaburō, the charismatic sec-ond-generation leader of Ōmoto, and had helped Onisaburō reach a wider audience of urban intellectuals in Ōmoto's formative years.[120] Onisaburō

had initiated Asano into the shamanistic practice of *chinkon kishin* (literally, "pacifying the spirit and returning to the divine"), and therefore had a direct influence on the writings that so attracted Kuroda decades later.[121] Onisaburō had also indirectly influenced Okada Kōtama, who founded Sekai Mahikari Bunmei Kyōdan in 1962 after a stint as a branch head in Sekai Kyūseikyō.[122] Kuroda eventually found his way into Okada's group, and the shared cosmology of the Ōmoto lineage is evident in Kuroda's own writings and teachings. Aside from practices related to formalized spirit possession, the main ritual activities common to groups in this lineage include the transmission of "light" from the hand (or an implement, in the case of Ōmoto) for curative and purgative purposes, including exorcism.[123]

Kuroda's initial interest in writing manga arose, as he put it, from a desire to eat—he fell into his job as a *mangaka* rather than seeking it out. After withdrawing from Chūō University, Kuroda was looking for work and landed a job through an acquaintance, writing girls' manga for one of the larger publishing houses (Kōdansha). Kuroda claims that he had little interest in drawing manga, particularly girls' manga, and was constantly pushing the envelope of what could be drawn. His long-standing intellectual interest in the unseen world at the boundaries of both religion and science was what he really wanted to draw, and these themes naturally found their way into his works. His exploration of the spirit world was partially manifested in the horror manga that he was writing in the 1960s and 1970s, especially a three-part series about the "ghost world, spirit world, and heaven" (*yūkai, reikai, shinkai*), and he says that eventually he got invitations from nearly fifty different religious groups to visit them during this period.

One of these was apparently Sekai Mahikari Bunmei Kyōdan. In the early 1970s, Kuroda began to study under leader Okada Kōtama, who apparently said to him, "at last we finally meet (*yatto aemashita ne*)!"[124] Kuroda says that he was impressed to see an actual religious group truly interested in studying the unseen world in a fashion that was not strictly limited to the scientific method while still being methodical. He continued to study under Okada until the leader's death. At that time disputes over the legitimate transmission of teaching authority led to a schism within Sekai Mahikari Bunmei Kyōdan, and two main factions of the group have existed since 1977. The group legally deemed the legitimate successor to Okada was headed by Sekiguchi Sakae and retains the name, while the group known as Sūkyō Mahikari acknowledges the charismatic authority of Okada Keishū. Sometime after this fissure, Kuroda had a revelatory experience and decided to found his own religious group.[125]

Throughout the 1970s, Kuroda's manga continued to reflect his views on the afterlife, the makeup of the soul, and a decidedly Mahikari-influenced cosmology, and Kuroda enjoyed considerable popularity as a *mangaka*; he was known for drawing comics with occult themes. His manga were apparently quite successful during this time, but he refused to follow the popular trend of writing long-running serializations focused on one lovable protagonist. He chose instead to use each individual manga as a vehicle to teach readers about a particular aspect of what he calls "the unseen world" (*mienai sekai*, a term he claims to have coined). He describes these works as *etoki*, basically didactic explanations of this unseen world that were supplemented with pictures. He mentioned that often he had to include detailed expository commentary in the margins of his works to fully instruct his readers, a practice that drew some criticism. Many people, however, seemed to be attracted to the content.

Shortly after his aforementioned revelatory experience, a group of people that took Kuroda's teachings as doctrine incorporated as a religious juridical person in 1980. Kuroda says that forming a religion was the most efficient way of spreading his knowledge of the unseen world, and there seems to have been a great deal of overlap between his manga audience and the membership of his religious group. The group took its current name in 1984 and has been based in Tokyo's Hachiōji since. The discernible differences in practice between SKSS and the other Mahikari groups are negligible; the main difference seems to be Kuroda's perception of himself as a "researcher" into the phenomena of the unseen world rather than the founder of a new religion as such. Incidentally, the appeal to scientific knowledge (if not scientism) is quite common among Japan's emergent religions, seen here in Kuroda's emphasis on "research" (*kenkyū*) and, for example, in the name of a larger group that developed in roughly the same period, Kōfuku no Kagaku (which translates as Happy Science).

Currently Kuroda's audience seems to be divided into two segments, although this division may be largely superficial. The casual fan-oriented portion of the group is known as Ai 200 Tomo no Kai (http://www.ai200.com/), and is basically a source of information about Kuroda and his teachings on what he calls "the unseen world." The group maintains a website that features its monthly magazine, which includes Kuroda's explanations of spiritual topics as well as excerpts from his manga.[126] The website also sells various goods (towels, soap, organizers, and so forth) that have salubrious properties due to the fact that they have been treated with *jōkō* (the transmission of light from the hands, described below), accompanied by a number of attestations of their effectiveness from satisfied customers.

The other portion of the group is the legal body of SKSS. Although the group's literature downplays its legal status as a religion and emphasizes Kuroda's teachings as a source of information about the unseen world, it does include ritual practices that would seem "religious" to an outside observer, including ritual ablutions before entering sacred space and bows and claps before an altar where various deities are enshrined. Kuroda's home includes a worship space (*shinden*), where the center of the altar holds a representation of the creator deity, and the right of the altar holds a representation of the deities of fire, water, and earth. During my visit, Kuroda's editor took me upstairs to this room, and we both performed cursory ablutions before entering. He instructed me to sit still while he performed his worship (*reihai*), which consisted of a pattern of bows and claps in front of the altar. He then explained the significance of some of the things in the room. For instance, the braided cords in five different colors on each side of the altar represented the five main ancestral groups of humanity (from the lost continent of Mu).[127] The tatami floor represented a grass field, and the multilayered colors on the walls represented mountains, hills, and lakes. The door showed a smaller version of the same scene, but at sunset.

Kuroda says that around five hundred people regularly attend the five or so major meetings of SKSS a year, and smaller numbers attend the bimonthly regional meetings. When I last spoke with him in 2008, the group was finishing construction on a large dome in the mountains of Yamanashi prefecture. The dome would serve as a channeling point for the three kinds of "light" that pervade the universe: fire, earth, and water.[128] The group practices what Kuroda calls *jōkō*, which is the transmission of light out of the hands during a state of concentration. This light is allegedly curative, and Kuroda says that practicing *jōkō* on food will alter its taste. Kuroda's editor told me that getting trained in *jōkō* practice requires a two-day training session with Kuroda. He, Kuroda's wife, and Kuroda himself offered several examples of the salubrious power of *jōkō* in conversation during our third meeting.

Although Kuroda's manga tends to be classified as occult or horror manga, he seems to think of it more as an explanation of the true makeup of the spirit and the structure of the cosmos. Kuroda emphasized, however, that although his manga might reflect his interest in what he calls the "principles" (*hōsoku*) of the universe, he intentionally downplayed his teachings in the manga so that it would not be too dogmatic. Aside from his numerous horror and girls' manga, Kuroda has written a series of books that are primarily text-based but that also include illustrations drawn by his staff and excerpts from his earlier works.[129] He no longer writes manga due to problems with his

eyesight, although he has a strong desire to spread his knowledge of what he refers to as the "principles" of the unseen world to as many people as possible. He sees the group as his response to many fans' requests for more information about the unseen world, and particularly about their uncertainties about their lives and their quests for meaning.

Although it generally avoids any explicit mention of religion, the group's literature definitely emphasizes its ability to provide comfort, stability, and happiness through knowledge of the unseen world. Some of Kuroda's books weave short fictional segments together with Kuroda's pronouncements on the nature of the unseen world and the subtle body, and these are interspersed with illustrations drawn by Kuroda's staff. The language is matter-of-fact and accessible, although getting accustomed to Kuroda's characteristic (unorthodox) use of obscure characters for everyday words requires some adjustment.

It is worth quoting Kuroda at length to get a sense of the flavor of these writings. The following is the entirety of the preface to his 1987 book, *The Boat of the Subtle Body* (*Yūtai no fune*). It offers a preliminary view into Kuroda's worldview, and I have attempted to reproduce his writing style in translation.

> Beneath this visible world, although we cannot see it with our eyes, there is a world that broadly expands, deep beyond the far reaches of the imagination.
>
> It was when I was a young man, long enough ago that it is even beyond memory, that I was [first] attracted to the existence of this [unseen] world, and I read several pioneering works by others as if I were devouring them, absorbing [the information therein] as knowledge [that is, not as experience].
>
> Now, when I look back upon it, I clearly remember that as I turned each page of these books written from the perspective of spiritualism [*shinrei kagaku teki na tachiba kara no hon*] in particular, a mysterious feeling of transcendence would arise in me, and my chest grew warm. Although people may not admit it now, sometime the day would come when this *real truth* [emphasis in original] would garner people's attention.
>
> Just around that time, just as I was coming to vividly and directly affirm the unseen world in my heart of hearts, I saw a ghost.
>
> An evening more than half a year after a young man in the neighborhood had died in a car accident.
>
> As I was heading home from school, in the gathering gloom I saw him happily step into his house as if he were dancing.

It was at such a close distance that it could not at all have been a mistaken impression.

Afterwards I realized that he was dead, and along with a fear that would freeze the soul, I keenly felt the ineffably pitiable nature of spirits, and I experienced a deep shuddering response.

In later years, I came to learn that the ghost that I had seen was a half-material object that closely resembles the flesh [*nikutai*] and exists immediately below the human corporeal form [*nikutai*].

However, after I had this one ghostly experience, in order to truly understand the unseen world, even if I learned of this [unseen] world as knowledge in my head, or even if I felt it with my body, that alone would be no good [insufficient].

Whether by knowledge or by experience [*taiken*], whatever! I came to strongly think that if I had not experienced a shuddering sort of feeling at least once when in the heights of a warm and deeply burning sort of response [that resulted] from touching upon a human feeling in the deepest depths of the heart, then I would have wound up not understanding the truth at all.

And, even today after many long years, that thought has not at all faded and continues to shine.

Over these past few years, between creating comics, I have been blessed with opportunities to put my research on this unseen world into writing. In the monthly magazine *Mu* I published installments of a series on ghosts [*yūrei*], and these form the first half of this book. In the second half, records of my conversations with six individuals who have refulgent subtle bodies [*yūtai kagayaku rokunin*] are included; these were conducted as part of a piece on conversations with spirits in the monthly magazine *Twilight Zone*.

In both cases, I wrote and spoke of the unseen world in a human way and with great passion.

With the various [aspects of] the subtle body that controls our lives as a central [theme], if people understand even a portion of the existence of the unseen world and the fact that it has a great relationship with us, I will be very happy.[130]

Kuroda sees his inductive and largely intuitive research into the unseen world as part of a grand plan in the development of the cosmos. His cosmological thought is highly detailed and generally maintains a clear internal logic, borrowing from science as much as from the Mahikari worldview. Kuroda believes in an intelligent designer (whom the group calls Sushin) who created the world and set a universal program called *gokeirin* (perhaps translatable as "the august cycle") in motion. Around the phenomenal world

is the larger unseen world, and humans are constantly in contact with this unseen world. Humans have subtle bodies made up of subtle cells, part of which may remain in the phenomenal world on death, while part of them may ascend to a different plane. In Kuroda's thought, the universe is currently at a cusp stage, for while many people are still trapped in excessively materialistic worldviews, there is growing awareness of the importance of spiritual matters. Kuroda expects a major paradigm shift soon that will reflect this awareness.

Kuroda is highly suspicious of the category of religion, but said that the group's practice of transmitting light through the hands to another person (for physical and spiritual healing) legally required incorporation as a religious body. I asked if one might say then that the incorporation as a religion was just a surface formality (*tatemae*), but Kuroda suggested that this was not the case, although he seemed clearly unwilling to go so far as to explicitly call his group a "religion." He prefers to think of it as a forum for people to explore the "irrational" (my word, by which I mean nonscientific or otherwise empirically unverifiable, but in a nonpejorative sense) without the structure of a formal religion and strictures of doctrine. It is the concept of static doctrine in particular that Kuroda dislikes, since he prefers to be able to modify his own teachings as his research dictates.

"Research" (*kenkyū*) is the word that Kuroda prefers when describing his activities as leader of SKSS. While it is still unclear to me what exactly he means by this term, I surmise that Kuroda's research method comprises, on the one hand, intuition and imagination, and, on the other, methodology rather similar to the scientific method of experimentation. He claims to have done numerous experiments that have involved testing the flavor of foods subjected to *jōkō* against those that have not been so treated, or subjecting certain materials to *jōkō* to see how they resonate compared to others. While these types of experiments are admittedly predicated on decidedly subjective evaluations, the important point here is that Kuroda's worldview is not wholly dismissive of science or of religion. Rather, he incorporates convenient ideas and methods from both in the creation of his teachings, and he modifies those teachings as he discovers new information about the unseen world. I speculate that Kuroda's formalized "research" into the unseen world could be described as a particular mode of concentrated imagination, in which he reconciles his latest observations from *jōkō* practice with the cosmology that he learned from his studies with Mahikari and the modifications to that cosmology that he himself has devised or discovered. Kuroda may be equally suspicious of science and religion, but he relies on both in the

creation of his worldview and sees his intuitive explorations of the unseen world as crucial to the advancement of society as a whole. During our interviews Kuroda repeatedly referred to the "principles" of the unseen world, and believes his main task is to disseminate information about these principles to whoever will listen.

Manga provided Kuroda with a forum to elaborate on his ideas about the unseen world, and through his celebrity as a *mangaka* he received invitations to visit religious groups, allowing him to encounter religious teachings and practices like those of Mahikari. Manga also provided Kuroda with an audience; undoubtedly his ability to form SKSS derived at least partially from his status as a famous author. It was apparently initially a struggle to write the kind of horror manga that Kuroda wanted to write, so Kuroda's celebrity and popularity in the late 1970s may also have been associated with impressions of his work as pioneering or radical. SKSS is not a large group, however, and even the numbers recorded in academic sources (between four thousand and six thousand) are significantly larger than the one thousand or so adherents that Kuroda claimed to have during our initial interview. However, Kuroda is a particularly fascinating figure in light of his public status as both a *mangaka* and as a leader of a legally recognized religious group.

In the cases of the few *mangaka* who have started their own religions, certainly their notoriety as religious leaders relies to a great extent on their celebrity as *mangaka*, and most adherents presumably encounter the ideas of the group through the manga first and only secondarily through other literature. Groups like Kuroda's are successful because of the affective power of the narrative and the intellectual persuasiveness of the ideas found in the artist's works. The appeal of the ideas or content, augmented by the charisma of the author, combines to form an imagined community (the audience) that can function in a religious or a quasi-religious fashion with or without legal incorporation as a religion.

Segue

As we have seen in this chapter, audiences are exposed to religious content through manga and anime. In addition to sometimes exhibiting increased intellectual interest in religious doctrine or history, some individuals may use the acts of reading manga or watching anime as opportunities for self-reflection, as motivations for changes in lifestyle (including conversion), or as models for ritual action. In some cases, certain interest groups may elevate

these products to the level of canonical texts. The example of Kuroda Minoru's group particularly illustrates a situation in which the carefully masked didactic intentions of the author and the religious inclinations of part of his audience coincide, resulting in the birth of a novel religious movement. In contrast, however, many times the intentions of authors and audiences are not so consonant. Chapter 3 examines one example, through a case study of the works of famed anime director Miyazaki Hayao.

Entertaining Religious Ideas

In this chapter I perform a detailed case study of several anime by an influential director, showing ways in which audience interpretations—including academic interpretations—of certain films as products deriving from directors' religious motivations or as media for imparting religious messages can be fruitfully juxtaposed with directors' reflexive statements about their own work. I focus on the oeuvre of director Miyazaki Hayao because of its domestic and international box office success and critical acclaim. Miyazaki's work has also attracted a great deal of scholarly attention, allowing me to conduct a critical appraisal of some prevailing tendencies in foregoing academic studies of his films (and, by extension, of anime more generally). Furthermore, since most of Miyazaki's anime are produced primarily for the theater, they provide an opportunity to examine anime that are not derived from manga.[1]

Jaqueline Berndt has offered a cogent critique of the scholarly fascination with Miyazaki, referring to the overabundance of academic literature on his oeuvre and the corresponding dearth of academic studies regarding the works of other equally fascinating directors.[2] While this chapter is one more contribution to the burgeoning literature on Miyazaki's work, its specific aim is to provide a corrective for essentialist tendencies in foregoing scholarship, including the common assertion that Miyazaki's films somehow reveal a mystical understanding of religion (particularly Shintō). I proceed on the presupposition that examining what a director and his audiences say about his oeuvre is more revealing than scouring the work for particular religious themes. Through commentary on fan sites, interviews with informants, academic literature, and citations of interviews with the director, I examine how various interest groups interpret Miyazaki's films as religious while also showing how Miyazaki himself resists such descriptions.

Miyazaki's Moving Pictures

Because of its blockbuster success, its critical acclaim, its lauded technical wizardry, and its contribution to broader international interest in anime, Miyazaki's work in many ways epitomizes the forefront of Japanese popular anime production.[3] Over his long career, Miyazaki has honed his ability to use painstakingly detailed illustration to create broadly palatable stories conveyed in a mode that packs affective punch while keeping narratives both intellectually stimulating and accessible. Despite his professed antipathy to religion, many of Miyazaki's movies are moralistic, and he has made some of them with the explicit intention of inculcating certain values that can be reasonably described as religious. Miyazaki draws on existing religious themes like *kami*, but he also modifies them for his own idiosyncratic purposes. From his public statements it is clear that he seeks to simultaneously entertain and exhort, and his films thus serve as propaedeutic or persuasive texts that attempt to inspire alterations in behavior.

Some audience responses to Miyazaki's films attest to their emotive efficacy and intellectual allure. The films are sometimes used ritually (repetitively, as liturgical texts, as scripture) for edification as well as entertainment. Furthermore, the cosmology and mythology of the films comes to be interpreted and applied to reality after the films end. Such responses can include ritualized actions that indicate a sincere, if sometimes temporary, acknowledgment of belief in the actual existence of the saviors and spirits featured therein. Responses also include the performance of rituals enacted vicariously through the films, and the conduct of rituals performed in reality but created through the influence of the films. Audience members may also identify certain physical places as sacred because they were the alleged inspiration for sacred places found within the narrative realms of the films themselves.[4]

All of these aspects of audience reception demonstrate the power of moving images, the ways in which audiences are animated by characters they perceive as animate, and the ways in which they imaginatively superimpose fictive geographies on actual topography. Yet audience reception has generally gone unexamined in academic work on Miyazaki's oeuvre and religion, which has hitherto been dominated by a method that focuses on tracing connections between filmic content and traditional religious doctrines. This method usually reveals little about the religious or ritual activity that accompanies Miyazaki fandom, and does not account for the discrepancies

between Miyazaki's professed motives and the available evidence on how audiences interpret the content of his films.

Framing Miyazaki as Religious

A number of authors have discussed the existence of apparently religious motifs in Miyazaki's work. Among these, writers such as James W. Boyd and Tetsuya Nishimura, Lucy Wright, Lucy Wright with Jerry Clode, and Hiroshi Yamanaka have focused on how the director has drawn on preexisting religious themes, particularly those of Shintō.[5] Japanese scholar of religion Masaki Akira has written at least two introductory texts on religious studies that are thematically based on Miyazaki's works, and Inoue Sizuka devotes a chapter to a discussion of Miyazaki's films and their connections to religion.[6] Hirafuji Kikuko has also written briefly on connections between Miyazaki's films and animism, and Sarah Pike has recently drawn attention to Miyazaki's films and nature religion, highlighting the importance of children's experiences with natural and virtually natural filmic spaces in the creation of religious worldviews.[7] These books and articles take the framework of Japanese religion (Shintō, animism, and Buddhism) as a backdrop against which to place Miyazaki's films, showing how they preserve and transmit traditional religious culture despite the allegedly inexorable process of progressive secularization. In these portrayals, the act of viewing film in ostensibly secular spaces such as theaters and through mundane formats such as DVDs surreptitiously (yet generally positively) inculcates religious knowledge and values in unwitting, passive audiences.

Many of these authors premise their assessments of Miyazaki's work on the assumption that it provides traditional religion with a requisite recovery, revival, or transformation in a social environment that is allegedly hostile to religion. Wright, for example, writes, "Miyazaki is cinematically practicing the ancient form of Shintō, which emphasized an intuitive continuity with the natural world," continuing: "[his] work transforms and reinvigorates the tenets of Shinto."[8] This statement suggests that Wright can definitively identify "*the* ancient form of Shinto" (as if there is only one). It is made even more problematic by the fact that Wright relies solely on Kokugaku (National Learning) scholar Motoori Norinaga for her definitions of "Shintō." As a Nativist scholar who was interested in recovering an allegedly pristine version of Shintō from Japanese mythology and literature, Motoori Norinaga

is hardly an unbiased source. Wright's articles on Miyazaki thus reproduce an essentialist and romanticized view of Shintō that ignores its categorical and historical complexity.[9]

In a slightly different vein, a number of scholars have suggested that Miyazaki's palatable portrayal of Shintō induces desirable personal and social transformation while deferring discussion of the form that transformation actually takes. Writing on *Spirited Away* (*Sen to Chihiro no kamikakushi*), Boyd and Nishimura state, "It is our interpretation that Miyazaki is reaffirming aspects of the Japanese tradition preserved in Shinto thought and practice that can serve as transformative sources of confidence and renewal for both the young and old."[10] Yamanaka Hiroshi makes a similar statement, saying that *Spirited Away* "offers a secularized vision of traditional Japanese folk Shinto" that "carries . . . a deeply spiritual message of self-renewal."[11]

These readings of the psychologically "transformative" power of Shintō engage in a mystifying rhetorical sleight of hand, because while the nature of the transformation is never described, the underlying assumption is that said transformation is inherently positive. Such studies make the unsubstantiated and somewhat romantic claim that as religion is revived through film, religiously deficient audiences are spiritually reinvigorated. Such reinvigoration is difficult to assess, and the authors cited above do not substantiate their claims with ethnographic work. The form that the lauded transformation takes is left as a vague notion lacking a theoretical framework supported by quantitative or qualitative data. It is thus not an indication of concrete changes in practice, action, or belief. As S. Brent Plate succinctly reminds us, "Films are not religious simply because of their *content* but become religious due to their *form* and *reception*."[12]

The aforementioned scholars' arguments about Miyazaki's oeuvre do helpfully expand the range of religious authenticity by contributing to greater understanding of how formal religious doctrines are vernacularized. Nevertheless, although tracing religious themes in popular film back to traditional denominational sources is helpful for determining the background from which religious symbols and content arise, limiting one's analysis of these films to that process of disclosure neglects the function of filmic entertainment as an alternative religious practice that may disdain connections with traditional religious forms. Audiences may choose to watch the films precisely because the films are not directly derived from traditional religious institutions and doctrine, and directors may manipulate traditional religious imagery and doctrine in a satirical fashion. Tracing themes back to formal religious doctrines or to idealized versions of premodern religion (including

so-called folk culture) is also problematic because it easily overlooks audience interpretation of apparently religious content and the very important ritual dimensions of watching film, including the reproduction of virtual filmic ritual in reality.

Watching Films Religiously

Movie watching as a type of religious behavior has only recently been systematically studied. John C. Lyden, for example, argues that many ostensibly nonreligious activities such as viewing film can fulfill a religious function, arguing that the delimited purview of the category of religion as it is commonly conceived often obscures the function of other cultural activities that are equally religious.[13] Lyden takes issue with analyses that solely focus on theological or ideological views on religion and film, emphasizing instead the act of viewing film religiously.[14] He states, "Films offer a vision of the way the world should be (in the view of the film) as well as statements about the way it really is; the ritual of filmgoing unites the two when we become a part of the world projected on screen. . . . Films offer an entry into an ideally constructed world."[15]

Lyden suggests not only that film can be a conveyor of moral lessons and mythic content, but also that film watching can be a ritualized activity. Although I hesitate to say that all movie watching is religious, I believe that Lyden helps us to find religious practice, not merely imagery or doctrine, in film.

However, limiting the analysis to social or ritual function alone overlooks the influence that the incorporation of conventional or traditional religious themes has on movie watching. It also avoids the more difficult subject of the effect entertainment has on people's religious knowledge and practice. The inclusion of traditional religious imagery may affect the extent to which people watch films in religious frames of mind, although personal predilection and prior experience also play significant roles. Furthermore, people's religious practices (including and beyond that of watching film) may be altered by film, not simply supplanted or supplemented by it. S. Brent Plate writes, "Films do not merely appear on a screen; rather, they only exist in any real sense as far as they are watched, becoming part of the fabric of our lives. Film viewing is thus a social activity that alters our interactions in the world."[16]

Films can teach religious content, reflecting the worldview of the filmmaker in the process. They also can provide sites and models for ritual activity,

reflecting both preexisting ritual traditions and modifications and innovations of ritual based on film. Ronald L. Grimes has provided a comprehensive classification of such connections between ritual and media, and several of his categories seem particularly applicable to ritual and film in light of Lyden's suggestion that we consider the act of watching film a religious practice. These are (1) subjunctive, or ludic, ritualizing (as in rituals performed in online games); (2) magical rites with a media device as fetish or icon (healing power from an evangelist through the television); (3) ritual use of a media device (worship services built around CD-ROMs); (4) mediated ritual fantasy (vicarious ritual); and (5) media as a model for ritual activity (Hollywood gestures imitated in liturgical space).[17] Recognizing that ritual and narrative are often interlinked, with these categories in mind we can determine more precisely how the ritual of film watching and the rituals that arise from filmic content operate.

JAI SANTOSHI MAA

Anthropologist Philip Lutgendorf's analysis of the Indian film *Jai Santoshi Maa* explores these connections, examining the religiosity of the movie content as well as the influence on its audience in light of mythological and ritual elements that inform Hindu devotional worship. He writes that the movie "incorporated both a modified enactment of the *vrat katha* [simply, a ritual story] narrative and a paradigmatic performance of the ritual."[18] In the process of watching the film, the audience is invited vicariously into a ritual visual communion (*darshan*) with the featured goddess.[19] As a whole, "the film presents a well-crafted narrative abounding in references to folklore and mythology and offering a trenchant commentary on social convention; it also develops a 'visual theology' that is particularly relevant to female viewers."[20]

Aside from the vicarious or mediated ritual within the film, cinemas and other sites of viewing film can become ritual spaces, and films can create new followings for particular deities. Summarizing Lutgendorf's essay on *Jai Santoshi Maa*, Plate states, "[D]evout viewers entered cinemas barefoot and performed *puja* [rituals] in front of the goddess Santoshi Maa [*sic*]. . . . As a result of the film, a massive following of this previously obscure goddess erupted across northern India."[21] Lutgendorf also cites Anita Guha, the actress who played the goddess Santoshi Ma in the film, who said, "Audiences were showering coins, flower petals and rice at the screen in appreciation of the film. They entered the cinema barefoot and set up a small temple outside. . . . It was a miracle."[22] In the case of *Jai Santoshi Maa*, the act of watching the film

came to serve a ritual function, and the explosion in Santoshi Ma worship shows that the film became a catalyst for religious behavior.

Lutgendorf's explanation of the multiple connections between film, ritual, and mythology refuses to simplify them by making film merely a conveyor of religious doctrine or a ritual substitute for traditional religion. His analysis shows the reciprocal and recursive process between existing doctrine and mediated ritual, between new ritual and renewed doctrine. Viewers can become adherents to an existing religious tradition even as the tradition changes in response to the film. Films thus can serve both as gateways to and creators of religious cultures.

Plate corroborates Lutgendorf's points by emphasizing the creative process of directors' deployment of religious themes and the fecundity of films as sites for the creation of ritual action, writing, "[R]eligions and cultures do not merely *use* media, but instead are *used by* media, and created by them."[23] To slightly modify his argument, I suggest that *media* do not use or create religions; *people* do. Authors, artists, directors, and audiences do so through proactive acts of rendition and interpretation.

The remainder of this chapter examines the ways in which people re-create religion in filmic contexts. Filmic content may certainly inspire audiences to participate in an existing religious tradition. However, in those situations where preexisting religions are viewed with doubt or suspicion, films also can provide alternative mythological and ritual spaces that draw viewers into imagined and real communities of like-minded consumers that are functionally akin to formal religions.[24] They may coalesce around the ideas of a specific individual, canonize particular works, or use films in a liturgical fashion. Lay producers may play with religion by casually deploying formal religious doctrine or imagery. Audiences may entertain religious ideas in response. Audience members also may play at being religious through rituals based on watching the film or through interaction with filmic characters. It is therefore imperative to analyze not only the religious doctrine that forms part of the cultural background of a film, but also the motivation and intended message of the filmmaker. It is crucial to examine not only the ritual of watching film, but also how film can give rise to other innovations or changes in ritual behavior.

"Playing with Religion"

Miyazaki has said that "all he wants to do is to entertain," and that he is just "a man who draws pictures."[25] Elsewhere, however, the director's statements

suggest that he is at least partially motivated by a type of "spirituality" largely infused with an environmentalist ethic. For example, Miyazaki envisions (and frequently depicts) an idealized past, now lost, in which connections between organisms were both stronger and more respectful.[26] He states, "In my grandparents' time . . . it was believed that spirits [*kami*] existed everywhere—in trees, rivers, insects, wells, anything. My generation does not believe this, but I like the idea that we should all treasure everything because spirits might exist there, and we should treasure everything because there is a kind of life to everything."[27]

Yet despite this nostalgia with evidently religious overtones, Miyazaki wants to distance himself from formal religion. Wright states, "Essentially, his films attempt to re-enchant his audiences with a sense of spirituality that eschews the dogmas and orthodoxies of organised religions and politics, instead reaching for the original, primal state of spiritualism [*sic*] in human history and how it can be lived today."[28] In an interview for *The Village Voice*, Miyazaki says, "Dogma inevitably will find corruption, and I've certainly never made religion a basis for my films. My own religion, if you can call it that, has no practice, no Bible, no saints, only a desire to keep certain places and my own self as pure and holy as possible. That kind of spirituality is very important to me. Obviously it's an essential value that cannot help but manifest itself in my films."[29]

The act of moviemaking begins as an act of entertainment, but along the way it shades into an expression of religion ("spirituality," in Miyazaki's words), not only reflecting the director's views, but also attempting to inculcate certain values in his intended audience. Considering that audience in light of this, it should also not go unnoticed that Miyazaki has publicly recognized the success of his methods, and has apparently made his movies with this success in mind.[30] Miyazaki's moviemaking, therefore, simultaneously reflects his personal take on religion and his audience's evident desire for certain types of content. Simultaneously, it reflects his basic desire to entertain and the audience's desire to be entertained. These overlapping desires result in new modes of religious entertainment, or playful religion, shown in the following examples.

Animated Audiences

I examine audience responses to four of Miyazaki's anime below. The 1984 film *Nausicaä of the Valley of the Wind* (*Kaze no Tani no Naushika*) is the

story of a young princess who reconciles humans and nature in a postapocalyptic polluted world thanks to her character attributes as nurturing telepath, perspicacious scientist, and charismatic messiah.[31] In the 1988 film *My Neighbor Totoro* (*Tonari no Totoro*), the protagonists Mei and Satsuki befriend a benign and lovable forest spirit who helps them through a difficult period of transition.[32] The 1997 film *Princess Mononoke* (*Mononoke Hime*) revolves around the intertwined relationships of gods and humans, and humans and nature, emphasizing the necessity of strengthening human connections with both.[33] The 2001 film *Spirited Away* (*Sen to Chihiro no kamikakushi*) shares this pedagogical approach, and takes place in a world populated with a diverse array of gods and spirits.[34] At two points in the movie, the protagonist saves river spirits whose natural habitats have been polluted or obstructed by human construction.

Although Miyazaki's studio (Studio Ghibli) has made other films since *Spirited Away*, I find these four to be most clearly representative of Miyazaki's work as it relates to religion. Two major films created by Studio Ghibli since *Spirited Away* have adapted works by non-Japanese authors such as Ursula K. Le Guin (*Tales of Earthsea* [*Gedo senki*, literally *Ged's war chronicles*], directed by Miyazaki's son Gorō and based on Le Guin's famous *Earthsea* series, 2006) and Diana Wynne Jones (*Howl's Moving Castle* [*Hauru no ugoku shiro*], 2004). They are thus less indicative of Miyazaki's thought than the films based on his own stories. Additionally, Miyazaki's most recent film at the time of this writing, *Ponyo on the Cliff by the Sea*, or simply *Ponyo* (*Gake no ue no Pon'yo* 2008), seems to target a younger audience than the four films examined here. While *Ponyo* is visually rich, its diegesis offers little purchase for the purposes of this chapter.

NAUSICAÄ OF THE VALLEY OF THE WIND

Nausicaä is a drama about the salvation of the world and humanity in which approaching social and environmental catastrophes set the stage for its eponymous messianic protagonist.[35] Nausicaä is a member of the royal family in a small community situated in a valley relatively safe from the poisonous vapors given off by the spreading Sea of Decay, a large forest of mutated fungi and plants that is populated by giant and dangerous insects. The soil in Nausicaä's world has been polluted by an earlier industrial civilization—a civilization now lost after the apocalyptic "Seven Days of Fire" perpetrated by the "Giant Spirit Warriors" (*kyoshinhei*, thinly veiled euphemisms for nuclear weapons). When war breaks out and her father is murdered, Princess

Nausicaä suddenly becomes the political and spiritual leader of her people. A precocious scientist and gifted telepath, Nausicaä discovers that the giant marauding insects that protect the fungal forest are doing so in order to preserve the forest's secret: the ancient fossilized trees at the forest floor are converting the polluted soil into clean, usable earth. Before she can transmit this message to the people of the world, however, she is taken hostage by the army of a large neighboring nation that seeks to politically unify the various warring states and revive the Giant Spirit Warriors to use against the giant insects. Nausicaä uses her political influence, exceptional charisma, and supernatural abilities to help humans understand their role as cooperators with, not dominators of, nature. She manages to return to her people just in time to stave off a major catastrophe by stemming the onslaught of a rampaging herd of giant insects called Ōmu. Although she pays the price of her life in this intervention, the insects miraculously cure and revive her, and the movie ends with her resurrection and the revelation that she is the fulfillment of an ancient messianic prophecy.

Scholars and critics have identified the manga that is the basis for Miyazaki's 1984 production *Nausicaä of the Valley of the Wind* as religious. Yamanaka Hiroshi places *Nausicaä* in the category of "manga that acts as a religious text" in his description of "religious manga."[36] He writes, "As a whole this manga [and I would add the anime based on the manga] provides the same structure as a religious text like the Bible." He continues, "In the midst of this drama of death and rebirth, Nausicaä the protector of the Valley of the Wind is reborn as Nausicaä the guardian angel [divine protector] of humanity."[37] Similarly, Shimizu Masashi indicates Nausicaä's messianic status and supernatural abilities.[38] To Shimizu, not only is Nausicaä immortal and possessor of supernatural powers (*chōnōryokusha*), but also she is good, just, and the embodiment of love.[39]

Nausicaä, with its vivid apocalyptic vision, reflects Miyazaki's pedagogical impulse. He states, "When I started Nausica [*sic*], my theory was one of extinction; when it ended, my theory was one of coexistence. . . . There is no mighty intelligence that guides the world. We just keep repeating our mistakes. . . . If we want mankind to live for another thousand years, we have to create the environment for it now. That's what we're trying to do."[40]

While denying the existence of a "mighty intelligence," Miyazaki uses preexisting religious motifs such as apocalypse and resurrection to influence future outlook and behavior. Significantly, Miyazaki also admits—with some chagrin—that the closing scene of the anime version of *Nausicaä* made the work more apparently religious than he intended. He states, "Even though

it wasn't my intention to create a miraculous movie, it turns into a fine old [*rippa na*] religious scene. Even in the scene where Nausicaä comes back to life, I didn't intend any religious desires or miracles. Rather, when I realized that whatever I had been thinking had suddenly entered into the realm of religion I was really taken aback.[41]

Miyazaki's depiction of Nausicaä's death and resurrection may have been unintentionally reminiscent of religion, but in this case audience reception trumps authorial intent. Miyazaki cannot undo the fact that he chose to render the scene thus, and audiences have responded accordingly. The comments of *Nausicaä* fans on fan-based message boards suggest that some audience members interpret the films and apply their lessons to reality. Comments may refer, for example, to belief in an immanent spiritual bond existing among all living things.[42] One fan draws a direct connection between *Nausicaä* and Christian ideas of death and resurrection, and suggests that the Ōmu (the giant insects that protect the fungal forest from the depredations of humans by threatening to overrun human settlements) are actually divine.[43] Another person says, "Now Nausicaä seems far away from this reality in which we live, but really [she] is pointing to our current actions (like treating nature disrespectfully)."[44] Some fans writing on the message board attest to the affective and intellectual appeal of the story through repetitive viewings of the movie (ritual performed around a media device). The following stories of two female interview respondents, Morimoto Ari and Nozawa Keiko, show that some fans take Nausicaä as a role model to emulate in real life.

In the case of Morimoto Ari, not only did she want to become her fictional heroine Nausicaä, but also she has decided to pursue a career in environmental education that is a combination of ethical, environmental, and political views that she says were solidified through her repetitive readings and viewings of the *Nausicaä* manga and anime. Although Ari's idealism has been tempered somewhat by several years of witnessing environmental and wilderness management firsthand in eastern Washington State as an exchange student, she has combined her *Nausicaä*-inspired and *Nausicaä*-influenced idealism with a pragmatic outlook on environmental management. After completing her graduate degree in environmental education abroad, Ari hopes to participate in grassroots environmental education programs in developing countries. When I asked if her career path had been shaped by her strong feelings towards *Nausicaä*, she replied that it had, and that the movie helped foster her strong sense of affinity and connection with nature and her desire to work towards environmental and conservation causes.[45]

Nausicaä also profoundly affected Nozawa Keiko, another respondent. Keiko was raised in a Christian household (a very small minority in Japan), and her relatively strict upbringing meant that she was generally not allowed to read manga or play video games. However, her parents recognized something in *Nausicaä* that was of educational value, and Keiko watched the anime repeatedly both as a child and as an adult. On yet another viewing shortly before we first met (that is, not performed in conjunction with the interview), Keiko found herself crying at the final scene of the film, which depicts Nausicaä's resurrection. Keiko also regularly used the word "mission" (*shimei*) in our interview to describe how she views her job as a teacher. Although she tries to keep her Christian faith private, she believes that, like Nausicaä, she has a strong mission to help people find their way in the world. Keiko also explicitly stated that she seeks to emulate Nausicaä's characteristics in her own life.[46]

Both Keiko and Ari may be exceptional cases. However, these were two women that I met through acquaints, essentially at random. They live on opposite sides of Tokyo and are several years apart in age. In both cases, they casually volunteered the information that *Nausicaä* had served as an inspiration for their lives on hearing about the nature of my research. Given these circumstances and the suggestive commentary on fan message boards, it is possible that many others may have had similar experiences with the film.

MY NEIGHBOR TOTORO

My Neighbor Totoro is the story of two young girls, Mei and Satsuki, who move to a ramshackle old house in a rustic neighborhood outside Tokyo with their father to be closer to their mother, who is convalescing at a hospital nearby. Although they struggle with this transition and the adjustment to the spooky old house, the girls also delight in the simple pleasures of countryside living, watching tadpoles, helping gather fresh vegetables in the garden, and collecting acorns. Following a mysterious creature through their yard one day, Mei, the younger of the two, tumbles down a hidden passageway beneath the giant camphor tree that dominates the lawn. There she discovers the den of the *totoro* (her mispronunciation of the Japanized English word "troll": *tororu*), a family of magical furry creatures that come in small, medium, and large sizes. Although Satsuki and her father initially greet Mei's story with bemusement, the father surmises that the spirit of the camphor tree protected Mei while she was lost. The family accordingly makes an outing to the old shrine situated at the base of the tree to pay their respects to this spirit.

Afterwards, the girls have a number of adventures with the *totoro*. The cuddly creatures help them grow a garden by performing a moonlight dance, and take them flying on a magical spinning top over the trees, houses, and fields. When Mei becomes lost again, Satsuki calls on the *totoro* for help, and soon Satsuki is whisked off by the Catbus (imagine the Cheshire Cat amalgamated with a school bus, with a dozen legs instead of wheels), finally finding her wayward sister.

The eponymous spirits in *Totoro* seem to be loosely based on traditional Japanese conceptions of *kami*. Yet Helen McCarthy reports that although Miyazaki referred to the *totoro* as " 'nature spirits' of the same kind as those familiar in Japanese religion," the movie has, according to Miyazaki, "nothing to do with that or any other religion."[47] As McCarthy notes, the film makes an active contrast between Miyazaki's fantastic spirits and the cold, inert symbols of traditional religion. In one notable scene near a bus stop, for example, the inert and vaguely ominous fox statues at a small Inari shrine under a tree alarm Mei, but when the *totoro* appears moments later she and her sister implicitly trust the furry spirit. The *totoro* therefore represent a simultaneously new-old type of nature spirit strategically set in contrast to preexisting (institutional) notions of *kami* such as those found in Shintō. Whether or not Miyazaki's audiences believe in the existence of the *totoro* themselves, McCarthy argues that the film promotes an alternative perception of *kami*, tactically deploying traditional religious motifs as a foil for the magical, cuddly, and spiritually fecund *totoro*. In her analysis, the movie's pastoral narrative, combined with this refashioned *kami*, simultaneously offers a critique of traditional religious institutions and contemporary urban living.[48]

Significantly, many people who have grown up with Miyazaki's films have referred to *My Neighbor Totoro* as a favorite or as an influential film in their lives. Casual conversations with many Japanese acquaintances have prompted more than one person to comment on the ability of this film to "soothe" or calm them spiritually (*seishintekini*). One survey respondent also suggested that watching *Totoro* made her more interested in religion in general. Audience reactions to the film on a Miyazaki-themed fan message board on the Japanese social networking site MIXI also include reactions that shade towards the religious. One person, writing about the influence of Miyazaki's films and about *Totoro* in particular, wrote, "Often, with my older sister we would . . . hold an umbrella and try to pray for the sprouts to grow," mimicking a scene in the movie in which the *totoro* lead Mei and Satsuki in a prayer-dance to grow sprouts into a giant tree.[49] The children's imitation of

the scene reveals the ways in which film watching can create opportunities for the mimetic performance of originally fictional rituals.

PRINCESS MONONOKE

Princess Mononoke is the story of a young warrior from a minority ethnic group living in a northeastern Japanese village who is cursed by a god (*tatarigami*) in the first scene of the film. Driven from his village because of the curse, Ashitaka travels on his trusty elk to the southwest, where the magical forest of the Shishigami (a deity) surrounds an ironworks in the middle of a lake. There is an uneasy relationship between the humans at the ironworks and the animal deities of the forest. Workers at the ironworks, which is owned by Lady Eboshi, mine the surrounding mountains for ore and thereby destroy the natural habitat. Although Eboshi's character initially seems entirely self-serving, her softer side is revealed when it becomes clear that she has provided sanctuary for former prostitutes and people suffering from Hansen's disease. On the side of the animals, a young human woman named San who was raised by wolves regularly raids the ironworks on behalf of the animals, trying to drive the humans away. Like her nemesis, Eboshi, the initially ferocious San reveals a softer side when she cares for the injured Ashitaka.

Ashitaka finds himself caught between these women and the groups they represent, and he must intervene when human hunters (led by an avaricious and duplicitous monk) try to steal the deity's head. Doing so, they hope to destroy the magical powers of the spirit of the forest, and thereby make the place safe for human enterprise. Although the hunters are successful in capturing the deity's head, the relentless power of the decapitated deity searching for his missing cranium threatens to destroy the whole forest and the ironworks. Fortunately, Ashitaka and San are able to return the head just in the nick of time, and life returns to the forest, although it will never be the same as in its former glory. One character murmurs to himself at the end of the film, "I never knew it was the Shishigami who made the flowers grow!"

Miyazaki said of *Princess Mononoke*, "I've come to the point where I just can't make a movie without addressing the problem of humanity as part of an ecosystem."[50] His "spiritual" commitments come to the fore in a statement cited by Susan J. Napier:

> It is Miyazaki's notion that he and presumably other Japanese are the spiritual descendants of the "glossy leafed forests" that . . . once covered Japan . . . and that these vanished forests still exert a spiritual pull on the

average urban dweller, and it was this that he attempted to dramatize in his creation of the forest of the [Shishigami]. He explains, "If you opened a map of Japan and asked where is the forest of the [Shishigami] that Ashitaka went to, I couldn't tell you, but I do believe that somehow traces of that kind of place still exist inside one's soul."[51]

For part of the audience, the movie resonates with extant mythology or promotes ritual action, as the posts on a Miyazaki fan board attest. In response to a post entitled "The Setting of *Princess Mononoke*" (*Mononoke hime no butaichi*), one person wrote, "I really went to Yakushima [the alleged inspiration for the forest], and it seemed as if Shishigamisama [the main deity in the film] would really appear!" Another respondent wrote, "There [in Yakushima] people really believe in *Princess Mononoke* . . . [and the other animal gods] whereas [in Kumano, another potential setting and the site of a famous pilgrimage] they believe in trees and waterfalls." A third person relates the story of how a friend traveled to Yakushima and had a *kodama* (a kind of small tree spirit that features in the film; see Figure 3.1) appear in a photograph.[52] The first person's comment suggests a kind of pilgrimage, a sort of ritual practice around a conception of sacred space created through the medium of film; the second person's comment shows connections (found or created) between existing mythology and the mythology of the film. The third person's story clearly crosses the porous boundary between the mythology of the film and reality: the *kodama* that appears in the photograph is an indication of its actual existence. Many of the commentators express a desire to visit Yakushima in the future, presumably to experience it as a place of mystery, inspiration, or the sacred.

SPIRITED AWAY

Spirited Away is a story of a young girl named Chihiro who finds herself in a magical world on the day of her move to a new home. Shortly after she arrives in this mysterious land, her parents are turned into pigs. Finding herself in danger and literally fading as night falls, Chihiro is befriended by a boy named Haku, who comforts her by giving her something to eat and introducing her to a job at the local bathhouse for the spirits. The old crone who manages the bathhouse steals Chihiro's name, leaving her with just the first character, read as "Sen."

Sen/Chihiro's new job involves cleaning the bathhouse while sedulously assisting its spirit patrons, but all the while she is anxious to restore her

Figure 3.1. A *kodama* in the forest of the Shishigami in *Princess Mononoke*. © Hayao Miyazaki/ Nibariki TNDG

parents to their original selves. Along the way, Sen's lustrations help cleanse the spirit of a polluted river, and she receives a magical token of appreciation in return. She also is the only person who can stand up to the ravenous Kaonashi (No-Face), whose gluttonous appetite threatens to destroy the bathhouse entirely (see Figure I.2 on p. 5). Finally, Sen realizes that she and Haku have a special bond: she once fell into a river called the Kohaku River and was swept to shore. When she recalls this, she helps Haku remember his true identity as the spirit of that river (a fictional deity named Nigihayamiko-hakunushi). Haku had lost his true name when his riverbed was filled in and turned into an apartment complex. At the end of the film, Sen/Chihiro restores her parents to their human forms and they walk together back to their car and ordinary human civilization.

Some responses to a leading post, "*Sen to Chihiro ni kakusareta meseeji*" (Hidden Messages in *Spirited Away*) on the MIXI Miyazaki fan page attest to the aforementioned environmental commitment based on the idea that all organisms are spiritually connected, others to a renewed respect for the distinction between divine and human (*kamisama no tabemono o taberu* [eating the food of the gods/spirits]), still others refer to striving for a kind of spiritual love (*sūkō na ai*). The focus on human activity interfering with the ability of the gods to return to their natural homes (rivers, in particular) recurs in the film and is also picked up by the message board commentators.[53]

Here again, fans use the films as a basis for determining moral action in their daily lives. The other reality of film has come to profoundly affect the audience in this reality; the powerful images and the feelings that they promote persist. More than simply drawing on previous religious themes, Miyazaki has actively changed them by adding an environmental focus, and fans have responded to the film in ways that can be interpreted as casually religious.

It is worth noting, however, that Miyazaki resists the notion that the memorable scene in which Sen helps the river spirit by pulling a pile of trash from its body reflects any religious idea or sentiment. Rather, he says, it derives from an experience he had seeing trash removed from a horribly polluted river.[54] Although the question remains of why Miyazaki chose to render the scene in the way he did (giving a purifying bath to a river deity), such questions become moot in the face of audience interpretations that posit a connection between divine habitats and pristine natural settings.

MIYAZAKI'S WORLD

These four examples show, on the one hand, how Miyazaki is playing with religion. He uses religious motifs in a calculated fashion to encourage a particular audience response and modifies traditional religious concepts for his particular pedagogical ends. On the other hand, Miyazaki's films—ostensibly created solely as a means of entertainment—not only reflect Miyazaki's "spiritual" beliefs, but also seem to have the power to create responses such as ritualized behavior. The films also appear to generate exegesis, seen above in audience members' interpretations of films and application of the lessons therein to daily life. The director's casual religiosity (what he calls his "spirituality") therefore elicits similarly casual religious responses in at least part of his audience.

Beyond Borders

As in Japan, these media also occasionally serve as something akin to scriptural or liturgical sources for international audiences. As Susan Napier describes in her analysis of the Miyazaki Mailing List (a group that is associated with the website http://www.nausicaa.net), the mailing list serves as a sort of "sacred space" for the members, where they can affirm and share their responses to Miyazaki's films.[55] Significantly, Napier uses the language of "pilgrimage" for fan visits to the website and message boards.

The similarities between fan networks in Japan and elsewhere reflect the power of media to surpass boundaries in language and translation, creating broader networks of like-minded individuals who share the "ideology" (Napier's word), in this case, of Miyazaki's films and other Studio Ghibli works. One of Napier's respondents described himself as an "atheist with some Ghiblist influences," and 28 percent of respondents claimed to have religious feelings but no religious affiliation, often mentioning an interest in Buddhism or Shintō (presumably, or at least possibly, as a result of watching Miyazaki's works).[56] While inconclusive, these responses suggest that Miyazaki's worldview may also be affecting international audiences in a moderately religious fashion. English-language theological readings of Miyazaki's works also contribute to this type of interpretation. For example, in a 2009 article, Ian De-Weese-Boyd reads Nausicaä as a female Christ-figure from a somewhat confessional perspective, mapping Miyazaki's story onto Christian messianism.[57]

Drawing on Miyazaki in the Classroom

Academic audiences' interest in using the religious content of Miyazaki's films to teach about religion also should not go overlooked. Masaki Akira's religious studies textbooks, for example, attempt to teach young adults about religion through the filter of Miyazaki's films. For example, in *Beginning Religious Studies: Reading "Nausicaä of the Valley of the Wind,"* Masaki writes, "This book is an introductory text [*nyūmon sho*] to religious studies that uses *Nausicaä of the Valley of the Wind* as its instructional material."[58] As to why he chooses *Nausicaä* as his particular text, Masaki states (1) that he "loves" [*daisuki*] the film; (2) that the film is "overwhelmingly superb" [*attō teki ni sugureteiru*]; (3) that an "enormous [amount of] information is enclosed within the film" [*bōdai na jōhō ga komerareteiru*]; and (4) that the film is "truly interesting and has truly been seen by many people" [*jitsu ni omoshirokute, jitsu ni ōku no hitobito ga miteiru*]. These subjective statements lay the groundwork for Masaki's haphazard analysis of the film, which jumps from discussions of ancient Greek mythology (the alleged source of Nausicaä's name) to prophecy, monotheism, shamanism, wind, and breath on macrocosmic and microcosmic scales, and valleys as related to the feminine or to Daoism—all in the first chapter! The chapters that follow take a similar approach, resulting in a hodgepodge of information that almost certainly perplexes as much as it instructs.

Masaki's books differ from other scholarship on Miyazaki and religion because they explicitly claim to teach the discipline of religious studies (*shūkyōgaku*) through Miyazaki's work. This claim may be somewhat disingenuous, for rather than introducing interpretive methods central to the academic study of religion through Miyazaki's oeuvre, Masaki has used Miyazaki's films in the service of providing his intended audience (young adults) with a barrage of information about religious traditions that often has little direct connection with the films in question. Masaki explicitly aims to blur distinctions, shooting for an expansive approach rather than a focused one.[59] The end result is impressionistic writing that elides important cultural and historic distinctions in an eisegetic reading of the chosen subject (religion) into Miyazaki's films.

As introductory texts to the academic discipline of religious studies, Masaki's works may contribute to arbitrary interpretations of these popular films as "religious" while ignoring Miyazaki's subtle (in his films) and not-so-subtle (in personal interviews) critique of formal religions. Unsuspecting Miyazaki fans who may have been attracted to religion because of the films might read Masaki's books uncritically, leading to yet another layer of interpretation of the films' religious content. This dynamic is difficult to gauge but deserves close attention, since the very existence of such books reinforces the interpretation of Miyazaki's works as inherently religious. The irony of making this point in a book that also seeks to elucidate the religious aspects of manga and anime culture is not lost on me, but I hope to have persuasively indicated that scholars have a responsibility to treat not only filmic content, but also authorial intent and audience reception, with fidelity and sensitivity.

In Masaki's defense, he has explained very recently that his books derive from his pragmatic recognition that his students in lecture classes on religious studies have not believed that the class subject matter had any relevance for their lives. Taking up Miyazaki's films provided Masaki with a way to make the course subject matter relevant to students who would otherwise be uninterested in it.[60] In this sense, Masaki presciently anticipated what has since become a growing movement among Japanese scholars of religion to use popular films like Miyazaki's as instructional materials in order to capture student interest. The year 2009 saw the publication of Inoue Nobutaka's edited volume on learning about contemporary religion through film, followed by his convening of a pedagogically focused international research forum on "Religious Culture in Film" later that year.[61] Studio Ghibli works like those of Miyazaki and his business partner Takahata Isao have received

particular attention in these academic conversations, but for the most part the scholars in question have focused, like Masaki, on finding traces of traditional religion in the films rather than examining how laypeople actually view and interpret them.[62]

Given his skeptical statements on organized religions, Miyazaki is doubtless somewhat displeased with such efforts to appropriate his work in the service of teaching about them. Yet in the public sphere Miyazaki's works cease to be his alone; they are re-created by his fans and by scholars in multiple ways (and of course the present work is no exception). The fact that scholars are using Miyazaki's films as the subject matter for religious studies courses and textbooks suggests that various interest groups will interpret his works as religious, using them as pedagogical sources for religious education (screenings at Buddhist temples paired with moralistic dharma talks, for example) or as supplementary materials for lectures in religious studies courses. Audiences will continue to enjoy the products in multiple ways, but those ways increasingly include using Miyazaki's films not only as sources of diversion, but also as inspirational texts, as liturgy, and—however accurately or inaccurately—as representative sources of information about Japanese religions.

The question remains, however, whether his films serve as genuine representations of these religions or whether they represent distinct religious innovations. I fear that they are only marginally helpful for scholars who are trying to assess how Miyazaki's films might be used in teaching about Japanese religions if those scholars' interest is in teaching about the history or doctrines of venerable denominations. Anime in general are useful for talking about the fungible nature of religious data in contemporary Japanese media, but they rarely serve as accurate depictions of Japanese religious history, nor are they likely to explicitly introduce doctrine, although they may depict religious ritual with some fidelity. Miyazaki's films demonstrate a view of religion that is simultaneously too skeptical and too romanticized to be commensurate with most academic portrayals of Japanese religions. The director disdains organized religion, preferring to draw deities rather than priests. As such, he can hardly be said to be depicting "Shintō," "Buddhism," or any religion other than his own idiosyncratic vision of an idealized spiritual world and the fictional deities that populate it. However, focusing on the ways in which audience members view Miyazaki's films in religious frames of mind can illuminate the ways in which these fictional worlds are composed with empirical reality. In my view, this exercise may be more illustrative of contemporary religiosity than a strict focus on traditional doctrine and iconography.

Segue

Miyazaki's ambiguous statements make it difficult to associate him with any one particular religion, but they also indicate that the director seeks a simultaneously playful religiosity or a religiously imbued entertainment. Meanwhile, entries on fan message boards suggest that some audience members respond to Miyazaki's films with religious frames of mind. These posts obviously represent only those fans motivated enough to participate in an online forum, and make up merely a fraction of the information available from and about Miyazaki fans, meaning that further ethnographic work on the reception of his films is necessary. While Lyden has suggested that the ritual of film watching can be a religious experience, certainly only some of these fans would actively identify their response to Miyazaki's films as such. As recipients of Miyazaki's messages, they probably "consider themselves part of the audience, information consumers, and have no sense of belonging to a particular organization, sect or church."[63] Yet fans seem to recognize something deeply meaningful in Miyazaki's films even if they do not consider the films religion.

Miyazaki's oeuvre can be profitably contrasted with the manga and anime produced by formal religious institutions. Whereas his films subtly underscore his skepticism of formal religion, some religions have clearly recognized the proselytizing potential that manga and anime present.[64] Yet when religious institutions attempt to package their doctrines in an ostensibly entertaining package, the effectiveness of that entertainment may be diminished if the didactic orientations of the product are insufficiently masked. Audiences may be open to learning moral or religious lessons through their entertainment media, but that is generally only if the media in question are moving and persuasive rather than excessively polemical or pedantic. Although the use of anime and manga as media for expressing and conveying religion is not going to disappear any time soon, it seems that films like Miyazaki's that project and elicit religious frames of mind without the strictures of specific institutional affiliations are more likely to reach and capture broad audiences than the overtly pedantic products created by some religious institutions.

As producers play with religion, audiences in turn consume the content in a manner that can be simultaneously playful and pious. While we can artificially distinguish these layers in Miyazaki's work as well as in other anime, the foregoing examples show that some audience members view his films in religious frames of mind, imaginatively compositing fictive worlds

and empirical reality. In the next chapter I explore religious frames of mind from a different angle in study of manga related to the infamous religious group Aum Shinrikyō, examining manga that influenced Aum doctrine, manga that Aum used to proselytize, and manga that have critically portrayed Aum in the aftermath of the subway gas attack.

Depicting Religions on the Margins

It is difficult to discuss religion in contemporary Japan without addressing the influence of Aum Shinrikyō, the infamous group responsible for the sarin gas attack on the Tokyo subway system in March of 1995. In the aftermath of the attack, religions—particularly religions of recent provenance—came to be popularly associated with violence, brainwashing, and fraud.[1] While attitudes towards religions were not overwhelmingly positive in Japan prior to March 1995, Aum has undoubtedly contributed to the perpetuation of negative images of religions since.[2]

This chapter examines some manga and anime that influenced Aum doctrine during the expansion of the group in the 1980s and early 1990s, some manga that Aum itself produced, and portrayals of religion in manga that have appeared since Aum's violent tendencies came to light. Manga that apparently influenced Aum doctrine featured apocalyptic themes and a small group of protagonists wielding supernatural powers to create a new world order. Aum's resident artists created manga and anime that reproduced these tropes, although they minimized the adventure aspects of stories in favor of focusing on conversion episodes, the acquisition of spiritual powers, Aum's salvific role in the face of impending apocalypse, and praising guru Asahara Shōkō.[3] In the years since the "Aum shock," *mangaka* have conducted critical evaluations of groups like Aum, attempting to explain the actions of marginal and potentially violent religious movements in a rational and accessible fashion.[4]

Aum Shinrikyō

Asahara Shōkō (born Matsumoto Chizuo) developed the eclectic yoga group that eventually became Aum Shinrikyō in the mid-1980s.[5] The group's generally well-educated membership shared an interest in the acquisition of spiritual powers and a rejection of previously valued moral and epistemological systems, including those of established religions and of modern rationality or scientific thought.[6] Many of these people initially encountered Aum through its promotional literature and ads in occult magazines like *Twilight Zone* and *Mu*.[7]

Aum's millennial outlook, its ideal of the spiritually enlightened and superior being, and its antisecular orientation led to a gradual secession from Japanese society in the early 1990s. The small yoga group became a large organization of renunciants (around 1,200, as well as a wider community of affiliated householders) headed by Asahara and his group of close disciples. Aum maintained several communes throughout Japan where participants engaged in extreme ascetic practices, and eventually where they developed the weaponry that would be used in Aum's "holy war" against its perceived opponents (secular forces in general, but particularly the United States, Freemasons, Jews, and the Japanese government).[8]

Aum's conflicts with secular society began with lawsuits filed against the group by concerned families of members, were exacerbated when Aum came under suspicion for the mysterious disappearance of a lawyer who had been investigating the group, escalated when Aum members made flashy but ultimately ineffective campaigns for political office in 1990, and came to a head when the group purchased the land for a commune against the wishes of the local community at Namino in the same year.[9] At first by accident and then intentionally, members carried out *poa* (a euphemism for murder based on a Tibetan word roughly meaning "liberation") in a few smaller isolated cases before moving to indiscriminate terrorism. Aum's sarin gas attack on the Tokyo subway on 20 March 1995 led to the deaths of twelve, seriously injured hundreds, and otherwise negatively affected thousands of people.[10]

By late 1995, the media was in an uproar about the dangers of "cults," and Japan was generally at a state of high alert regarding religions of any kind.[11] Scholars and journalists attempted to account for young people's attraction to Aum, and some analyses rather simplistically attributed the source of Aum's putative social pathology to members' shared interest in the fictive worlds of manga and anime.[12] At the same time, scholars of religion noticed

a sharp increase in college students' interest in religion as a social problem.[13] Against this background, in the years since the Aum incident authors of various types of popular fiction and nonfiction, including manga, have dealt with the Aum issue—explicitly or by allusion—through combinations of sensationalism, critique, curiosity, satire, and psychoanalysis.[14]

Schemes and Plots

Earlier chapters focused on sketching a method somewhere between auteur theory and audience reception theory, highlighting the visual elements of manga and anime while paying close attention to the people who produce and consume them. This chapter takes a slightly different approach by focusing on narrative. It examines the social lives of certain narrative styles and tropes by appropriating and reconfiguring familiar—if sometimes problematic—terminology.

Specifically, I argue that the terms "cult," "myth," and "epic" elucidate otherwise easily overlooked aspects of the narratives surrounding the Aum incident. I mobilize these terms to show how stories that ostensibly function as entertainment can invite religious interpretation and inform religious doctrine. I also demonstrate that stories that are apparently highly critical of "cults" (and of religions more generally) can still subtly encourage positive dispositions regarding certain ways of religious being. Finally, whereas some scholars have borrowed the literary terminology of "dramatic denouement" to explain the sociological process whereby marginal religious groups come into conflict with mainstream society, I investigate the role that literature itself—illustrated literature in this case—has played in Aum's doctrinal development, its propaganda, and the popular analyses that followed its violence.[15]

I proceed by examining the narrative trope of the "cult"—namely, an allegedly pernicious religious group that exists in high tension with mainstream society—in conjunction with the idea of the "cult classic," a specific type of narrative with an esoteric cachet. I furthermore demonstrate that the manga that influenced Aum doctrine, Aum's own propagandistic manga, and some of the more recent manga that have mobilized the now-commonplace trope of the deleterious "cult" have all benefited from what I call the aesthetics of extremity. This dramatic narrative style lends these stories an epic quality in which righteous protagonists fight to save human-

ity despite opposition at all costs. At the same time, this style also functions to explain—and sometimes justify—the actions of the leaders and members of marginal religious groups.

"CULT"

Using the word "cult" indiscriminately easily elicits misconceptions regarding emergent and alternative religious movements.[16] Here I will use the word in three very specific senses. First, in popular discourse "cult" often serves as a descriptor of ostensibly or actually violent religious movements that exist in high tension with mainstream society. While this view is not academically sustainable, it can be used analytically to highlight a specific kind of rhetoric that contrasts ostensibly malignant religious groups with supposedly benign religions or secularisms. Many of the manga that I analyze in this chapter use "cults" and their members as foils for their depictions of social and psychological normalcy. I refer to "cult" in this sense not because it is a suitable analytic term for a certain class of religious groups, but rather because it serves as an apt catchall term for a specific narrative trope based on pejorative images of marginal religions.[17] When using the term in this way I have added scare quotes to it: "cult."

A second way to look at the word is simply as a group of veneration practices or an organization centered on a particular person, place, or story (similar to the *shinkō* found in phrases such as *Tenman shinkō*: the cult of Tenman Tenjin). In this usage, there is the cult of leader veneration found in Aum's own literature regarding Asahara Shōkō. This usage is also evident in the cult surrounding protagonists within the narrative of certain fictional works, particularly protagonists endowed with exceptional charisma who are surrounded by loyal followers.

Finally, the word "cult" is often used to refer to an inordinate degree of popularity attributed to a particular media product, with an emphasis on the cultural cachet that accompanies familiarity with it (a "cult classic" or "cult film"). When used in this fashion, "cult" loses its pejorative ring and instead garners some validity. The status of "cult classic" derives both from a product's esoteric qualities (the novelty or quirkiness of its content) and from its ability to monopolize the interest of a particular demographic. Cult classics are subjected to detailed exegesis, become the basis for ritual action or repetition of dialogue, or become informally canonized (must-see films or must-read books) among a subculture.[18]

MYTH AND EPIC

The word "myth" often is used in a pejorative sense to refer to falsehood or to credulous primitive attempts at authentic history. However, myths in any period serve to explain the world or the existence of something in the world (e.g., cosmogonies, pourquoi stories). While some of the manga discussed below clearly draw on the myth—in the sense of fictive or false—of marginal religions as avaricious institutions solely concerned with deceiving followers for the personal benefit of the leaders, they also provide explanations of the origins and existence of "cults." As myths, they also may illustrate supposedly perennial truths through emotionally appealing narrative.

Stories also serve to entertain and inspire through presenting admirable protagonists with exceptional qualities (e.g., exceptional strength or faith, impeccable morality, or supernatural abilities) performing righteous actions in extreme situations. These narratives can be categorized as epics. Some manga and anime rely on a narrative structure that, as epic, emphasizes extraordinary circumstances and features protagonists who serve as exemplars of moral, religious, or political righteousness. The appeal of epic lies in its ability to inspire through the exemplary actions of exceptional heroic protagonists faced with seemingly insurmountable opposition.

The Aesthetics of Extremity

If myths work to explain the existence of the world and its material and social constituents, epics operate to confirm or renew its moral order through what I call the aesthetics of extremity. Some stories acquire their emotional appeal and inspirational qualities via their situation of the protagonists in extreme situations (nuclear war, for example) and their endowment of those protagonists with a combination of moral virtue, dogged tenacity, and exceptional courage and charisma. Villains in such stories are likewise extreme in their personality traits; they may also be the cause or a side effect of the crises the heroes must face. In short, the extremity of the circumstances (e.g., the end of the world) combined with the extremism of antagonists (an evil "cult," an oppressive government) and the extremism of the protagonists (their commitment to peace, justice, or salvation beyond the bounds of normal reason, to the extent that they suffer persecution or otherwise place themselves in danger) combine to create powerful epic narratives.

In what follows, I show that the aesthetics of extremity were character-istic of many of the manga and anime that apparently influenced Aum doc-trine. I also show that Aum's own manga reproduced this aesthetic, while Aum's confrontations with secular society derived in part from it. The "dra-matic denouement" of the gas attack was a perhaps inevitable consequence of the group's moral interpretive frame and the developing story supercilious Aum members told themselves about their antagonistic relationship with the incorrigible and deluded outside world.[19] Furthermore, the dramatic diegesis of gradual secession from secular society—punctuated with the compelling climax of the gas attack—has provided an attractive model for thrilling tales of fictional antagonistic religious groups in manga since 1995. I will show that there is indeed a connection between manga and Aum, but that this connection is not one that can be simply mapped onto the binary logic of delusion and sanity. As I show through the case of Urasawa Naoki's lauded manga *20th Century Boys*, there is a discomfiting parallel between the righ-teousness of the religious terrorist and that of the epic hero, and the line dividing the two is simply one of perspective.

Manga on Which Aum Shinrikyō Drew

Some manga that evidently influenced Aum doctrine highlighted this aes-thetics of extremity through apocalyptic settings and the cult (veneration) of protagonists who bring about reconciliation through their moral fortitude. In addition to the obvious influence of Japan's direct experience of atomic bombing, the popularity of apocalyptic themes in manga has its roots in a boom in millennial thought in Japan that was largely prompted by Gotō Ben's numerous translations of Nostradamus' prophetic writings starting from the mid-1970s.[20] Some manga and anime that inherited these themes formed a common imaginary for potential and actual Aum members, focusing their attentions on impending apocalypse, the limits of science and secularism, and the acquisition of supernatural powers.[21] To be clear, manga and anime influenced Asahara's thought and provided a common background for the Aum membership, but they did not form the primary substance of Asahara's teachings, nor were they the basis for Aum's religious practice.[22]

However, some manga and anime did have an observable effect on Asa-hara and Aum. These products can be characterized as epics that used reli-gious vocabulary and narrative structures for aesthetic rather than didactic purposes, but Aum's members later interpreted them to be delivering spe-

cific religious messages. In their shared religious frame of mind, the fictive worlds of certain manga and anime were composed with empirical reality and mapped onto the developing Aum cosmology. For example, Helen Hardacre has documented how Aum mimicked some language from the popular anime *Space Battleship Yamato* (*Uchū senkan Yamato*, 1974), which features the end of the world twice over (that of the Earth and that of another planet).[23] In addition to *Yamato*, manga and anime such as *Nausicaä of the Valley of the Wind* and *Akira* seem to have influenced Aum. Part of the appeal of these narratives is the very extremity of the situations in which the protagonists find themselves (impending cataclysm) and the extremity of the same protagonists' commitments to solving the problems with which they are confronted—the tenacity with which they fight to protect their homes and their loved ones. In these moving stories, rationalism, secularism, and unbridled military development are sharply called into question. They end with the inauguration of new world order through the actions of morally superior heroes wielding supernatural powers to save humanity.[24]

NAUSICAÄ OF THE VALLEY OF THE WIND

The manga version of *Nausicaä*, serialized from 1982 to 1994, forms the basis for the hastily filmed 1984 film of the same title that I described in Chapter 3. Asahara is known to have been a fan of *Nausicaä*, and the manga was featured in an issue of Aum's publication *Vajrayāna Sacca* just a few months before the sarin gas attack. The article was entitled "*Gendai no yogenshatachi ga egaku senritsu no kinmirai!*" (The horrific near future depicted by the prophets of today!), and included several manga series with narratives centered on the theme of apocalypse.[25]

The previous chapter included a synopsis of the anime version of *Nausicaä*, so I will forgo extensive summary here. In the more detailed manga version of the story, Nausicaä fulfills her messianic role as the culmination of an ancient prophecy while reluctantly becoming the focus of religious devotion. It is through her unique blend of charisma, supernatural power, and scientific insight (that is, esoteric knowledge) that Nausicaä is able to finally reconcile humanity with its environment. The cult (veneration) of Nausicaä the heroine within the story combines with the epic nature of the narrative arc, which features a charismatic and morally impeccable character confronted with apocalypse compounded on apocalypse. Nausicaä's heroism derives from her extreme commitment to the reconciliation between warring human groups and between humans and nature; the extreme setting of the

story contributes to the epic quality of the work. Although Miyazaki suggests that *Nausicaä* (the film) inadvertently became religious due to the power of its closing scene in which Nausicaä dies and is resurrected, the manga version of the story emphasizes Nausicaä's messianic status—characters call the heroine an "angel" and "savior."[26]

The members of Aum were hardly immune to the power of this image or to the message of the work as a whole—the salvation of a polluted and deluded world characterized by war and strife would be understood and enacted by only a select few equipped with supernatural abilities and esoteric knowledge. Furthermore, the purification of the same world would happen through the very *source* of the poisonous gases—the fungal forest—that served as the source of toxic pollution in the first place.[27] Although drawing too much of a connection would stretch the limits of plausibility, it is intriguing that Aum's obsession with sarin gas as both threat (Aum claimed to have been attacked with sarin) and expiatory tool seems to have reflected the dual role of the atmospheric gases in Nausicaä's world as both poisons and purifying agents.[28] Incidentally, the giant insect guardians of the fungal forest—the Ōmu—happen to share a homophonic relationship with Aum (both pronounced "Ōmu" in Japanese).

AKIRA

Ōtomo Katsuhiro's manga and anime masterpiece *Akira* (1984–1993) was one of the first anime to gain "cult" appeal outside Japan, and the film enjoyed considerable domestic impact. Although it is the more complex manga diegesis that I describe here, the anime evidently affected Aum's own animators. The former head of Aum's MAT group (Manga and Anime Team) stated that he personally was strongly influenced by Ōtomo's work, and apparently the anime cameraman who worked in MAT had worked on the *Akira* project before joining Aum.[29]

Also a product of the mid-1980s, *Akira* similarly addresses apocalypse, albeit from a different perspective from that found in *Nausicaä*. Government experiments on young children have produced extraordinary psychic abilities—especially telekinesis—in the subjects, and one boy in particular proved himself to be far too powerful to be let loose. Locked in a cryogenic vault deep below a postapocalyptic "Neo Tokyo," Akira is the focus of government intrigue and fear. When Tetsuo, a young member of a motorcycle gang, collides with one of the other test subjects, he too is exposed to extensive testing and develops immense psychokinetic powers near the same lev-

els as Akira's. Tetsuo's ability to manage his powers, though, is hampered by his addiction to drugs and his inferiority complex. Tetsuo frees Akira from his underground prison, but shortly afterward Akira destroys Neo Tokyo in an emotional outburst.

In this post-postapocalyptic city, two groups (both centered on the veneration of a charismatic leader) vie for power. One is the Neo Tokyo Empire, nominally headed by Akira but managed by Tetsuo, who maintains order through displays of sheer psychic power. The other is the religious order headed by the mysterious Miyako, also a former test subject. Miyako provides healing and food for people in the ravaged city while training her acolytes in psychic powers necessary for combating Tetsuo's and Akira's more unpredictable and violent telekinetic outbursts. Miyako and her acolytes fight valiantly to control the increasingly unstable Tetsuo, who turns monstrous as his exceptional powers swing out of his control. In the end, only Akira can contain the berserk youth. In Tetsuo and Akira's final apotheosis, Akira absorbs Tetsuo into himself and the two disappear in a scene of fragmentary dialogue. The two merge with the cosmos, signaling the dawn of a new spiritual and political order on Earth, the nature of which is left almost entirely to the audience's imagination.

Again, in *Akira* as in *Nausicaä*, there is a cult (veneration) of certain characters, although in the case of the former the turbulent nature of Akira and Tetsuo's group is contrasted with the more benign order of Miyako and her acolytes (only shown in passing in the film version). Akira, only a child, is politically passive and entirely lacking in ambition but extremely volatile due to his immense psychic powers. His followers in the Neo Tokyo Empire are attracted to his ability to work miracles or wreak destruction more than to his charisma. Miyako, on the other hand, along with the other protagonists, serves as a model of a character equipped with both charisma and supernatural abilities of nearly the same order as the two tempestuous boys. Miyako is also present for their final apotheosis, explaining the nature of the interconnection of the universe to protagonist Kaneda (Tetsuo's friend who seeks to control his berserk pal) before Akira and Tetsuo vanish in a rapidly diminishing globe of light. Again, the epic nature of the story is created through the extreme situation of a post-postapocalyptic world threatened with total annihilation; the cult (veneration) of the most prominent superhuman characters adds an additional layer of complexity within the narrative.

Both *Nausicaä* and *Akira* play on themes of apocalypse and religious figures; interestingly, the latter in both cases are presented as a positive solution to the extreme circumstances brought about by the former. Specifically, the

protagonists' supernatural powers (such as telekinesis, telepathy, and clairvoyance), while occasionally destructive, ultimately provide salvation for ordinary people and the dawn of a new age.[30] These manga also criticize secular, rational society—including consumerism and unbridled technological and military development—while valuing alternative, spiritual knowledge.[31] Significantly, scholars of religion have identified this antisecularist stance as common among the Aum membership. Although its members exhibited different reasons for joining on a personal level, in general Aum's constituents sought a retreat from capitalist society and the acquisition of spiritual power through severe ascetic practices, the founding of alternative communities devoted to religious practice, and the creation of a new holy country on Earth.[32]

The Manga That Aum Shinrikyō Drew

In the eclectic fashion characteristic of the age, Aum drew on esoteric Buddhism, Tantra, yogic practice, and messianic and eschatological elements of Christianity.[33] The group's thought also reflected Asahara's time spent as a follower of Agonshū, another Japanese religion of recent provenance. Aum's members—generally highly educated and yet also exhibiting a strong dissatisfaction with the materialism and mores of contemporary Japanese society—seem to have been attracted to Aum because it provided answers at the limits of science and reason, advocated an ascetic technology for the acquisition of supernatural powers, and was headed by a charismatic leader whose most extreme teachings still retained an impressive internal logic.[34]

To attract new followers and to inspire current members, Aum established its MAT studio, where several quite talented amateur artists worked to produce propagandistic manga and anime.[35] MAT created both at relatively high volume considering its small staff.[36] Manga enthusiast Frederik Schodt points with considerable suspicion to Aum's doctrinal eclecticism as well as its use of manga as part of its success in gaining so many converts, writing,

> One secret of the cult's success . . . was its ability to package its twisted message in an attractive fashion. The teachings are a blend of Hinduism and tantric Buddhism, and—other than the fact that they encouraged blind obedience to a nearly blind guru with apocalyptic visions who is paranoid and psychotic—fairly innocuous. Anime and manga—because they are so popular, because they can be used to dramatize and exaggerate information

and simplify a complex reality, and because they were often rendered in a cute, "fashionable" style—were the perfect vehicle for the cult to proselytize. . . . It is hard to imagine a more sinister abuse of the manga medium.[37]

According to a former member of MAT, however, the doctrinal demands of Aum's leadership often inhibited the artists' ability to make anime or manga that was enjoyable to watch or read.[38] Because the group had such a reclusive mindset, inspiration drawn from outside sources was treated with suspicion; the entirety of Aum's manga was supposed to be drawn directly from Asahara's teachings and treated as scripture.[39] Therefore, the illustrators and animators had little freedom in adding new or exciting elements to the stories, which suffered considerably as a result. This led to some internal dissension. The former head of MAT complained of his strained relationship with Matsumoto Tomoko (Asahara's wife), who apparently repeatedly made unreasonable demands of the manga and anime staff.[40] Despite these tensions, MAT successfully produced several manga and anime, although it is difficult to assess today how popular they actually were at the time. They are now extremely difficult to find, and bookstores refuse to carry them for obvious reasons. Nevertheless, while in Tokyo I managed to track down copies of two volumes of Aum manga.

Metsubō no hi is a manga attributed to Asahara and illustrated by an artist using the sobriquet "The Star of David." It relates Asahara's predictions about the end of the world, trumpeting on its cover, "Asahara Shōkō opens the seal on John's Book of Revelation!!"[41] The story features a flatteringly drawn Asahara putting the Book of Revelation into the context of the late twentieth century, tying in the Biblical message of revelation with his budding messianic aspirations. The manga predicts a cataclysmic series of events accompanied by world war; Asahara's theories regarding Islam, the United States, and various other religious and secular forces as contributing to the coming confrontation also feature prominently. Other characters serve as foils for Asahara, asking innocent (leading) questions and becoming increasingly concerned, then convinced that they must join Asahara in saving as much of the world as possible through proselytizing efforts. The manga ends with a direct plea to readers to join Asahara and Aum:

My plan for salvation unfortunately falls a fraction behind each year. This is because my elite [*yūshū na*] disciples from previous lives are still fixated [*shūchaku*] upon the present world and have not yet realized the mission for which they were born. Without delay they should recognize that this

world is illusion [*gen'ei*, glossed as *māya*] and gather under me (one of those very same elite disciples may be you, even as you are reading this now).

 If all of them could gather and combine their strength, I'm sure that the delay in salvation up until now could be recovered. I want them to come to me quickly; I want them to lend their strength to my salvation movement. After all, more than anything else their mission is salvation.[42]

In another Aum manga called *Spirit Jump*, ordinary people find their lives drastically changed and improved by their meetings with a flatteringly drawn Asahara and the teachings of Aum.[43] The title page of the first volume emphasizes Aum members' acquisition of supernatural powers, stating, "You can experience it too!" Below, a note says, "Both of these stories are nonfiction." The back pages include contact information for the group, including a list of Aum centers throughout Japan. Frederik Schodt describes these manga as follows: "I was most impressed by *Spirit Jump*, a three-volume set of paperback manga filled with true stories of how various disciples had become disillusioned with their humdrum, spiritually empty lives in modern Japan, joined the cult, and found happiness. The stories are rendered in a variety of styles. . . . All are remarkably high in quality."[44]

 Despite this relatively positive appraisal of the quality of Aum's manga, Schodt's description overall is laden with disparaging comments regarding the group and its members (note his use of "cult" in the pejorative sense). The most "twisted" or "paranoid and psychotic" elements of Asahara's teachings were not intended for the uninitiated and never made it into public until after the sarin gas attack in 1995. Aum's message in its manga was largely focused on salvation activities and conversion stories. After all, the group's purpose in creating manga was to attract new adherents, not to scare them away. Once people entered the group, the promise of access to higher levels of esoteric information provided the impetus for diligent ascetic practice and the willingness to participate in initiation rituals that included extreme practices such as taking hallucinogenic drugs, drinking Asahara's bodily fluids, or being buried alive to test one's aptitude at physiological control. Schodt's assessment, written immediately after the sarin attacks when anti-"cult" sentiment was at a fever pitch, shows how discourse about religion within Japan become increasingly characterized by negative impressions of marginal religions and their adherents.[45] Since the sarin attack, Aum has frequently been the model for depictions of "dangerous cults" within entertainment media, including manga and other fictional literature.[46]

Manga That Have Drawn on Aum Shinrikyō

After Aum's terrorism became widely publicized, manga came to provide easily accessible and rational—yet sensational and entertaining—explanations for the behavior of ostensibly dangerous religious groups. These products have responded to an obvious interest in "cults" (*karuto*) evident in the mass media frenzy that followed the terrorist attacks.[47] The manga I discuss below relate somewhat accurate information about marginal religious movements in an explanatory fashion even as they rely on the aesthetic thrill of religions as a source of terror and social malaise.

Some of these manga treat "cults" as fiendishly designed groups based on leaders' thirst for power and use of mind control techniques. Others focus on the epistemology and psychology of believers and founders, trying to make sense of the ways these people decide to separate from traditional religions or secede from secular society. A third type criticizes religious institutions and their founders for preying on people's weaknesses even as they settle on an epic narrative structure wherein protagonists with supernatural powers are confronted with apocalyptic crises and work to save the world from destruction.[48] I present an example of each type below, focusing in particular on the third type through a detailed examination of Urasawa Naoki's popular manga *20th Century Boys*.

FRAUD, SEXUAL PERVERSION, AND BRAINWASHING IN *CHARISMA*

Charisma is a manga rendition of a work by thriller novelist Shindō Fuyuki.[49] Serialized in the relatively minor magazine *Action*, *Charisma* uses the well-worn models of brainwashing, intimidation, fraud, sexual misconduct, and violence in its portrayal of "cults." Marketed for its sensational value and horrific content, the promotional bands affixed to the covers of the different volumes trumpet phrases like, "What would YOU do if the woman you love was stolen by a CULT religion?" and "A CULT RELIGION destroyed a happy family!"[50]

At the beginning of the story, Heihachirō worries as his mother becomes increasingly estranged and divorced from reality due to her involvement in a "cult" led by the mysterious leader "Messiah." Heihachirō's father attempts an intervention with his mother, but she goes berserk and stabs him multiple times in the chest with a knife, then rips out his internal organs looking for the "demon" she is sure has possessed him. She then strips off her soiled

clothes. Standing naked in front of Heihachirō, she stabs herself in the groin, pulling the knife up through her abdomen and telling her son, with her last breath, to find the demon in her. After undergoing some cruel ostracism after this embarrassing familial murder-suicide, Heihachirō eventually resolves to become a "cult" leader himself in order to enact revenge on the society that created the "Messiah" and his tormentors.

Under his new identity as leader of the "Village of God" (Kami no Sato; Heihachirō adopts the religious name Shingō Hōsen), Heihachirō uses his group to extort money from his followers while sexually abusing his female disciples, setting up exorbitant lecture fees for self-help seminars and retreats that turn into indoctrination and mind control sessions. As Asahara's followers did in Aum, Shingō/Heihachirō's followers repeatedly listen to tapes of his sermons or mantras. As was the case with Aum, elite members quietly murder followers who question the leader's motives or who attempt to secede from the group. Although believers are instructed to live an austere and ascetic lifestyle, the guru keeps a private room where he drinks alcohol, eats meat, keeps animal hides, and collects pornography.[51] He also maintains a system of surveillance cameras for watching his disciples, using them primarily to determine which of the women he will select for "special ceremonies."

Early in the story we meet Mami, a young woman who is engaged to a promising young bachelor. Mami's life is going very well except for the fact that her mother is deathly ill. Desperate to help her mother in some way, Mami turns to the Village of God for guidance. Soon after she has joined, Heihachirō picks her out from among his disciples for an emergency exorcism—Mami is led to a private soundproofed chamber where she is instructed to undress and is blindfolded. Heihachirō has his way with the young woman sexually, convincing her that the ritual is necessary for purifying her and saving her mother. Mami becomes completely enslaved to him thanks to his mind control techniques, so much so that when her fiancé comes looking for her out of concern she hides behind Heihachirō's bulk while the leader grins at the crestfallen would-be groom and says, "She's not brainwashed . . . but she just may have become prisoner to my penis!"[52]

Heihachirō eventually meets a young housewife, Reiko, who reminds him so much of his deceased mother that he will go to all costs to keep her as a maternal figure and sexual partner. He murders his high-ranking disciple and former sexual partner (feeding her corpse to a snake to dispose of it) and attempts to separate the new woman from her family, effectively doing the same to her as was done to his own mother. He goes to extra

efforts to have her participate in "seminars" and "retreats," playing on her desire to be a better parent so that her son will perform well in school. At first his efforts are successful, and Reiko is completely brainwashed—she accepts him as "Messiah" and fawns over him, prancing about in the nude to his delight.

However, due to the unexpected intervention of another "cult" leader masquerading as a "cult victims' counselor," Heihachirō loses his credibility with his disciples and is exposed as a fraud. The rival is none other than the man who had brainwashed his own mother years before, and a final show-down between the two over Reiko ensues. Although the story ends with the triumphant restoration of the woman to her family and to secular society, like any good thriller, *Charisma* ends with the promise of the return of one of these fiendish charlatans.

Charisma focuses on sensationalizing the character of the fraudulent and salacious leader, following the pattern often seen in mass media portrayals of Aum leader Asahara Shōkō, and the adult Heihachirō looks suspiciously similar to Asahara (although the fictional guru is bald).[53] Ordinary people join the group because of real-world problems or concerns such as curing a relative's illness or performing well in school. Within the group, however, the avaricious and concupiscent leader shrewdly uses the group as a means for advancing his worldly ends while subjecting his followers to brainwashing, entirely reshaping their values. This fundamental change in values, combined with the use of esoteric and euphemistic language, leads to an ability to rationalize extortion and murder—extortion becomes "donation" or "seminar fee" and murder becomes "enlightenment" or "release."[54]

Rhetorically, *Charisma* is vehemently secularist, serving as a warning to people to avoid religion in general. Through the cases of the two women who succumb to the group, *Charisma* humanizes the ordinary people who are lured into "cults" while demonizing charlatan leaders. However, focusing exclusively on the activities of "cult" leaders neglects conferring equal responsibility on the audiences who support them.[55] *Charisma* places an inordinate amount of attention on the fiendish guru, while the adherents other than the two women discussed above form a bland backdrop of forgettable people. The resulting overall impression is that "cult" members lack individuality and autonomy; they are slavish and gullible victims of manipulative swindlers. While it does provide some useful information about how groups like Aum function (the use of euphemistic language for murder, for example) *Charisma*'s overall analysis is rather simplistic.

SECESSIONIST WORLDVIEWS: *BELIEVERS*

Yamamoto Naoki is a *mangaka* known for his explorations of human desire and group mentality. His work has a strong erotic element but also includes social commentary through examinations of group behavior. *Believers*, which was serialized in the major manga publication *Big Comics Spirits*, uses a psychologically and sexually tense narrative to provide commentary on what draws people to "cults," delving deeply into the epistemology and motivations of the believers themselves.[56] The manga portrays the worldview of the group by introducing various nonsensical words that stand in as euphemistic substitutes for other words (something common to all three manga presented here and significant in light of Aum's similar use of euphemistic language).

The story takes place on a small island off the mainland of Japan. Two young men and a young woman who share a strong critique of consumerist society battle with their libidos, with their desires for the comforts of mainland civilization, and with growing confusion and doubt regarding the intentions of their "Teacher." Additionally, as they engage in daily meditation practices and attempts to develop their supposedly inherent supernatural abilities, they all gradually succumb to an inability to distinguish hallucination from reality.

The three rely on nighttime shipments of supplies from the mainland, but when the shipments become sporadic they are forced to forage for food. As they adjust to this subsistence lifestyle, the believers attempt to develop their telekinetic abilities and telepathy through assignments sent to them via email from headquarters. They engage in daily meditation in which they sit with their legs spread, placing the soles of their feet against those of the other believers. They also engage in severe ascetic practices such as being buried up to the neck without food or water for an entire day in order to purify themselves after committing some sort of transgression. Transgressions can include those committed in dreams, and the believers carefully monitor and share their dream experiences for hints of abnormal or unacceptable attitudes and behavior, especially lust.

The story spirals out of control when a group of inebriated young people lands on the island. The partiers cannot understand the ascetic attitudes of the believers, who in turn see the mainlanders as depraved, especially when one of them makes sexual advances towards the female member (Vice Chairperson) of their small community. With no apparent peaceful alternative, the two men murder the mainlanders. Shortly afterward, perhaps spurred by

the intensity of this experience, the woman and one of the men (Operator) succumb to sexual temptation despite their vows of celibacy. Also burdened with a vow of absolute honesty, the two guiltily confess only part of their deed to the other man (Chairperson). His jealousy and anger lead to the final disintegration of their small community. Ultimately, none of the three can resist sexual temptation, especially given the pressure provided by their limited environment and the lack of supplies or communication from headquarters. The initial couple makes increasingly frequent trysts in hidden spots on the island, and Chairperson decides that he can only be cured of his sexual desire by confronting it head-on—he forces Vice Chairperson to fellate him in front of the other man as punishment.

Chairperson is slowly losing his grip on reality. After several days of hallucinations brought on by strange foods provided from headquarters, he rambles on incessantly about a space opera he is in the process of writing. The others recognize that he is caught up entirely in a fictive universe and growing mentally unstable. In order to resist his repeated demands for sexual satisfaction from Vice Chairperson, they fight against him, eventually dispatching him to the mainland and creating an island paradise for two. Effectively seceding both from mainland society and, through relaxing their vows, from their religious group, the two become increasingly confused as their own ability to separate reality from hallucination grows weaker.

Yamamoto's manga is notoriously erotic, and *Believers* is no exception. While the story relies on some accurate information regarding secessionist religions, it also uses the highly effective narrative technique of sexual titillation to move the plot forward. The passionate time spent by the two lovers draws attention away from their religious affiliation, except for the fact that throughout their dialogue and shared experiences they struggle to reconcile the teachings of their group, the Niko Niko Jinsei Sentā (Smiley Life Center) with their very human desires. The fantastic quality of their time alone on the island is punctuated by their hallucinations—family members appear and plead with them to return to their former lives, the corpses of the murdered intruders haunt their memories.

In the final scenes, a huge group of believers arrives from the mainland seeking refuge from secular antagonists. The leader distributes glasses of a mysterious liquid to his seated followers (reminiscent of the 1978 Peoples Temple group suicide) while guards with automatic weapons stand by, saying that anybody who moves will be shot on suspicion of sedition. The leader promises that by drinking the liquid all of his faithful will be able to leave the polluted present world behind and go to "the land of peace."[57] Just then, mili-

tary teams arrive in helicopters from the mainland, the woman disappears, and Operator is captured in the ensuing battle with the authorities.

In prison, still unable to distinguish dream from reality, Operator escapes into a daydream world where his missing lover still waits for him. Meanwhile, authorities investigating the group trace its origins back to a computer game. The believers, drawn together through a common critique of secular society and a strong desire to escape the consumer lifestyle, had originally banded together through the electronic media they shared.

Many critics have isolated geek (*otaku*) culture as the source of attraction to Aum and similar groups.[58] Tracing the source of the religion to a video game undoubtedly strikes a strange chord with the manga audience, since manga and video games are equated with geek culture in the popular imagination. These themes also resonate with Aum's membership, who were bound together through a shared interest in occult literature, a dissatisfaction with contemporary society and a corresponding desire to replace the bad "data" of that society with something more "real"—namely, a search for the "true self" and a desire to master the powers they perceived to be working at the limits of scientific explanation.[59] Aum also developed an internal hierarchy that evidently appealed to its young membership, and the characters in Yamamoto's work abandon their secular names in favor of their rank titles much as Aum members took initiation names. Aum used euphemistic language to refer to murder and to secular society, just as the believers do. While the argument that geek culture breeds the tendency to become initiated in groups like Aum is not entirely compelling or convincing on its own, *Believers* stands out as a well-researched, if sensational, exploration of some of the connections between young people's dissatisfaction with secular society and isolationist religious groups.

A Twenty-first-Century Epic: *20th Century Boys*

Post-Aum manga have used information about religion in an aesthetic fashion (the horrific potential of "cults") while providing a sort of education about marginal movements' structure and organization, including thinly veiled references to Aum, the Peoples Temple, and similar groups notorious for their violence. Among the various post-Aum manga, some works also mobilize an epic narrative framework, featuring heroes with supernatural abilities who save the world from apocalyptic destruction while rationally explaining "cults" and the patterns of human behavior that give rise to them.

As one example, Urasawa Naoki's work *20th Century Boys* (*Nijū seiki shōnen*; the final two volumes are entitled *21st Century Boys*) uses a two-tiered aesthetics regarding religion: it both criticizes "cults" and their violent behavior and celebrates its protagonists as flawed—but estimable and miracle-working—heroes.[60] *20th Century Boys* therefore has an overall narrative structure similar to epic literature, with the redemptive activities of righteous and just superhuman protagonists set against an apocalyptic backdrop. Urasawa's work represents an important aspect of post-Aum attitudes towards religion, presenting an inspirational story that fuses a sharp critique of cults with a modern-day epic that includes cultic veneration of its fictive miracle-working protagonists. This is particularly significant since Urasawa is one of the most lauded *mangaka* in contemporary Japan; his work has received considerable attention due to its commercial success, which derives from its powerful imagery and content.[61]

Like *Believers*, *20th Century Boys* was serialized in the widely read *Big Comics* magazine, *Spirits*, and on completion ran to nearly five thousand pages in twenty-four volumes. The series is immensely popular throughout Japan, has won prestigious manga awards, and has been turned into a three-part live-action film. It boasts a convoluted and intriguing plot, an element of foreboding associated with a mysterious evil genius, and irrepressibly likeable protagonists.

In the story, the villain, known only as Tomodachi (Friend), starts a "cult" with a clearly stated purpose of world domination. Tomodachi's identity remains in doubt throughout most of the series (he always wears a mask), although it is clear that he is a childhood acquaintance of the protagonists. Through his organization, Tomodachi effects psychological, physical, and political control of Japan and eventually the entire planet.

Ironically, this evil organization was actually dreamed up by the protagonist Kenji in a childhood fantasy. In the summer of 1969, Kenji and his friends, influenced by the apocalyptic themes they find in manga and films, dream of their adult selves as superheroes who save the world from imminent destruction. The friends create a logo for their group of heroes and while away summer afternoons in their secret hideout dreaming up horrific catastrophes that might demand their heroic intervention. Giant robots equipped with lasers and biological weapons, a deadly virus that wipes out huge parts of the world's population, flying saucers spreading panic—these are the fantasies of the childhood friends.

For the boys, rock and roll and love and peace (symbolized by the 1969 Woodstock music festival), and the power of science (evidenced in the 1969

moon landing and the various exhibits at the 1970 Osaka World Exposition) are the quintessence of the twentieth century. They envision their future selves living in a futuristic world filled with technological wonders and powered by a hard-driving rock and roll soundtrack. Yet as they grow older they forget about their passion for peace and justice. Kenji pursues a dead-end career as a rock musician, Occho becomes a selfish workaholic who suffers a breakdown when his son dies, Yoshitsune is a timid yes-man with no ambition, and the other men in their group of childhood friends are similarly washed up and resigned to the monotony of daily life.

The story actually begins in 1997, with Kenji working a miserable job as the manager of a convenience store, responsible for the upbringing of his niece (abandoned by his older sister), and harried by the franchise parent corporation. Within this endless daily grind, Kenji gets word of the mysterious and uncharacteristic suicide of a childhood friend, Donkey. As Kenji attempts to pursue the mystery of Donkey's death, he runs into the logo of the heroic organization from his childhood fantasies. Soon he discovers that a secret organization called the "Tomodachi" (Friends) or "Tomodachikai" (Friends' Society) is using the mark as its logo. The villain and leader of the group, Tomodachi, is clearly a figure from Kenji's childhood. He knows details about Kenji's past, and claims to be the father of Kenji's niece.

Tomodachi, appropriating Kenji's childhood plot, creates a real evil organization to fight against Kenji and his friends, expropriating the logo they had created for their group of futuristic heroes. Through contacts in the police department and political suasion, the influential Tomodachi uses the media to turn Kenji and his group into a mob of terrorists. The heroes retreat to lives underground, sharing abandoned subway tunnels with the city's homeless. Tomodachi threatens the world with extinction by releasing dangerous biological weapons on New Year's Eve 2000, and Kenji and the other childhood friends, having abandoned their careers and all semblance of ordinary life, take a stand against him. The last scene before a major temporal transition is the seven of them striding purposefully toward the giant robot (modeled on Kenji's childhood drawings) that is spraying a virulent and instantly deadly virus throughout Tokyo. Later it becomes clear that the Friends would blame Kenji and the other men and women for the robotic terrorism. Through its shrewdly timed provision of vaccine for the citizens of Tokyo and some clandestine political machinations, the Friends organization is able to secure political control of Japan.

Fast-forward to the year 2014. Kanna, Kenji's niece, is working as a delivery person for a Chinese restaurant in a dangerous section of the city

(Kabukichō). Teenaged Kanna is clearly exceptional. She speaks Thai and Chinese, displays extraordinary charisma (in one of her first appearances as a teen she fearlessly steps between flying bullets and chastises rival gang members in their respective languages, putting an end to the fight), and also has preternatural luck; later we discover that Kanna actually has telekinetic abilities and an unusual degree of empathy. The world in which Kanna lives is one mainly run by the Friends, now also a powerful political party backed by the religious organization (the Yūmintō, or "Friends Party").

Kanna uncovers a Tomodachikai plot to assassinate the Pope during his visit to Tokyo, and she and the other protagonists rush to stop it. In the days before the papal visit, Tomodachi himself is apparently killed, causing the world to mourn the loss of its powerful and popular de facto leader. As the Pope addresses crowds facing the decorated corpse of the deceased cult leader turned politician, Tomodachi, in a masterful sleight-of-hand, rises from his bed of flowers and steps in to save the Pope by taking a bullet (fired by one of the Friends faithful) in his stead. Although it is not clear until later how he managed this miraculous resurrection, with it the role of Tomodachi as religious and political leader of the world is secured; the day marks the end of the Western calendar and the beginning of the "Tomodachi Era."

Yet Tomodachi's vengeful plot is not finished, and Kenji and the other protagonists are not dead. Tomodachi again threatens the world with extinction, this time with another virus spread throughout the world, killing many. Yet because the Friends' Party has shrewdly provided a portion of the world population with a vaccine for the deadly virus, it now controls the entire world through fear, propaganda, and careful policing. In this sense, Urasawa's work moves far beyond the other works described in this chapter, since it presents the kind of utopia (dystopia?) a marginal religion would make, given the resources and opportunity to do so.

Kanna survives as the leader of an underground resistance movement, and occasionally has contact with her "uncles"—Kenji's childhood friends. Meanwhile, Kenji himself, presumed dead for years, returns from the outskirts of Japan on a motorcycle with only a guitar and apparently no memory. Meanwhile, other characters revisit the childhood memories of Kenji and the other boys through flashbacks and virtual reality simulations. Between these virtual trips to the past and the inexorably developing future, Urasawa's narrative describes not just the potential for religious groups to use violence (such as Aum) or to seek political power (as in the case of Aum, and of Sōka Gakkai through the political party Kōmeitō), but also the potential for human beings to become cowed by fear or buoyed by feelings of cohesion. The

world that Tomodachi develops reflects his childhood inferiority complex as well as the human tendency to band together under strong leadership, even if it is false or evil.

People in the glorious future Tomodachi has provided for them live in ramshackle housing in constant fear of overzealous police and alien invasions. Meanwhile, Tomodachi, fanatic about the promise of future technology found in his beloved manga from childhood, spends considerable amounts of energy on developing laser guns, flying saucers, and photon bombs. In this way Urasawa also plays on the tendency of groups like Aum to occupy spaces rooted in fiction as much as in reality, tracing problems to geek culture in his own way.

Urasawa's work maintains the "evil cult" theme by presenting a religion as the cause of the impending apocalypse (on three separate occasions), but also relies on the model of a small group of protagonists equipped with supernatural powers saving the world. Over the course of the story many of these protagonists display some sort of superhuman quality. They are variously clairvoyant, telekinetic, equipped with supernatural strength or charisma, or even resurrected from the dead.

In contrast to these heroes, although Tomodachi does seem to display supernatural powers, time and again his abilities are revealed as nothing more than a sham, further emphasizing suspicion regarding "religion" and rhetorically reinforcing the true abilities of the protagonists. As one example, in a flashback scene one character describes helping another follower winch Tomodachi up so that it appears he is floating. A simple ruse to promote faith among credulous followers early in Tomodachi's career as a religious leader, the character realizes the true power of Tomodachi's illusion when the other assistant, holding the rope that anchors the floating man, looks up and says, "He really *is* floating!" Urasawa is therefore able to both criticize "cults" as manipulative organizations and simultaneously to celebrate the use of supernatural powers in extreme situations. This latter element gives his work an epic narrative structure, especially in light of Tomodachi's persecution of the protagonists, which lends an added urgency to the righteousness of their mission.

KANNA

The character that displays the greatest collection of powers is Kanna, a young woman who wields an intense charisma capable of binding warring groups together and forging immediate connections with people in desper-

ate times. She can bend spoons telekinetically and also can destroy objects at will in extreme situations.[62] In addition to these supernatural powers, she has an unusual ability to dodge bullets, she has incredible athletic reflexes, and she always wins at games of chance. As the Ice Queen (the leader of an underground resistance movement), Kanna is not just obeyed, but also treated with respect bordering on reverence. Many of her followers (largely drawn from among the homeless, gangsters, and other fringe elements of society) would die for her without hesitation. In short, due to the combination of her exceptional charisma, supernatural abilities, and dedication to her cause, Kanna takes on a role similar to that of a religious leader.

KENJI

In part, Kanna's authority is derived from her uncle Kenji, the leader of the group of boys in childhood. Kenji's disappearance after facing the giant marauding robot at the turn of the century leads to his martyrdom among the resistance, and his return late in the narrative functions as a kind of "resurrection." It is Kenji's commitment to justice that serves as continual moral inspiration for Kanna and the other protagonists. Kenji's music serves also as a point of communion for the underground, and eventually one of his songs becomes a hymn of liberation. When groups of citizens finally decide to stand up and resist the Friends regime, Kenji's music, broadcast from speakers in homes throughout Tokyo, gives them strength. Like the boys' childhood visions of Woodstock—the themes of love and peace pursued through rock and roll and crowds of people unhindered by fences or boundaries—the people gathered in Tokyo for Kenji's triumphant return abandon fear of authority and gather for the sake of the music, both mournful and uplifting, that Kenji has written.[63]

THE RESISTANCE COMMUNITY

Gathered around Kanna and Kenji are a group of individuals who all have sworn to end Tomodachi's reign and return peace to the world. In his absence, Kenji's presence is felt through the mythology surrounding his brave attempt to stop the marauding robot at the turn of the twenty-first century. Although due to the influence of the Friends he has been vilified in the media as a terrorist responsible for the death and destruction, to the resistance community he is hailed as a martyr. Kanna serves as de facto leader in Kenji's absence, and here her charisma allows her to act as a political and religious

figurehead whose followers will offer their lives on her behalf if she asks. Kenji's music acts as a hymn for the group, and they all sing the wordless refrain as a way of encouraging themselves in adverse situations. A homeless clairvoyant man who is called Kamisama (a Japanese word of reverence for deities or spirits) joins the fight against the Friends by giving prophecies to the protagonists, thus becoming a central figure among Kanna's followers. In short, the resistance movement, due to a combination of the persecution it suffers under Tomodachi's government, the mythology surrounding Kenji's martyrdom, Kanna's charismatic leadership and telekinetic abilities, and Kamisama's prophecies, takes on the character of a religious organization.

Considering the fact that its members are persecuted and reviled by the wider society in the postapocalyptic world managed by the Friends, and considering the fact that it does resort to violence for the sake of peace and justice, within the frame of the story the group of protagonists can be considered a marginal religious and political group devoted to Kenji's memory and headed by Kanna. Within the group, the epic story of Kenji's heroism, the power of Kanna's charisma, the appeal of Kenji's music, and the fervent commitment to the cause displayed by all of the members act as markers of the group's religiosity. Yet because these characters are the protagonists of the story (and thus necessarily righteous), the audience perceives them not as shady "cult" members but rather as unjustly persecuted heroes. The cult (veneration) of Kanna and Kenji is thus not immediately nor explicitly equated with the violent and aberrant "cult" that serves as a foil for their heroism (the Friends).

IMPROVISED NARRATIVE DEVICES AND TERRORIST PLOTS

20th Century Boys thus takes on an epic dimension. The extremism of the plot elements (apocalypse, indiscriminate terrorism, fervent devotion to a cause by both Friends and the protagonists' resistance movement) is precisely the appeal of the story. Furthermore, the proliferation of speculative exegesis surrounding the most mysterious elements of the story (namely, the actual identity of Tomodachi) on fan message boards also places it in the third usage of cult given above.[64] *20th Century Boys*, while immensely popular, has become a something of a "cult classic." As such, the manga speaks to something its audience craves, and I argue that it is both an explanation of how cults like Aum come to be and a narrative characterized by an extreme plot (righteous heroes staving off the destruction of the world) that the audience desires.

Urasawa and his fans would no doubt downplay or deny the possibility of the manga having a religious dimension or serving a religious function. However, it seems that Urasawa's narrative techniques have contributed to the story's mythic and epic qualities. That is, if myth can be defined as a story that uses fiction to tell the truth about a natural or social phenomenon, and if an epic often involves exceedingly tenacious heroes endowed with supernatural abilities acting bravely despite seemingly insurmountable challenges, then *20th Century Boys* is a contemporary myth that seeks to explain, through fiction, the existence of "cults" and religious terrorism while simultaneously mobilizing the inspirational quality of an epic.

Urasawa's story therefore harbors intriguing implications regarding the human attraction to religion that nuance the simplistic image of the delusional "evil cult" and its sane, secular victims. His protagonists, desperate to save the world as they see fit, are turned into terrorists by the forces arrayed against them. In the dystopia created by the Friends, they are treated as villains and radical fringe elements of society. They collect weapons, organize subversive movements, and resort to violence on many occasions. They act to save the world by whatever means necessary for the sake of their perception of peace and justice. Urasawa has deftly placed his protagonists into the double role of religious heroes and terrorist martyrs, and their cause is one with which the audience necessarily identifies. In the early twenty-first century, which has already been characterized by so much religious violence, Urasawa's work hits home as both a celebration and condemnation of humanity's tendency towards religious extremism and the ideal of fighting for justice, however it might be perceived.

My request for an interview with Urasawa received no response, so unfortunately I cannot directly share his thoughts on this particular work. Urasawa speaks primarily through his work, not about it, and I can only hypothesize about his underlying motivations as follows. First, it seems clear that the Aum Shinrikyō incident served as a model for part of Urasawa's narrative.[65] I also speculate that another major point in contemporary religious history—the attacks on the United States on 11 September 2001 and the continuing aftereffects that have embroiled multiple countries and their citizens in wars on terror and continuing acts of indiscriminate terrorism—also contributed to Urasawa's depictions of the future world run by the Tomodachikai. Urasawa *has* publicly expressed frustration that fans have focused more on the mystery of Tomodachi's identity than on the point of his story, and I further surmise that Urasawa's frustration lies in his hope that his readership might pay attention to the tension created in the story by the

very anonymity of the character.[66] Because Tomodachi could be anyone, he could just as easily represent *everyone*.

Urasawa's work thus undermines the common narrative tendency to use aberrant "cults" as foils for an apparently normal secular society. He draws his readers into the potentially disturbing recognition that their own attraction to Kenji, Kanna, and their cause (albeit fictional) may be frighteningly similar to the narratives created by groups like Aum Shinrikyō. On my reading, Urasawa equates people's attraction to "cults" with their attraction to participation in the extreme events of miracles, apocalypse, or redemption. As one of his characters states relatively late in the story, "It doesn't matter. To them, anything is fine . . . they just want something in which to believe!"[67]

Another telling exchange happens in the middle of the final volume, which is the second volume of *21st Century Boys*. Urasawa's thinly veiled self-referential characters, a group of *mangaka*, discuss how to finish the story on which they are working, perhaps reflecting Urasawa's own internal debates—or debates with his editors—about how to end the narrative:

Kamata: The protagonist saved the world from crisis!! After that, what do we do?

Ujiko: What do you think, Mr. Kamata?

Kamata: Hmmm . . . If it ends like this it's boring That's all I know.

Ujiko: What if the enemy reappeared once more?

Kaneko: Yeah, like the Terminator or Jason.

Kamata: OK, and then what finally happens to the hero?

Kaneko: Does he die?

Ujiko: I don't want to make him die.

[Pause]

Kaneko: Heroes, right They're heroes at the very instant that they win

Ujiko: That moment is the climax, but if they live then there's old age

Kamata: That's why the endings you often see in heroic stories are that the protagonist disappears off to somewhere, or . . . dies

Ujiko: It makes me sad to think that way[68]

Although Tomodachi is defeated as the story winds to a close, a final nefarious trap is revealed. A photon bomb capable of destroying the world lies hidden someplace in Tokyo, and the giant robot (guided by one of the Tomo-

dachi faithful) reappears as the trigger for the bomb. Kenji again heroically intervenes, and significantly this is juxtaposed with Urasawa's thinly veiled reflexive explorations of what makes a good denouement (as in the exchange above). I suggest that Urasawa's decision to finish the story with Kenji's heroic intervention to save the world from Tomodachi's final posthumous trap was based on his (perhaps reluctant) acceptance of the fact that the audience desired an epic ending characterized by the aesthetics of extremity.

Finally—and again this is speculative—Urasawa may have decided that this seemingly heroic ending would actually be nearly horrific, for the veneration accorded to Kenji and Kanna and their group has merely replaced, not obliterated, the need (in their fictional world or in ours) for something or someone in which to believe, even at the expense of reason or the adoption of violence. In other words, just as stories in the horror genre nearly always conclude with the return or revival of the fiendish antagonist (the Terminator or Jason, in the exchange above, and obviously in Tomodachi's posthumous trap), in Urasawa's work the superficial triumph of Kenji and Kanna may actually indicate the "return" or reappearance of horrific and violent tendencies in his audience, the very tendencies represented by the extremity of the Tomodachikai and its terror.

Denouement

The three post-Aum manga briefly presented here exist on a spectrum in terms of their conclusions about "cults," "cult" leaders, and "cult" adherents. *Charisma* simply depicts "cults" as the product of conniving and lascivious leaders' quests for power. As such, it does little to explain the complex connections between leaders and followers, except to explain these connections away with the concept of brainwashing. Yamamoto Naoki makes a stronger case in *Believers* by tying the believers' motivations for joining the group back to the everyday medium of video games. In the manga format, this explanation is rhetorically effective because in the popular imagination manga and video games form intersecting aspects of geek subculture, which has in turn often been blamed for the rise of groups like Aum. *Believers* also positively benefits from the erotic elements of its story (also apparent in *Charisma* but absent in *20th Century Boys*), both because many marginal religions are imagined to promote unorthodox sexual arrangements and because their leaders are often suspected of sexually abusing their disciples.

Yet, among these, *20th Century Boys* is the most nuanced and perhaps the most disturbing. Urasawa manages to make heroes out of terrorists, turning his protagonists into messiahs and martyrs who fight against an oppressive regime (the world created by the "evil cult"). The story is ultimately a relativization of values: even as violent "cults" are criticized, the inherent moral integrity and supernatural abilities—in short, the religious nature—of the protagonists is valorized, and their ability to wield violence for the sake of justice celebrated.

Manga and anime provide a window into the complex and shifting relationships between secularism, religiosity, and entertainment that influence contemporary attitudes towards religious practice and affiliation in Japan. Works like *Akira* and *Nausicaä* that elaborated on the themes of apocalypse, messianic figures, and the use of supernatural powers clearly influenced the membership of Aum Shinrikyō. Aum's own production of manga and anime in order to proselytize reflects the group's recognition of these media as effective tools in disseminating religious content. Additionally, some manga produced after Aum's terrorist activities became widely publicized have played on the model that Aum has come to represent, attempting—with varying degrees of success—to explain the attractiveness of "cults" and their internal workings (mind control, the use of euphemistic language, secession from secular society). Finally, commercially successful, award-winning manga like *20th Century Boys* seem to reflect both a critique of religion and a revalidation of the concept of a small group of people armed with supernatural powers working to save the world, taking on an epic narrative structure and a tone similar to religious stories designed to inspire and instruct.

Although Urasawa may not have a specific religious message to transmit, his work provides readers with a sobering look at humanity's inclination towards religion. He subtly emphasizes the fact that no matter how much we may criticize specific religious groups for their deception, their fraud, or their violence, we are still attracted to stories that present superhuman, righteous individuals and their unwavering efforts to save the world. The aesthetics of extremity is related to the thrill of narratives depicting religious violence, but it also provides the appeal for the heroism of characters like Kanna and Kenji. The cult of veneration surrounding these protagonists within the narrative is intimately related to the epic structure of the narrative itself.

Although the twenty-first century has thus far been plagued by religious terrorism, the attitudes towards religion that we can trace through this particular manga suggest that authors and audiences are filled with both opti-

mism and trepidation regarding the future of religions, secular societies, and their conflicts. The seemingly mutually exclusive categories of (evil) terrorist and (righteous) freedom fighter are really two sides of the same coin. Both represent human attraction to the pursuit of the highest ideals at all costs, adumbrating an aesthetic of extremity that is simultaneously awe inspiring and—truly—terrifying.

Manga and anime reflect the protean—and often conflicting—interests of the people who produce and consume them. Although they are often simply sources of profit for producers and diversion for audiences, they sometimes feature moving pictures and stories that may animate audiences, prompting the creation or perpetuation of religious frames of mind. The religious aspects of manga and anime culture are visible in the ways in which people visualize religious worlds, entertain religious ideas, and appropriate religious sites and concepts for novel purposes.

Creators of popular illustrated fiction re-create religion by depicting apparently religious themes—characters, settings, plots—in a variety of modes that reflect attitudes ranging from piety to playfulness. Some of these portrayals closely resemble traditional religious stories and iconography. Some stretch the limits of plausibility in their irreverent depictions of formal religious doctrines, rituals, and ideals. Yet the adulteration of traditional religious vocabulary, imagery, and concepts does not necessarily imply religious degeneration or decline, nor does the deployment of religious imagery or vocabulary indicate formal commitment to any particular religion.

Audiences re-create religion in the interpretation and exegesis that accompany narrative and visual reception. In some cases, the verisimilitude of fictive worlds—regardless of their fidelity to formal religious cosmologies—is so entirely convincing that figments become facts and chimera incarnate. In their religious frames of mind, audiences imaginatively animate the characters that populate fictional universes, granting them vitality beyond the frames on the page and outside the layered cels that make up a scene. Jesus and the Buddha become the boys who live next door, tree spirits lurk in the forests on the island of Yakushima. Furthermore, through this imaginative compositing of fictive and empirical realities, audiences can be animated by stories in turn, prompted to ethical and ritual action. Fictional figures like Nausicaä become role models deserving emulation, and visiting Yasukuni Shrine becomes a moral imperative.

The field is rich and its subject matter fecund, leaving considerable latitude for future study. I encourage others to use manga and anime that I have not discussed—particularly products marketed primarily to girls and women—to examine other aspects of religious production and consumption that I may have overlooked or merely noted in passing. I also expect that future studies will necessarily include more emphasis on the material aspects of religious manga and anime culture, including the technical apparatuses used in the production of these products, the anime- and manga-derived paraphernalia such as *ema* and amulets (*omamori*) that are currently proliferating at formally religious institutions, and the toys that help fans get in touch with their favorite characters. There are also other embodied aspects of manga and anime culture that I have not addressed. These include the physical discipline of producing thousands of meticulously drawn images, the technical skill of punctiliously arranging the cels that comprise a single scene in an anime, the multisensory experience of attending fan conventions, the vicarious, votary, and dramatic qualities of cosplay masquerade, and the virtual and actual embodied experience of playing video games related to manga and anime.

Finally, studies of religion and religiosity do not necessitate the study of formal religions and their doctrines. Building on recent research into emergent religions, everyday religion, religious visual culture, and the authenticity of ostensibly ersatz religious practices, this book sketches a somewhat novel approach to these subfields within the study of religion but at the peripheries of studies of specific religious traditions. The methodological combination of history, ethnography, and formal analysis of narrative and image has served the purpose of taking a synchronic snapshot of contemporary Japanese religion (as seen through the viewfinder of manga and anime) while also providing a diachronic narrative of the development of illustrated vernacular religious media over time. Taking a page from its subject matter, this study has situated a static image—the state of contemporary Japanese vernacular religious media—within a larger narrative flow that gives an impression of movement, from its premodern precursors to—through the imaginative process of closure—its possible future iterations or manifestations.

PREFACE

1. *Hiragana* and *katakana* are the two phonetic syllabaries Japanese children learn before studying the Chinese characters known as *kanji*.

INTRODUCTION

1. Hardacre (2003).
2. On the Aum incident, see Reader (2000) and Hardacre (2007); for a more impressionistic account of the attack that includes extended interviews with members and victims, see Murakami (1999); for a reflection on the "cult" problem, see Sakurai (2006); for a documentary, see Mori Tatsuya (1998).
3. Gardner (2008); Hardacre (2007).
4. Shimazono (1995; 1997, esp. 70–88).
5. Inoue N. (1999); Miyadai (1998); Ohsawa (1996); Ōtsuka (2004).
6. Given the nature of the subject matter here, "novel" seems the best adjective to use for emergent groups that have recently legally incorporated as religious juridical persons. The inherently relative nature of the terms like "new religious movements" is problematic, but discussion of this issue will have to wait for another publication.
7. Foregoing works on this subject of religion in manga and anime include MacWilliams (2000, 2002), Masaki (2001, 2002), Pandey (2008), and Yamanaka (1996, 2008).
8. MacWilliams (2008a, 12–13, 25 n. 1); Schodt (1996, 19).
9. Steve Trautlein, cited in MacWilliams (2008a, 6).
10. Napier (2000, 20).
11. Ohba and Obata (2004–2006); Urasawa (2000–2007).
12. Anno (1995–1996); GAINAX and Sadamoto Yoshiyuki (1995–2007).
13. Levi (2006, 46–48).
14. Examples include Schodt (1996) and Napier (2000).
15. Berndt (2008).
16. On the subject of *otaku* apologetics, see Azuma (2009, 5). On manga aesthetics and composition, see M. Takahashi (2008). An older study of industrial tendencies is Kinsella (2000); for a more recent take, see Condry (2009).

17. Berndt (2008).
18. Prough (2011); Shamoon (2012); M. Takahashi (2008, 114).
19. For example, Yoshioka (2008).
20. Berndt (2008, 296–297); MacWilliams (2008a, 17–18).
21. Examples include Ito (2008), Poitras (2008), and Schodt (1996).
22. Azuma (2009, 11).
23. Berndt (2008); Lynch (2009); Marsh (2009); Thomas (2009).
24. For example, Tezuka Osamu states that several experts were displeased with the artistic license he took in his manga hagiography of the Buddha. See Tezuka Production (1994, 6). A number of scholars with whom I spoke also expressed misgivings about the misleading images of religion in both manga and anime.
25. For example, Inoue N. (2009, i).
26. For example, Yamanaka (2008).
27. For recent statistics on these trends, see Inoue N. (2006). A comprehensive article on the complex relationships between belief and practice in Japan is Yumiyama (1994). A recent article in English that compensates for some shortcomings in earlier statistical studies is Roemer (2009).
28. Dorman (2007).
29. On this problem, see Reader (1991, 6–7). See Roemer (2009) for suggestions on how to compensate for this problem.
30. Nancy Ammerman has outlined this problem in North Atlantic contexts. See Ammerman (2007b, 223–224).
31. See Reader (2005, 2007).
32. Dorman (2007); Hamada (2006a, 2006b); G. Tanabe (2004).
33. Inoue N. (2006).
34. Reader and Tanabe (1998, 4–8).
35. Ammerman (2007a, 5).
36. I am familiar with (and somewhat sympathetic to) the argument that the category of religion is not applicable to Japan, but I am not convinced that it is sustainable. A proper disquisition on this subject must await a later publication. In the meantime, I recommend Isomae (2003); see also the exchange between Timothy Fitzgerald and Ian Reader in the *Electronic Journal of Contemporary Japanese Studies* (Fitzgerald 2003, 2004a, 2004b; Reader 2004a, 2004b).
37. I draw here on Ian Reader and George Tanabe's distinction between "cognitive" and "affective" belief. See Reader and Tanabe (1998, 129–131).
38. Itō, Kashio, and Yumiyama (2004); Sakurai (2009); Shimazono (2004, 293–305, 2007a 2007b); Yumiyama (1994, esp. 106).
39. Shimazono (2004, 297); Yumiyama (1994, 110–115).
40. Shimazono (2004, 303).
41. Ammerman (2007b, 223–224).

42. Shimazono (2004, 299–300).
43. Kimbrough and Glassman (2009).
44. Ibid. (204–205).
45. Brent Plate has highlighted the dual meaning of this term in a recent book on religion and film. See Plate (2008, esp. 2–3, 8).
46. Inoue N. (1999, 115–217).
47. Nakamura H. (2008–2010).
48. Thomas (2007).
49. For another treatment of this term, see Hur (2000).
50. Ed Gilday has pointed out to me that the verb is used in a causative-honorific form (*asobaseru*) within imperial ritual to describe the ritual activities of the emperor.
51. Shinmura (1998).
52. The Japanese definition traces this connection between play and ritual: "*shinji ni tan o hasshi, sore ni tomonau ongaku, buyō ya yūraku nado o fukumu.*"
53. The Japanese text reads, "*nichijōteki na seikatsu kara shinshin o kaihō shi, bettenchi ni mi o yudaneru i.*"
54. Plate (2008, 8).
55. G. Tanabe (2007).
56. For an overview of methodological problems in the study of manga and anime in general, see Berndt (2008). For problems related specifically to the study of religious aspects of anime, see Thomas (2009).
57. NHK (2007). Urasawa is an avid reader of Tezuka's work, but there is no indication that his use of the phrase adumbrates the common epithet for Tezuka.
58. Berndt (2008, 296–297).
59. Marsh (2009, 255–262).
60. Ishii (1996).
61. Yamanaka (1996).
62. Berndt (2008, 301–305). Two studies that attempt to compensate for this tendency are M. Takahashi (2008) and Shamoon (2008).
63. Lamarre (2009, 14).
64. Morgan (2005).
65. Sharf and Sharf (2001).
66. Gimello (2004); Horton (2007, 2008); Kaminishi (2006); Ruch (2002); Sharf (2001b).
67. Horton (2007, 1–21).
68. Sharf (2001a).
69. G. Tanabe (1992, 4–6).
70. Plate (2008, esp. 78–91).
71. As one example of a Star Wars wedding, see Soodin (2009). On college Quidditch, see the website of the International Quidditch Association (http://

www.internationalquidditch.org/). Other examples of Harry Potter fans re-producing J. K. Rowling lore in reality can be found in the documentary film *We Are Wizards* (Koury 2007). For Heinlein's reflections on his treatment as a "guru" following the publication of *Stranger in a Strange Land* (1961), see Heinlein (1989, 272–273, 281). For information on the Church of All Worlds, see the group's website (http://www.caw.org/).

72. Shahar (1996).
73. Lutgendorf (2003).
74. Kimbrough (2008).
75. Allison (2006); MacWilliams (2008a, 9).
76. Lyden (2009); Martin and Oswalt (1995); Mitchell and Plate (2007); Plate (2003, 2008); Watkins (2008).
77. Lynch (2009).
78. Plate (2008, ix).
79. Marsh (2009).
80. For example, Lyden (2003); Lutgendorf (2003); Plate (2008, 78–91).
81. Lamarre (2009); Poitras (2008, 60–65).
82. Lamarre (2009, xxiii; 3–102).
83. Ibid. (xxiii–xxv).
84. MacWilliams (2000).
85. Plate (2008, 3).
86. See Imai (2009) on fan pilgrimage to sacred sites.
87. Ibid. (2–3).

CHAPTER 1: VISUALIZING RELIGION

1. Berndt (2008, esp. 305–309). One example of the attempt to trace themes in modern manga back to traditional Buddhist literature is Pandey (2008). The distinction between *kibyōshi* and manga is explored below.
2. For an overview of pictorial exposition worldwide, see Mair (1988).
3. W. Tanabe (1988, esp. 50–52).
4. Ruch (1992).
5. Kaminishi (2006, 54).
6. Ibid. (31–54).
7. Yamagishi (1994).
8. The *Jigoku zōshi* (*Hell Picture Scroll*) and other examples can be found on the website of the Tokyo National Museum (http://www.tnm.jp/modules/r_collection/index.php?controller=dtl&colid=A10942&t=type&id=11, n.d.).
9. Kaminishi (2006, 74–99).
10. Takahata (1994, scene at 1:16:10).
11. Ruch (2002).

12. Yonei (1999b).
13. Moerman (2005).
14. Collcutt (2009).
15. Kaminishi (2006, 31–54).
16. Horton (2007, 17).
17. Kaminishi (2006, 54). Kaminishi focuses on Buddhism in her book, but the Shintō tradition also demonstrates the use of image in explicating mythology and doctrine. On the culture of *etoki*, especially its practitioners and its content, see Ruch (2002). Ruch describes how the intended audience (women, for example) led to changes in *etoki* sermon content. Also see Ruch (1992). The specificity of audience needs applies to contemporary manga and anime as well; see Berndt (2008, 296–298).
18. Kaminishi (2006, 193).
19. For example, Pandey (2008); Takahata (1999).
20. For one example, see Ito (2008). For a critique, see the aforementioned Berndt essay in the same volume.
21. Kitahara (2005, 87–149).
22. Kaminishi (2006, 31–54).
23. Kern (2006, 35); also see Berry (2006).
24. Kern (2006, 8).
25. Ibid. (37–41).
26. Ibid. (10). As Nam-lin Hur (2000) has suggested, the brothel and temple cultures of Edo were, in some respects, two sides of the same coin.
27. Kern (2006, 112).
28. Ibid. (97 98).
29. Ibid. (104).
30. Ibid. (26).
31. Ito (2008, 30–32).
32. Ibid. (35–37).
33. Sharp and Arnold 2002.
34. See Stalker (2008, 108–141). Whelan (2007) discusses the role of film in the practices of GLA (God Light Association).
35. Kata (2004).
36. Kata (2004, 3–7). On these moralistic stories, see Matisoff (1992, 234–261).
37. Kinsella (2000, 24).
38. Foster (2008; 2009a; 2009b, 160–203); Schodt (1996, 177–182); also see Papp (2009).
39. Mizuki (2000).
40. Japanese features two types of mimetic vocabulary: *giongo* are onomatopoetic words that represent sounds, and *gitaigo* are words that represent actions, tactile sensations, or facial expressions.

41. Jeff Bezos, cited in Levy (2007).
42. Berndt (2008, 299–300).
43. Kinsella (2000, 42–44); McCloud (1993, 77–80); Schodt (1996, 22–28).
44. Kinsella (2000, 42–44); Schodt (1996, 25).
45. Kern (2006, 13–23); McCloud (1993, 9).
46. McCloud (1993, 35–45).
47. Natsume (1997, 172–178).
48. Natsume describes closure with the term *yakusokugoto*. See Natsume (1997, 80–96).
49. Berndt (2008, 301–305); MacWilliams (2000, 117); Natsume (1997, 17–21); Schodt (1996, 25).
50. Motohiro (2007, 38–39).
51. Berndt (2008, 301–305).
52. Schodt (1996, 263).
53. Most notably, MacWilliams (2000, 2002).
54. Natsume (1997, 66–96).
55. McCloud (1993, 113–114).
56. Schodt (1996, 26).
57. M. Takahashi (2008, 122–129).
58. Natsume (1997, 80–124).
59. Tezuka (1993 [vol. 6], 246–247).
60. McCloud (1993, 35–45, esp. 43–45).
61. Funazuka n.d., http://www.sotozen-net.or.jp/.
62. Tezuka Production (1994, 6).
63. MacWilliams (2000).
64. Tezuka Production (1994, 7–8, 214).
65. Kure (2009, 230).
66. Until recently, Kōfuku no Kagaku was translated as the "Institute for Research in Human Happiness," or IRH.
67. Lamarre (2009, 12–25).
68. Napier (2001, 10); Poitras (2008, 62–63).
69. Azuma (2009, 11).
70. Ibid.
71. Lamarre (2009, 64–67).
72. Aramaki (2004, based on Shirow 1985); Kon (2006, based on Tsutsui 1997).
73. Lamarre (2009, 64–66).
74. Drazen (2003, 21).
75. Arias (2006, based on Matsumoto 1994).
76. See especially the scene from 43:45 to 46:15.
77. Morgan (2005).
78. Ishii (1996, 203).

CHAPTER 2: RECREATING RELIGION

1. Nakamura H. (2009).
2. Kobayashi (2009).
3. Kure (2009); Yamanaka (1996).
4. Yumiyama (2005).
5. Marsh (2009).
6. There were about one hundred students in all. When minors' responses were removed I had a sample size of eighty-seven.
7. The main problem with the survey was that it was too long. I wanted to determine if students' attitudes towards religion, religions, and spirituality were consistent with the findings of Inoue Nobutaka and others who had recently conducted similar surveys, and students took so much time answering these questions that some of them ran out of time when it came to answering the questions specifically about manga and anime. Additionally, the students had all heard me talk about my research in general terms prior to taking the survey, which no doubt influenced their responses. Finally, the ambiguity of the phrasing of the questions that sought to determine whether students' worldviews had been changed by manga and anime in ways that might be considered religious (either by themselves or by clerics or scholars) made the results somewhat inconclusive. Fortunately, students' written responses to lectures I had given at the same institution a year prior (30 June 2006) provided some useful material that somewhat compensated for these shortcomings.
8. My findings were not terribly different from those of a (more rigorous) study conducted two years prior. See Inoue N. (2006).
9. Only 21.8 percent of respondents said that they had not had such feelings or experiences, meaning that around 20 percent of respondents chose not to answer the question.
10. I used a snowball sampling method to conduct interviews with acquaintances and friends of acquaintances. Most interviews were conducted in 2007.
11. Anno (1995–1996); Kobayashi (2005); Takei (1998).
12. The students filled out the survey after I had finished a brief lecture on studying as a foreigner in Japan and, as part of that, had introduced the topic and some of the content of my research on religious manga culture. Students' reports of the effects of manga and anime on their worldviews can only be taken at face value given this context, and obviously I have focused on externally verifiable data such as ritual practice and conversion in this and other chapters because they are more reliable (or at least suggestive) indicators of the effectiveness of manga and anime in educing or inculcating religious attitudes.
13. In my lecture, I had mentioned *Phoenix* as an example of the type of manga I was examining.

14. Nagashima Kay-ichi collected the responses after lectures I gave in his classes "International Information" and "Introduction to International Relations" on 30 June 2006. Personal communication, 12 July 2006.
15. For an equivalent look into young people's absorption of religious information in the United States, see Clark (2007).
16. Hirafuji (2007). The concept of "hyper-mythology" is based on Inoue Nobutaka's concept of "hyper-religion." See Inoue N. (1999, 115–178).
17. Hirafuji (2007, 168).
18. Yonei 1999a, 379. English text is from the online translation, accessed at http://eos.kokugakuin.ac.jp/modules/xwords/entry.php?entryID=1181.
19. From an Inuyasha fan site: http://www.freewebs.com/inuyasha6/. Accessed 25 January 2007. Also see Takahashi R. (1997).
20. Shirow (1991). For an example of the type of vocabulary used in English, see Schodt (1996, 320, illustration). Tendai is a Buddhist sect, whereas Susanoo is a Shintō deity.
21. Hagazono (1998 [vol. 4], 206). I discuss the epic functions of such extreme settings in Chapter 4.
22. Nakamura H. (2008 [vol. 1], 3 [my pagination]). The joke depends on the near-homophonous relationship between the words "*Hottoke*" (scram!) and "*hotoke*" (a buddha).
23. Ibid. (131–132 [pagination and emphasis added]). *Daigomi* was originally a loan word used to describe unexcelled Buddhist awakening. It is now used colloquially to describe the "true flavor" or "essence" of something.
24. Furuya (2000).
25. Ibid. (27–28).
26. Takei (1997).
27. Takei (1997 [vol. 3], Afterword, 190–191).
28. Ibid. (191).
29. Ohba and Obata (2004–2006).
30. Ohba and Obata (2004 [vol. 1], 49).
31. Hotta and Obata (1999).
32. Fujishima (1991).
33. Yamamura (2007).
34. Ibid. (206–207).
35. Nakamura R. (1998).
36. See Thomas (2009, 206). For a detailed analysis of the film, see Napier (2007).
37. I use the word "apocalypse" here to indicate a style of literature that features cataclysmic events that happen because of divine intervention or that otherwise have some sort of soteriological significance.
38. Anno (1995–1996).
39. Anno (1997).

40. Tada I. (1998, 139).
41. Ibid. (147–148); Okada (1997).
42. Maki Kōji (2004).
43. Ibid. (i [added pagination]).
44. See the scene beginning at 1:10:20 and lasting until 1:11:30 in Arias (2006). For the manga, see Matsumoto (1994 [vol. 3], 22–23, 31–33).
45. CLAMP (2003); Morohoshi (1996).
46. Yamanaka (1996, 164–167).
47. Okuse and Meguro (2001–2004).
48. Umezu (1997).
49. Koike (2002–2009).
50. The store is Village Vanguard, in the Shimokitazawa area of Tokyo.
51. The meditation center demonstrates its powers over the phenomenal world through spoon-bending displays in television advertisements.
52. The only other place I have seen the manga carried is the Junkudō in Shinjuku, Tokyo, in June 2010.
53. See the MIXI fan community at http://mixi.jp/view_community.pl?id=44959. Last accessed 17 September 2011. See the 5 December 2009 thread entitled "I tried to think of why Mr. Koike is [so] unprolific" and the 5 December 2009 thread entitled "Please share your impressions of Volume 3 (spoiler alert!)."
54. Post #1 on "Please share your impressions of Volume 3 (spoiler alert!)."
55. "*Iyā, omoshirokatta*. Hi no tori *irai no kamoshirenai*."
56. Inoue T. (1998–2007). Personal interviews with Satō Kenji, 24 April 2007, and Kurosaki Shin, 26 July 2007.
57. Yumiyama et al. (2003, 16). See Ogino (1997).
58. Personal communication, 5 April 2007.
59. For an introduction to the realm of cosplay, see Winge (2006).
60. For a discussion of ritual activity and media, see Grimes (2002).
61. Jesse LeFebvre photographed and informed me of this *ema*. Unfortunately, I cannot reproduce the image here.
62. See Reader and Tanabe (1998) for many examples of *ema*.
63. Ishii (1996, 205). Also see Imai (2009).
64. Personal interview with Satō Kenji, 24 April 2007.
65. Okano and Yumemakura (1999).
66. Thanks to Carolyn Pang for indicating this connection in her paper at the Harvard East Asian Studies Graduate Student Conference (2007).
67. Miller (2008).
68. Uchiyama and Fukui (2004, 12–13).
69. Tada K. and Takujinsha (2005).
70. Mizuki (2000, 332).
71. Baron and Yamaori (1990).

72. Yamaori (1990, 3–8).
73. Dobbins (2004, 107–121).
74. Hiro Sachiya is a pseudonym. For an overview and analysis of his works, see G. Tanabe (2004). Examples of manga adaptations of Hiro Sachiya's work include Hiro Sachiya and Tatsumi (1992) and Hiro Sachiya and Koshiro (1994).
75. Pye and Triplett (2007, 59–76, esp. 61–68).
76. Ibid. (61).
77. Ishii (1996, 203).
78. Okada (1997, 207–213).
79. Kitahara (2005, 87–149, 64–67).
80. Honda (2008 [1979], 150–151).
81. Kitahara (2005, 87); Tsukada 2009, 102–103.
82. Note that although the anime takes an overtly internationalist stance with the inclusion of two obviously non-Japanese characters, these characters reveal themselves to be spiritually inferior to their Japanese peers.
83. Thanks to Tsukada Hotaka, a colleague and mentor at the University of Tokyo (now at Kokugakuin University), for the statistics on Kōfuku no Kagaku publications. See Tsukada (2010).
84. Matsumoto (1994 [vol. 2], 13–14; 58). Also see the anime version directed by Michael Arias, esp. the scene beginning at roughly 38:45 and lasting until roughly 41:48.
85. Urasawa (2000 [vol. 1], 102).
86. Kobayashi (1995, 5–16).
87. Kobayashi (1998).
88. Kobayashi (2005).
89. Kobayashi (2009, 31–38).
90. Watanabe N. (2007, 66–77).
91. The survey took place in June 2007; the casual conversation took place in June 2009.
92. Nōjō (1990–1991).
93. Nōjō Jun'ichi Dōmei: http://kochi.cool.ne.jp/nojo_domei/index.html. Last accessed 8 March 2010. The "Cool Online" web server discontinued service as of 30 June 2011 (attempted to access 18 September 2011).
94. I purchased all four volumes in hardback, used, for the extremely low price of 400 yen in 2006—less than a dollar per volume at the time.
95. Uchiyama and Fukui (2004, 12–13).
96. Takahata (1994).
97. See the scene from roughly 1:07 to 1:17 in Takahata (1994).
98. Tezuka (1993).
99. Tezuka (1997, 75–82).
100. Tezuka (1997, 77).

101. Interview with Kurosaki Shin, 26 July 2007.
102. MacWilliams (2002).
103. Kageyama (1992, 284–287).
104. Personal interview with Morimoto Ari, 4 May 2007.
105. Tezuka Production (1994).
106. Tezuka (1993 [vol. 12], 190–191).
107. Tezuka Production (1994, 208–209).
108. Shahar (1996, 193–194).
109. Miuchi (1994, 1995).
110. See Miuchi's website: http://homepage2.nifty.com/suzu/profile/profile_top .htm. Last accessed 29 November 2007.
111. Shimazono (2007b, 43). Shimazono also mentioned to me in person that Miuchi regularly leads tour groups to "power spots" like Tenkawa Benzaiten Shrine as a quasi-religious leader. For one article that touches on religious dimensions of Miuchi's work, see Suter (2009).
112. Yamamoto S. (2002).
113. Yamanaka (1996, 162).
114. See Anonymous (n.d.). Last accessed 19 September 2011. Thanks to Erica Baffelli of Otago University for the link.
115. See her blog post "Ēsu hitorigoto no. 1": http://www.cosmo.ne.jp/~sumihime/ monolog/No001.html. Last accessed 18 September 2011.
116. Yoneyama (1995).
117. Tsushima Hirofumi, "Subikari Kōha Sekai Shindan," online *Encyclopedia of Shinto*, http://eos.kokugakuin.ac.jp/modules/xwords/entry.php?entryID=662. Accessed 20 September 2006.
118. For example, when he was a teenager he spent a night in a temple, and saw a human figure floating in the air above his head.
119. Hardacre (1998).
120. Stalker (2008).
121. Hardacre (1998).
122. Broder (2008).
123. Davis (1980). I speculate, but haven't definitively confirmed, that Kuroda drew some of the illustrations in Davis' figures. See Davis (33, 40).
124. Yoneyama (1995, 68–74).
125. Ibid. (73–74).
126. The magazine can be found at http://www.ai200.com/. Accessed 8 January 2007.
127. For a detailed explanation of Mahikari cosmology, which directly influenced Kuroda's teachings, see Davis (1980, 64–98).
128. Kuroda's wife told me that the group's usage of the word *hikari*, or light, is actually closer to "vibration."

129. Kuroda (1987, 1990–1991, 1999, 2000, 2003, 2004).
130. Kuroda (1987, 4–5; emphasis in the original).

CHAPTER 3: ENTERTAINING RELIGIOUS IDEAS

1. While most of Miyazaki's films are not based on manga, one exception is the seven-volume manga series *Nausicaä of the Valley of the Wind* (*Kaze no Tani no Naushika*), discussed in more detail in the next chapter. Ironically, Miyazaki is disparaging of the televised series that generally derive from manga, which he describes pejoratively as "anime." He prefers to describe his own work as "manga film." See Lamarre (2006, 130).
2. Berndt (2008, 296–297). The overabundance of articles on Miyazaki and his oeuvre can be seen in the database of academic articles on manga and anime maintained by Mikhail Koulikov: http://corneredangel.com/amwess/. Last accessed 10 December 2010.
3. Drazen (2003, 37); Inoue S. (2004); McCarthy (1999); Napier (2000); Poitras (2008, 59); Shimizu (2001).
4. Imai (2009).
5. Boyd and Nishimura (2004); Wright (2005); Wright and Clode (2004); Yamanaka (2008).
6. Inoue S. (2004, 99–121); Masaki (2001, 2002).
7. Hirafuji (2009); Pike (2009, esp. 69–70).
8. Wright (2005, 1 [my pagination]).
9. Havens (2006).
10. Boyd and Nishimura (2004, 8 [my pagination]).
11. Yamanaka (2008, 252–253).
12. Plate (2003, 1; emphasis in the original).
13. Lyden (2003, 2–3).
14. Ibid. (32–35).
15. Ibid. (4).
16. Plate (2003, 5).
17. Grimes (2002, 220).
18. Lutgendorf (2003, 22).
19. Ibid. (26).
20. Ibid. (21).
21. Plate (2003, 1).
22. Nasreen Munni Kabir, *Bollywood: The Indian Cinema Story* (London: Channel 4 Books, 2001), quoted in Lutgendorf (2003, 19).
23. Plate (2003, 4).
24. Plate (2008, ix–x); Shimazono (2004, 300–301).

25. McCarthy (1999), 89; quoted in English in Mes 2002, 3 [my pagination]. I borrowed this section heading from the title of G. Tanabe (2007).

26. These attitudes are generally representative of the types of thought Shimazono describes in his chapter on "New Spirituality Movements and Culture." See Shimazono (2004, 293–305). On Miyazaki's nostalgia, see Yamanaka (2008) and Yoshioka (2008).

27. From the *Japan Times Weekly*, 28 September 2002, cited in English in Boyd and Nishimura (2004, 5; my pagination).

28. Wright (2005, 2 [my pagination]). Wright's use of the word "spiritualism" is inexact; it seems that she actually means "spirituality" in this instance.

29. Quoted in English in Vintacelli (1999, 3 [my pagination]). Also see Yamanaka (2008, 251).

30. Mes (2002, 4 [my pagination]).

31. Miyazaki (1984).

32. Miyazaki (1988).

33. Miyazaki (1997).

34. Miyazaki (2001).

35. Yamanaka (1996, 176).

36. Ibid. (esp. 175–181).

37. Ibid. (181).

38. Shimizu (2001, 133–137).

39. Ibid. (141–142).

40. Cited in English in an interview with Charles T. Whipple (1994), 8–9 (my page numbering).

41. Miyazaki, cited in Takeuchi (1992, 12).

42. See, for one example, the MIXI (Social Networking Service) message board entitled "Studio Ghibli": http://mixi.jp/view_community.pl?id=139456. Accessed 22 April 2005. Also see Nausicaa.net: http://www.nausicaa.net/miyazaki/. Accessed 15 November 2004.

43. Thread entitled "*Naushika no saigo wa* . . . [The End of *Nausicaä* . . .]," on the community page *Miyazaki Hayao kantoku eiga no nazo wo tsuikyū/kaimei* [Pursuing and Elucidating the Mysteries of Director Miyazaki Hayao's Films], found on the MIXI (Social Networking Service) at http://mixi.jp/view_bbs.pl?page=1&comm_id=290365&id=1884432. Accessed 1 September 2005. Here I cite the posts numbered 6 through 10. As of December 2010, the community listed above seems to be defunct. Here and below I cite the links to the original content in the interest of full disclosure, but several of these threads or the communities that host them may no longer be active. Using the MIXI social networking service (http://mixi.jp/) requires the ability to read Japanese, and one must register an e-mail address and password, but all of the threads cited here were otherwise open to the public.

44. Post #7 on the aforementioned topic *"Naushika no saigo wa"* on the community page *Miyazaki Hayao no nazo wo tsuikyū/kaimei*: http://mixi.jp/view_bbs.pl?page=1&comm_id=290365&id=1884432. Accessed 1 September 2005.

45. Personal interview, 4 May 2007.

46. Personal interview, 28 June 2007.

47. McCarthy (1999), 120–121.

48. Ibid. (122). *Totoro* are not just refashioned, but also fashionable *kami*, if the ubiquitous mass-marketed stuffed *totoro* are any indication. See Yamanaka (2008, 251).

49. Post #13 on a thread entitled *"Miyazaki kantoku eiga no eikyō wa?* [What is the Influence of Director Miyazaki's Movies?]," on the discussion page *Miyazaki Hayao kantoku eiga no nazo wo tsuikyū/kaimei*: http://mixi.jp/view_bbs.pl?id=3413393&comm_id=290365. Accessed 2 January 2006. As of December 2010, this community is no longer active.

50. *Asia Pulse*, May 1997, cited in English in McCarthy (1999, 185).

51. See Napier 2000, citing Miyazaki in English, 186–187; also see Yamanaka 2008, 250–251.

52. Thread entitled *Mononoke hime no butaichi* ["The Setting of *Princess Mononoke*"], *Miyazaki Hayao kantoku eiga no nazo wo tsuikyū/kaimei* found at http://mixi.jp/view_bbs.pl?id=2444019&comm_id=290365. Accessed 23 October 2005. I cite here posts #4, #6, #9, and #13. As of December 2010, this community is no longer active.

53. Thread entitled *Sen to Chihiro kantoku no messeeji* [The Director's Messages in *Spirited Away*], *Miyazaki Hayao kantoku eiga no nazo wo tsuikyū/kaimei* at http://mixi.jp/view_bbs.pl?page=3&comm_id=290365&id=2205445. Accessed 2 October 2006. I cite in particular posts #9, #23, and #25. As of December 2010, this community is no longer active.

54. Mes (2002, 3–4 [my pagination]).

55. Napier (2006, 51).

56. Ibid. (57).

57. DeWeese-Boyd (2009).

58. Masaki (2001, i).

59. Ibid. (iii).

60. Masaki (2010).

61. Inoue N. (2009, 2010a, 2010b).

62. I was also invited to participate in the aforementioned forum, where I presented a critique of the excessive focus on narrative content at the expense of audience reception. See Thomas (2010).

63. Shimazono (2004, 303).

64. Kitahara (2005, 87); Yamanaka (1996, 161–163).

CHAPTER 4: DEPICTING RELIGIONS ON THE MARGINS

1. Hardacre (2007).
2. Dorman (2007, 45–46); Dorman and Reader (2007, esp. 6–8); Inoue N. (1999, 7–17); Shimazono (2001, 1, 16–19); Yumiyama (1994, 108–110).
3. Okada (1997, 202–213).
4. Inoue N. (1999, 19–76, esp. 30–38 "The Aum Shock."
5. Shimazono (1995).
6. Yumiyama (2004).
7. Reader (2000, 100–101).
8. Ibid. (11–12).
9. Ibid. (126–223).
10. Murakami (1999).
11. Hardacre (2007); Ishii (1996, 185–188); Watanabe M. (2001, 87–106).
12. Gardner (2008).
13. Inoue (1999, 32).
14. Gabriel (2006, 87–172).
15. Bromley (2002); Reader (2002).
16. Gallagher (2007); Shimazono (2001, 1–9).
17. One attempt to use "cult" to describe some religious groups is Stark and Bainbridge (1979).
18. For example, the Church of the Latter-Day Dude, found at http://dudeism .com/, is an online community based on the "teachings" of the Dude, a.k.a. Jeffrey Lebowski, the protagonist of the Coen brothers' sleeper hit *The Big Lebowski* (1998). Last accessed 9 July 2010.
19. Reader (2002, 206).
20. Yumiyama (1994, 112).
21. Gardner (2008, 201–204); Reader (2000, 50–51).
22. Shimazono (1995, 382).
23. Hardacre (2007, 201).
24. Gardner (2008, 203).
25. Gardner (2008, 207–208) and Ōsawa (1996, 94). On Asahara as a fan of *Nausicaä*, see Napier (2001, 195).
26. Miyazaki Hayao, quoted in Takeuchi (1992, 12).
27. Ōsawa (1996, 93–97).
28. Reader (2000, 188, 196–198).
29. Okada (1997, 202–213).
30. Shimazono (1997, 29).
31. Ibid. (70–88).
32. Reader (2000, 98–101); Shimazono (1997, 70–121; 2001, 28–36).
33. Inoue N. (1999, 115–178); Reader (2000, 65–69); Shimazono (1997, 13–14; 40–68).

34. Reader (2000, 95–125). On the attraction of Aum, see Morioka (1996, 3–66).
35. Okada (1997); Schodt (1996, 228–232).
36. Okada (1997, 210); Schodt (1996, 46–47).
37. Schodt (1996, 230).
38. Okada (1997, 207, 210, 213).
39. Gardner (2008).
40. Okada (1997).
41. Asahara (1989).
42. Ibid. (224–225).
43. Asahara (1992).
44. Schodt (1996, 232).
45. Dorman and Reader (2007, 5–12).
46. Gabriel (2006, 87–172).
47. Hardacre (2007, 177–178).
48. Yamanaka (1996, 175–184).
49. Shindō, Yashioji, and Nishizaki (2005–2006).
50. On volume 2 and volume 1, respectively.
51. Reader (2000, 36). Asahara also has been accused of worldliness and sexual impropriety.
52. Shindō et al. (2005 [vol. 2], 166).
53. Hardacre (2007, 175–176); Reader (2000, 36–37).
54. Reader (2000, 18–19, 217–218).
55. Shimazono (1997, 34).
56. Yamamoto N. (2000).
57. *"Anjū no chi."* Yamamoto has published a manga with this title, but I am not prepared to comment on it here.
58. Gardner (2008); Miyadai (1998, 18–20); Metraux (1999, 48–56); Ōtsuka (2004, 358–371); Schodt (1996, 46–47); Shmazono (1995, 382).
59. Yumiyama (2004).
60. Urasawa (2000–2007, 2007).
61. Motohiro (2007, 38–39); Mori Tatsuya (2005, 48–49); NHK (2007).
62. Spoon bending was one of the popular topics associated with the occult boom in the 1970s. See Yumiyama (1994, 112–113).
63. The song is actually a tune by Urasawa, entitled "Bob Lennon" and included on CDs inserted in copies of the first printing of volume 11.
64. See the thread entitled "Tomotachi" [*sic*] on the "Urasawa Naoki" fan community page on the social networking site MIXI: http://mixi.jp/view_bbs .pl?id=34603831&comm_id=233. Thread started by "Betty" (incidentally, a non-native Japanese speaker) on 2 September 2008. Although most respon-

dents agree on one character as the true identity for Tomodachi, at least three different interpretations were apparent as of 20 July 2010.

65. Yoshida (2005, 50–53).
66. NHK (2007).
67. Urasawa (2005 [vol. 18], 194–195).
68. Urasawa (2000 [vol. 2], 86–87).

Ai 200 Tomo no Kai. http://www.ai200.com/.

Allison, Anne. 2006. *Millennial Monsters: Japanese Toys and the Global Imagination.* Berkeley: University of California Press.

Ammerman, Nancy. 2007a. "Introduction: Observing Religious Modern Lives." In *Everyday Religion: Observing Modern Religious Lives*, ed. Nancy Ammerman, 3–18. Oxford: Oxford University Press.

———. 2007b. "Studying Everyday Religion: Challenges for the Future." In *Everyday Religion: Observing Modern Religious Lives*, ed. Nancy Ammerman, 219–238. Oxford: Oxford University Press.

Anno Hideaki, dir. 1995–1996. *Shinseiki ebuangerion.*Tokyo: GAINAX.

———. 1997. *The End of Evangelion: Shinseiki ebuangerion gekijō ban: Air/magokoro o, kimi ni.* Tokyo: GAINAX.

Anonyomous. n.d. "Ēsu o nerae no kyōsosama." http://www002.upp.so-net.ne.jp/soo/text11.html.

Arias, Michael, dir. 2006. *Tekkon Kincrīto.* Tokyo: Shōgakukan, Aniplex, Asmik Ace, Beyond C, Dentsū, Tokyo MX.

Asahara Shōkō [draft], with Dabide no Hoshi (the "Star of David") [illustrator]. 1989. *Metsubō no hi: Asahara Shōkō, 'Yohane no mokujiroku' no fūin wo toku!!"* Tokyo: Aum Press.

Asahara Shōkō and Aum MAT Studio. 1992. *Spirit Jump*, vol. 1. Tokyo: Aum Press.

Azuma, Hiroki. 2009. *Otaku: Japan's Database Animals*, trans. Jonathan E. Abel and Shion Kono. Minneapolis: University of Minnesota Press.

Baron Yoshimoto and Yamaori Tetsuo. 1990. *Shinran*, vol. 1. Tokyo: Kadokawa Comikkusu.

Berndt, Jaqueline. 2008. "Considering Manga Discourse: Location, Ambiguity, Historicity." In *Japanese Visual Culture: Explorations in the World of Manga and Anime*, ed. Mark W. MacWilliams, 295–310. Armonk, NY: M. E. Sharpe.

Berry, Mary Elizabeth. 2006. *Japan in Print: Information and Nation in the Early Modern Period.* Berkeley: University of California Press.

Boyd, James W., and Tetsuya Nishimura. 2004. "Shinto Perspectives in Miyazaki's Anime Film *'Spirited Away.'*" *The Journal of Religion and Film* 8(2). http://www.unomaha.edu/jrf/Vol8No2/boydShinto.htm.

Broder, Anne. 2008. "Mahikari in Context: Kamigakari, Chinkon kishin, and Psychical Investigation in Ōmoto-lineage Religions." *Japanese Journal of Religious Studies* 35(2): 331–362.

Bromley, David G. 2002. "Dramatic Denouements." In *Cults, Religion, and Violence*, ed. David G. Bromley and J. Gordon Melton, 11–41. Cambridge: Cambridge University Press.

Church of All Worlds. http://www.caw.org/.

Church of the Latter-Day Dude. http://dudeism.com/.

CLAMP. 2003. *Ṛg Veda*, vol. 1. Tokyo: Shinshokan.

Clark, Lynn Schofield. 2007. "Religion, Twice Removed: Exploring the Role of Media in Religious Understandings among 'Secular' Young People." In *Everyday Religion: Observing Modern Religious Lives*, ed. Nancy Ammerman, 69–81. Oxford: Oxford University Press.

Collcutt, Martin. 2009 (4 March). "Dancing to Paradise." Princeton University East Asian Studies Lunch Colloquium Presentation.

Condry, Ian. 2009. "Anime Creativity: Characters and Premises in the Quest for Cool Japan." *Theory, Culture, and Society* 26(2–3): 139–163.

Davis, Winston. 1980. *Dojo: Magic and Exorcism in Modern Japan*. Stanford: Stanford University Press.

DeWeese-Boyd, Ian. 2009. "*Shōjo* Savior: Princess Nausicaä, Ecological Pacifism, and the Green Gospel." *Journal of Religion and Popular Culture* 21(2, Summer). http://www.usask.ca/relst/jrpc/art21(2)-ShojoSavior.html.

Dobbins, James C. 2004. *The Letters of the Nun Eshinni: Images of Pure Land Buddhism in Medieval Japan*. Honolulu: University of Hawai'i Press.

Dorman, Benjamin. 2007. "Representing Ancestor Worship as 'Non-Religious': Hosoki Kazuko's Divination in the Post-Aum Era." *Nova Religio* 10(3): 32–53.

Dorman, Benjamin, and Ian Reader. 2007. "Projections and Representations of Religion in Japanese Media." *Nova Religio* 10(3): 5–12.

Drazen, Patrick. 2003. Anime *Explosion: The What? Why? and Wow! of Japanese Animation*. Berkeley: Stone Bridge Press.

Fitzgerald, Timothy. 2003. " 'Religion' and 'the Secular' in Japan: Problems in History, Social Anthropology, and Religion." *Electronic Journal of Contemporary Japanese Studies*, Discussion Paper 3 in 2003. http://www.japanesestudies.org.uk/discussionpapers/Fitzgerald.html.

———. 2004a. "Postscript: Religion and the Secular in Japan: Problems in History, Social Anthropology and the Study of Religion." *Electronic Journal of Contemporary Japanese Studies*, Discussion Paper 6 in 2004. http://www.japanesestudies.org.uk/discussionpapers/Fitzgerald3.html.

———. 2004b. "The Religion-Secular Dichotomy: A Response to Responses." *Electronic Journal of Contemporary Japanese Studies*, Discussion Paper 2 in 2004. http://www.japanesestudies.org.uk/discussionpapers/Fitzgerald2.html.

Foster, Michael Dylan. 2008. "The Otherworlds of Mizuki Shigeru." In *Mechademia 3: Limits of the Human*, ed. Frenchy Lunning, 8–28. Minneapolis: University of Minnesota Press.

———. 2009a. "Haunted Travelogue: Hometowns, Ghost Towns, and Memories of War." In *Mechademia 4: War/Time*, ed. Frenchy Lunning, 164–182. Minneapolis: University of Minnesota Press.

———. 2009b. *Pandemonium and Parade: Japanese Monsters and the Culture of Yōkai*. Berkeley: University of California Press.

Fujishima Kōsuke. 1991. *Aa, megamisama!* vols. 1–4. Tokyo: Afternoon Comics, Kōdansha.

Funazuka Junko. *Dōgen-sama*. http://www.sotozen-net.or.jp/kids/f_07a.html.

Furuya Usumaru. 2000. *Garden*. Cue Comics, East Press.

Gabriel, Philip. 2006. *Spirit Matters: The Transcendent in Modern Japanese Literature*. Honolulu: University of Hawai'i Press.

GAINAX and Sadamoto Yoshiyuki. 1995–2007. *Shinseiki evangerion*, vols. 1–11. Tokyo: Kadokawa Comics A, Kadokawa Shoten.

Gallagher, Eugene V. "Compared to What? 'Cults' and 'New Religious Movements.'" History of Religions 47(2–3): 205–220.

Gardner, Richard A. 2008. "Aum Shinrikyō and a Panic about Manga and Anime." In *Japanese Visual Culture: Explorations in the World of Manga and Anime*, ed. Mark W. MacWilliams, 200–218. Armonk, NY: M. E. Sharpe.

Gimello, Robert M. 2004. "Icon and Incantation: The Goddess Zhunti and the Role of Images in the Occult Buddhism of China." In *Images in Asian Religions: Text and Contexts*, ed. Phyllis Granoff and Koichi Shinohara, 225–256. Vancouver: University of British Columbia Press.

Grimes, Ronald L. 2002. "Ritual and the Media." In *Practicing Religion in the Age of the Media: Explorations in Media, Religion, and Culture*, ed. Stewart M. Hoover and Lynn Schofield Clark, 219–234. New York: Columbia University Press.

Hagazono Masaya. 1997–2000. *Inugami*, vols. 1–10. Tokyo: Afternoon Comics, Kōdansha.

Hamada Nami. 2005. "Kamisama wa imasuka?" *AERA* (Asahi Shimbun Extra Report and Analysis) 18(47): 42–46.

———. 2006a. "Shōene shikō no Ehara genshō." *AERA* (*Asahi Shimbun Extra Report and Analysis*) 19(9): 51–52.

———. 2006b. "Uranai nippon doko e iku." *AERA* (*Asahi Shimbun Extra Report and Analysis*) 19(9): 47–50.

Hardacre, Helen. 1998. "Asano Wasaburō and Japanese Spiritualism in Early Twentieth-Century Japan." In *Japan's Competing Modernities: Issues in Culture and Democracy 1900–1930*, ed. Sharon A. Minichiello, 133–153. Honolulu: University of Hawai'i Press.

———. 2003. "After Aum: Religion and Civil Society in Japan." In *The State of Civil Society in Japan*, ed. Frank J. Schwartz and Susan J. Pharr, 135–153. Cambridge: Cambridge University Press.

———. 2007. "Aum Shinrikyō and the Japanese Media: The Pied Piper Meets the Lamb of God." *History of Religions* 47(2–3): 171–204.

Havens, Norman. 2006. "Shintō." In *The Nanzan Guide to Japanese Religions*, ed. Paul L. Swanson and Clark Chilson, 14–37. Honolulu: University of Hawai'i Press.

Heinlein, Robert A. 1961. *Stranger in a Strange Land*. New York: Putnam.

———. 1989. *Grumbles from the Grave*. New York: Del Ray.

Hirafuji Kikuko. 2007. "Rōru pureingu gēmu no naka no shinwagaku." In *Shūkyō to gendai ga wakaru hon 2007*, ed. Watanabe Naoki, 168–171. Tokyo: Heibonsha.

———. 2009. "Miyazaki Anime to Animizumu." In *Eiga de manabu gendai shūkyō*, ed. Inoue Nobutaka, 65. Tokyo: Kōbundō.

Hiro Sachiya and Koshiro Takeshi. 1994. *Miroku bosatsu: Mirai no hotoke*. Tokyo: Suzuki Shuppan.

Hiro Sachiya and Tatsumi Yoshihiro. 1992. *Dainichi nyorai: Uchū no hotoke*. Tokyo: Suzuki Shuppan.

Honda Genshō. 2008 [1979]. *Dengyō Daishi*. Hiei-zan: Hiei-zan Enryaku-ji.

Horton, Sarah J. 2007. *Living Buddhist Statues in Early Medieval and Modern Japan*. New York: Palgrave Macmillan.

———. 2008. "Mukaekō: Practice for the Deathbed." In *Death and the Afterlife in Japanese Buddhism*, ed. Jacqueline Stone and Mariko Walter, 27–60. Honolulu: University of Hawai'i Press.

Hotta Yumi and Obata Takeshi. 1999. *Hikaru no go*, vol. 1. Tokyo: Jump Comics, Shūeisha.

Hur, Nam-lin. 2000. *Prayer and Play in Late Tokugawa Japan: Asakusa Sensōji and Edo Society*. Cambridge, MA: Harvard University Press.

Imai Nobuharu. 2009. "Anime 'seichi junrei' jissensha no kōdō ni miru dentō teki junrei to kankō katsudō no kakyō kanōsei: Saitama ken Washinomiya Jinja hōnō ema bunseki o chūshin ni." *CATS Sosho* 1: 89–111.

Inoue Nobutaka. 1999. *Wakamono to gendai shūkyō: Ushinawareta zahyōjiku*. Tokyo: Chikuma Shinsho.

———. 2006. *Wakamono ni okeru kawaru shūkyō ishiki to kawaranu shūkyō ishiki*. Tokyo: Kokugakuin Press.

———, ed. 2009. *Eiga de manabu gendai shūkyō*. Tokyo: Kōbundō.

———, ed. 2010a. *Kokusai kenkyū fōramu: Eiga no naka no shūkyō bunka: Hōkokusho*. Tokyo: Kagaku Kenkyūhi hojokin/kiban kenkyū [A] "Daigaku ni okeru shūkyō bunka kyōiku no jisshitsuka o hakaru shisutemu kōchiku," dai 2 gurūpu [Kokugakuin University].

———. 2010b. "Shūkyō o kaitai shiteiku eizō media." In *Shūkyō to gendai ga wakaru hon 2010*, ed. Watanabe Naoki, 26–31. Tokyo: Heibonsha.

Inoue Sizuka. 2004. *Miyazaki Hayao: Eizō to shisō no renkinjutsushi*. Tokyo: Shakai Hihyōsha.

Inoue Takehiko. 1998–2007. *Bagabondo*, vols. 1–20. Tokyo: Kōdansha Comics Morning.

International Quidditch Association. http://www.internationalquidditch.org/.

Inuyasha Fansite. http://www.freewebs.com/inuyasha6/.

Ishii Kenji. 1996. "Jōhōka to shūkyō." In *Shōhi sareru "shūkyō,"* ed. Shimazono Susumu and Ishii Kenji, 185–208. Tokyo: Shunjusha.

Isomae Jun'ichi. 2003. *Kindai Nihon no shūkyō gensetsu to sono keifu: Shūkyō/kokka/Shintō*. Tokyo: Iwanami Shoten.

Ito, Kinko. 2008. "Manga in Japanese History." In *Japanese Visual Culture: Explorations in the World of* Manga *and Anime*, ed. Mark W. MacWilliams, 26–27. Armonk, NY: M. E. Sharpe.

Itō Masayuki, Kashio Naoki, and Yumiyama Tatsuya, eds. 2004. *Supirichuaritī no shakaigaku: Gendai sekai no shūkyōsei no tankyū*. Tokyo: Sekaishisō Press.

Kageyama Tamio. 1992. "Kaisetsu." In Tezuka Osamu, *Hi no tori*, vol. 2, 284–287. Tokyo: Kadokawa Bunko.

Kaminishi, Ikumi. 2006. *Explaining Pictures: Buddhist Propaganda and* Etoki *Storytelling in Japan*. Honolulu: University of Hawai'i Press.

Kata Kōji. 2004. *Kamishibai Shōwa shi*. Tokyo: Iwanami Shoten.

Kern, Adam. 2006. Manga *from the Floating World: Kibyōshi and the Comicbook Culture of Edo Japan*. Cambridge, MA: Harvard University Press.

Kimbrough, R. Keller. 2008. *Preachers, Poets, Women, and the Way: Izumi Shikibu and the Buddhist Literature of Medieval Japan*. Honolulu: University of Hawai'i Press.

Kimbrough, R. Keller, and Hank Glassman. 2009. "Editors' Introduction: Vernacular Buddhism and Medieval Japanese Literature." *Japanese Journal of Religious Studies* 36(2): 201–208.

Kinsella, Sharon. 2000. *Adult Manga: Culture & Power in Contemporary Japanese Society*. Honolulu: University of Hawai'i Press.

Kitahara Naohiko. 2005. *Hon'ya ni wa nai manga*. Tokyo: Nagasaki Publishing.

Kobayashi Yoshinori. 1995. "Aum teki! to wa nani ka?" In Kobayashi Yoshinori and Takeuchi Yoshikazu, *Aum teki!*: 5–16. Osaka: Fangusu.

———. 1998. *Shingōmanizumu sengen special: Sensōron*. Tokyo: Gentōsha.

———. 2005. *Yasukuniron*. Tokyo: Gentōsha.

———. 2009. *Tennōron*. Tokyo: Gentōsha.

Koike Keiichi. 2002–2009. *Ultraheaven*, vols. 1–3. Tokyo: Enterbrain, Beam Comics.

Kon Satoshi, dir. 2006. *Papurika*. Tokyo: MADHOUSE/Sony Pictures Japan.

Koury, Josh, dir. 2007. *We Are Wizards*. Brooklyn: Underground Films.

Kure Tomofusa. 2009. "Shūkyō tēma no mangatachi." In *Shūkyō to gendai ga wakaru hon 2009*, ed. Watanabe Naoki, 228–233. Tokyo: Heibonsha.

Kuroda Minoru. 1987. *Yūtai no fune*. Tokyo: Kokonoe Shuppan.

——. 1990–1991. *Reibusshitsu jinrui ki jō/ge kan*. Tokyo: Kokonoe Shuppan.

——. 1999–2004. *Sanshoku no kotonoha*, vols. 1–4. Tokyo: Kokonoe Shuppan.

Lamarre, Thomas. 2006. "The Multiplanar Image." In *Mechademia 1: Emerging Worlds of Manga and Anime*, ed. Frenchy Lunning, 120–144. Minneapolis: University of Minnesota Press.

——. 2009. *The Anime Machine: A Media Theory of Animation*. Minneapolis: University of Minnesota Press.

Levi, Antonia. 2006. "The Americanization of Anime and Manga: Negotiating Popular Culture." In *Cinema Anime*, ed. Steven T. Brown, 43–63. Gordonsville, VA: Palgrave Macmillan.

Levy, Steven. 2007 (17 November). "The Future of Reading." *Newsweek*. http://www.newsweek.com/2007/11/17/the-future-of-reading.html.

Lutgendorf, Philip. 2003. "*Jai Santoshi Maa* Revisited: On Seeing a Hindu 'Mythological' Film." In *Representing Religion in World Cinema: Filmmaking, Mythmaking, Culture Making*, ed. S. Brent Plate, 19–42. New York: Palgrave Macmillan.

Lyden, John C. 2003. *Film as Religion: Myths, Morals, and Rituals*. New York: New York University Press.

——, ed. 2009. *The Routledge Companion to Religion and Film*. London and New York: Routledge.

Lynch, Gordon. 2009. "Cultural Theory and Cultural Studies." In *The Routledge Companion to Religion and Film*, ed. John Lyden, 275–291. London and New York: Routledge.

MacWilliams, Mark W. 2000. "Japanese Comic Books and Religion: Osamu Tezuka's Story of the Buddha." In *Japan Pop! Inside the World of Japanese Popular Culture*, ed. Timothy J. Craig, 109–137. Armonk, NY: M. E. Sharpe.

——. 2002. "Revisioning Japanese Religiosity: Osamu Tezuka's *Hi no tori* (The Phoenix)." In *Global Goes Local: Popular Culture in Asia*, ed. Timothy J. Craig and Richard King, 177–207. Honolulu: University of Hawai'i Press.

——. 2008a. "Introduction." In *Japanese Visual Culture: Explorations in the World of Manga and Anime*, ed. Mark W. MacWilliams, 3–25. Armonk, NY: M. E. Sharpe.

——, ed. 2008b. *Japanese Visual Culture: Explorations in the World of Manga and Anime*. Armonk, NY: M. E. Sharpe.

Mair, Victor. 1988. *Painting and Performance: Chinese Picture Recitation and Its Indian Genesis*. Honolulu: University of Hawai'i Press.

Maki Kōji. 2004. *Godsider Second*, vol. 1. Tokyo: Bunch Comics.

Marsh, Clive. 2009. "Audience Reception." In *The Routledge Companion to Religion and Film*, ed. John Lyden, 255–274. London and New York: Routledge.

Masaki Akira. 2001. *Hajimete no shūkyōgaku: "Kaze no tani no Naushika" o yomi toku*. Tokyo: Shunjusha.

———. 2002. *Obake to mori no shūkyōgaku: Tonari no totoro to issho ni manabō*. Tokyo: Shunjusha.

———. 2010. "Miyazaki anime ga hisomeru shūkyō no honshitsu." In *Shūkyō to gendai ga wakaru hon 2010*, ed. Watanabe Naoki, 68–73. Tokyo: Heibonsha.

Matisoff, Susan. 1992. "Holy Horrors: The Sermon-Ballads of Medieval and Early Modern Japan." In *Flowing Traces: Buddhism in the Literary and Visual Arts of Japan*, ed. James H. Sanford, William R. LaFleur, and Masatoshi Nagatomi, 234–262. Princeton: Princeton University Press.

Matsumoto Taiyou. 1994. *Tekkon kincrīto*, vols. 1–3. Tokyo: Big Spirits Comics Special, Kōdansha.

McCarthy, Helen. 1999. *Hayao Miyazaki, Master of Japanese Animation*. Berkeley: Stone Bridge Press.

McCloud, Scott. 1993. *Understanding Comics: The Invisible Art*. New York: Harper Perennial with Kitchen Sink Books.

Mes, Tom. 2002 (7 January). Hayao Miyazaki [interview]. http://www.midnighteye .com/interviews/hayao_miyazaki.shtml.

Metraux, Daniel A. 1999. *Aum Shinrikyo and Japanese Youth*. Lanham, MD: University Press of America.

Miller, Laura. 2008. "Extreme Makeover for a Heian-Era Wizard." In *Mechademia 3: Limits of the Human*, ed. Frenchy Lunning, 30–46. Minneapolis: University of Minnesota Press.

Mitchell, Jolyon, and S. Brent Plate, eds. 2007. *The Religion and Film Reader*. London and New York: Routledge.

Miuchi Suzue. 1994. *Garasu no kamen*. Tokyo: Hakusensha Bunko.

———. 1995. *Yōkihi den*. Tokyo: Hakusensha Bunko.

Miuchi Suzue website. http://homepage2.nifty.com/suzu/profile/profile_top.htm.

MIXI (Social Networking Service) Koike Keiichi fan community. http://mixi.jp/ view_community.pl?id=44959.

MIXI (Social Networking Service) Miyazaki Hayao fan community. (This community is now defunct.)

MIXI (Social Networking Service) Urasawa Naoki fan community. http://mixi.jp/ view_bbs.pl?id=34603831&comm_id=233.

Miyadai Shinji. 1998. *Owari naki nichijō o ikiro: Oumu kanzen kokufuku manyuaru*. Tokyo: Chikuma Bunko.

Miyazaki Gorō, dir. 2006. *Gedo senki*. Tokyo: Nibariki, GNDHDDT.

Miyazaki Hayao. 1982–1995. *Kaze no Tani no Naushika*, vols. 1–7. Nibariki, Tokuma Shoten.

———, dir. 1984. *Kaze no Tani no Naushika*. Tokyo: Nibariki, Tokuma Shoten.

———, dir. 1988. *Tonari no Totoro*. Tokyo: Nibariki, Tokuma Shoten.

———, dir. 1997. *Mononoke Hime*. Tokyo: Nibariki, Tokuma Shoten.

———, dir. 2001. *Sen to Chihiro no kamikakushi*. Tokyo: Nibariki, Tokuma Shoten.

———, dir. 2006. *Hauru no ugoku shiro*. Tokyo: Nibariki, TGNDDDT.

———, dir. 2008. *Gake no ue no Pon'yo*. Tokyo: Nibariki, GNDHDDT.

Mizuki Shigeru. 2000. *Shinpika retsuden*, vol. 1. Tokyo: Kadokawa Sofia Bunko.

Moerman, D. Max. 2005. *Localizing Paradise: Kumano Pilgrimage and the Religious Landscape of Premodern Japan*. Cambridge, MA: Harvard University Asia Center.

Morgan, David. 2005. *The Sacred Gaze: Religious Visual Culture in Theory and Practice*. Berkeley: University of California Press.

Mori Tatsuya, dir. 1998. *A*. Tokyo: *A* Production Committee.

———. 2005. "Urasawa Naoki: Fukuzatsu de tamentekina nijūisseiki o kanchi suru tame ni." *Quick Japan* 59: 48–49.

Morioka Masahiro. 1996. *Shūkyō naki jidai o ikiru tame ni*. Kyoto, Hōzōkan.

Morohoshi Daijirō. 1996. *Ankoku shinwa*. Tokyo: Shūeisha Bunko.

Motohiro Katsuyuki. 2007. "Komawari jitai ga kanpeki na e konte: Kono mama toreba eiga ni naru!" *AERA Comic: Nippon no manga*, 38–39. Tokyo: Asahi Shinbunsha.

Murakami Haruki. 1999. *Andāguraundo*. Tokyo: Kōdansha Bunko.

Murasaki Shikibu. 2001. *Genji monogatari*, trans. Royall Tyler. New York: Penguin.

Nakamura Hikaru. 2008–2010. *Seinto oniisan*, vols. 1–5. Tokyo: Kōdansha Morning Comics.

Nakamura Ryūtarō, dir. 1998. *Serial Experiments: Lain*. Tokyo: Geneon, TV Tokyo.

Napier, Susan J. 2000. Anime *from Akira to Princess Mononoke*. New York: Palgrave.

———. 2006. "The World of Anime Fandom in America." In *Mechademia 1: Emerging Worlds of* Anime *and Manga*, ed. Frenchy Lunning, 47–64. Minneapolis: University of Minnesota Press.

———. 2007. "When the Machines Stop: Fantasy, Reality, and Terminal Identity in *Neon Genesis Evangelion* and *Serial Experiments: Lain*." In *Robot Ghosts and Wired Dreams: Japanese Science Fiction from Origins to Anime*, ed. Christopher Bolton, Istvan Csicsery-Ronay, and Takayuki Tatsumi, 101–122. Minneapolis: University of Minnesota Press.

Natsume Fusanosuke. 1997. *Manga wa naze omoshiroi no ka*. Tokyo: NHK Raiburarii.

Nausicaa.net. http://www.nausicaa.net/miyazaki/.

NHK. 2007. *Purofesshonaru shigoto no ryūgi 38: Urasawa Naoki*. Television program, aired 18 January 2007.

Nōjō Jun'ichi. 1990–1991. *Goddo Hando*, vols. 1–4. Big Spirits Comics Superior, Kōdansha.

Nōjō Jun'ichi Dōmei. http://kochi.cool.ne.jp/nojo_domei/index.html. (Server now defunct.)

Ogino Makoto. 1997. Kujakuoh, vols. 1–5. Tokyo: Shūeisha Bunko.

Ohba Tsugumi and Obata Takeshi. 2004–2006. *Death Note*, vols. 1–12. Tokyo: Jump Comics, Shūeisha.

Ohsawa Masachi. 1996. *Kyokō no jidai no hate: Oumu to sekai saishū sensō*. Tokyo: Chikuma Shinsho.

Okada Toshio. 1997. "Firumu wa ikiteiru ka? moto Oumu animētā no kokuhaku." *Quick Japan* 3: 202–213.

Okano Reiko and Yumemakura Baku. 1999. *Onmyōji*, vols. 1–4. Tokyo: Jets Comics, Hakusensha.

Okuse Saki and Meguro Sankichi. 2001–2004. *Teizokurei DAYDREAM*, vols. 1–6. Tokyo: Kadokawa Comics A, Kadokawa Shoten.

Online Bibliography of Anime and Manga Research. http://www.corneredangel .com/amwess/acad_1.html.

Ōtomo Katsuhiro. 1984–1993. *Akira*, vols. 1–6. Tokyo: Kōdansha.

Ōtsuka Eiji. 2004. *"Otaku" no seishinshi: 1980 nendairon*. Tokyo: Kōdansha.

Pandey, Rajyashree. 2008. "Medieval Genealogies of Manga and Anime Horror." In *Japanese Visual Culture: Explorations in the World of* Manga *and Anime*, ed. Mark W. MacWilliams, 219–236. Armonk, NY: M. E. Sharpe.

Papp, Zillia. 2009. "Monsters at War: The Great Yōkai Wars, 1968–2005." In *Mechademia 4: War/Time*, ed. Frenchy Lunning, 225–240. Minneapolis: University of Minnesota Press.

Pike, Sarah M. 2009. "Why Prince Charles Instead of *Princess Mononoke*? The Absence of Children and Popular Culture in *The Encyclopedia of Religion and Nature*." *Journal of the American Academy of Religion* 77(1): 66–72.

Plate, S. Brent. 2003. "Introduction: Filmmaking, Mythmaking, Culture Making." In *Representing Religion in World Cinema: Filmmaking, Mythmaking, Culture Making*, ed. S. Brent Plate, 1–15. New York: Palgrave Macmillan.

———. 2008. *Religion and Film: Cinema and the Re-creation of the World*. London and New York: Wallflower.

Poitras, Gilles. 2008. "Contemporary Anime in Japanese Pop Culture." In *Japanese Visual Culture: Explorations in the World of* Manga *and Anime*, ed. Mark W. MacWilliams, 48–67. Armonk, NY: M. E. Sharpe.

Prough, Jennifer S. 2011. *Straight from the Heart: Gender, Intimacy, and the Cultural Production of Shōjo Manga*. Honolulu: University of Hawai'i Press.

Pye, Michael, and Katja Triplett. 2007. *Streben nach Glück: Schicksalsdeutung und Lebensgestaltung in japanischen Religionen*. Berlin: Lit Verlag.

Reader, Ian. 1991. *Religion in Contemporary Japan*. Honolulu: University of Hawai'i Press.

———. 2000. *Religious Violence in Contemporary Japan: The Case of Aum Shinrikyō*. Honolulu: University of Hawai'i Press.

———. 2002. "Dramatic Confrontations: Aum Shinrikyō against the World." In

Cults, Religion, and Violence, ed. David G. Bromley and Gordon Melton, 189–208. Cambridge: Cambridge University Press.

———. 2004a. "Dichotomies, Contested Terms and Contemporary Issues in the Study of Religion." *Electronic Journal of Contemporary Japanese Studies,* Discussion Paper 3 in 2004. http://www.japanesestudies.org.uk/discussionpapers/Reader2.html.

———. 2004b. "Ideology, Academic Inventions and Mystical Anthropology: Responding to Fitzgerald's Errors and Misguided Polemics." *Electronic Journal of Contemporary Japanese Studies,* Discussion Paper 1 in 2004. http://www.japanesestudies.org.uk/discussionpapers/Reader.html.

———. 2005. *Making Pilgrimages: Meaning and Practice in Shikoku.* Honolulu: University of Hawai'i Press.

———. 2007. "Positively Promoting Pilgrimage: Media Representations of Pilgrimage in Japan." *Nova Religio* 10(3): 13–31.

Reader, Ian, and George J. Tanabe Jr. 1998. *Practically Religious: Worldly Benefits and the Common Religion of Japan.* Honolulu: University of Hawai'i Press.

Roemer, Michael. 2009. "Religious Affiliation in Contemporary Japan: Untangling the Enigma." *Review of Religious Research* 50(3): 298–320.

Ruch, Barbara. 1992. "Coping with Death: Paradigms of Heaven and Hell and the Six Realms in Early Literature and Painting." In *Flowing Traces: Buddhism in the Literary and Visual Arts of Japan,* ed. James H. Sanford, William R. LaFleur, and Masatoshi Nagatomi, 93–130. Princeton: Princeton University Press.

———. 2002. "Woman to Woman: Kumano bikuni Proselytizers in Medieval and Early Modern Japan." In *Engendering Faith: Women and Buddhism in Premodern Japan,* ed. Barbara Ruch, 537–580. Ann Arbor: University of Michigan.

Sakurai Yoshihide. 2006. *'Karuto' o toinaosu.* Tokyo: Chūō Kōron Shinsha.

———, ed. 2009. *Karuto to supirichuariti: Gendai Nihon ni okeru "sukui" to "iyashi" no yukue.* Kyoto: Mineruba Shobō.

Schodt, Frederik. 1996. *Dreamland Japan: Writings on Modern Manga.* Berkeley: Stone Bridge Press.

Shahar, Meir. 1996. "Vernacular Fiction and the Transmission of Gods' Cults in Late Imperial China" In *Unruly Gods: Divinity and Society in China,* ed. Meir Shahar and Robert P. Weller, 184–211. Honolulu: University of Hawai'i Press.

Shamoon, Deborah. 2008. "Situating the *Shōjo* in *Shōjo Manga*: Teenage Girls, Romance Comics, and Contemporary Japanese Culture." In *Japanese Visual Culture: Explorations in the World of Manga and Anime,* ed. Mark W. MacWilliams, 137–154. Armonk, NY: M. E. Sharpe.

———. 2012. *Passionate Friendship: The Aesthetic of Girls' Culture in Japan.* Honolulu: University of Hawai'i Press.

Sharf, Robert H. 2001a. "Introduction: Prolegomenon to the Study of Japanese Buddhist Icons." In *Living Images: Japanese Buddhist Icons in Context,* ed. Robert H. Sharf and Elizabeth Horton Sharf, 1–18. Stanford: Stanford University Press.

——. 2001b. "Visualization and Mandala in Shingon Buddhism." In *Living Images: Japanese Buddhist Icons in Context*, ed. Robert H. Sharf and Elizabeth Horton Sharf, 151–199. Stanford: Stanford University Press.

Sharf, Robert H., and Elizabeth Horton Sharf, eds. 2001. *Living Images: Japanese Buddhist Icons in Context*. Stanford: Stanford University Press.

Sharp, Jasper, and Mike Arnold. 2002 (16 July). "Forgotten Fragments: An Introduction to Japanese Silent Cinema." *Midnight Eye*. http://www.midnighteye.com/features/silentfilm_pt2.shtml.

Shimazono Susumu. 1995. "In the Wake of Aum: The Formation and Transformation of a Universe of Belief." *Japanese Journal of Religious Studies* 22(3–4): 381–415.

——. 1997. *Gendai shūkyō no kanōsei: Oumu Shinrikyō to bōryoku*. Tokyo: Iwanami Shoten.

——. 2001. *Posutomodan shinshūkyō: Gendai nihon no seishin jōkyō no teiryū*. Tokyo: Tōkyōdō Shuppan.

——. 2004. *From Salvation to Spirituality: Popular Religious Movements in Modern Japan*. Melbourne: Trans Pacific Press.

——. 2007a. *Seishin seikai no yukue: Shūkyō, kindai, reisei*. Tokyo: Akiyama Shoten.

——. 2007b. *Supirichuariti no kōryū: Shinreisei bunka to sono shūhen*. Tokyo: Iwanami Shoten.

Shimizu Masashi. 2001. *Miyazaki Hayao wo yomu: Bosei to kaosu no fantashī*. Tokyo: Chōeisha.

Shindō Fuyuki, Yashioji Tsutomu, and Nishizaki Taisei. 2005–2006. *Karisuma*, vols. 1–4. Tokyo: Futaba Press.

Shinmura Izuru, ed. 1998. *Kōjien*, Fifth Edition [electronic version]. Tokyo: Iwanami Shoten.

Shirow Masamune. 1985. *Appurushīdo*, vol. 1. Osaka: Seishinsha.

——. 1991. *Senjutsu chōkōkaku orion*. Tokyo: Kōdansha.

Soodin, Vince. 2009 (5 May). "Jedi Do." *The Sun*. http://www.thesun.co.uk/sol/homepage/news/article2411163.ece.

Stalker, Nancy. 2008. *Prophet Motive: Deguchi Onisaburō, Oomoto, and the Rise of New Religions in Imperial Japan*. Honolulu: University of Hawai'i Press.

Stark, Rodney, and William Sims Bainbridge. 1979. "Of Churches, Sects, and Cults: Preliminary Concepts for a Theory of Religious Movements." *Journal for the Scientific Study of Religion* 18(2): 117–131.

Suter, Rebecca. 2009. "From Jusuheru to Jannu: Girl Knights and Christian Witches in the Work of Miuchi Suzue." In *Mechademia 4: War/Time*, ed. Frenchy Lunning, 241–256. Minneapolis: University of Minnesota Press.

Tada Iori. 1998. "*Shinseiki ebuangerion* to Material children," *Nichibunken sōsho* 17: 137–154.

Tada Kazuo and Takujinsha. 2005. Manga *de satoru Nihon no bukkyō to kaisotachi*. Tokyo: Futabasha.

Takahashi, Mizuki. 2008. "Opening the Closed World of *Shōjo Manga.*" In *Japanese Visual Culture: Explorations in the World of Manga and Anime*, ed. Mark W. MacWilliams, 114–136. Armonk, NY: M. E. Sharpe.

Takahashi Rumiko. 1997. *Inuyasha*, vols. 1–4. Tokyo: Shōgakukan Shōnen Sunday Comics.

Takahata Isao, dir. 1994. *Heisei tanuki gassen ponpoko*. Tokyo: Studio Ghibli Production.

———. 1999. *Jūniseiki no animēshon: Kokuhō emakimono ni miru eigateki/animeteki naru mono*. Tokyo: Tokuma Shoten.

Takei Hiroyuki. 1997. *Butsuzōn*, vols. 1–3. Tokyo: Jump Comics, Shūeisha.

———. 1998. *Shāman Kingu*, vol. 1. Tokyo: Jump Comics, Shūeisha.

Takeuchi Osamu. 1992. *Tezuka Osamu ron*. Tokyo: Heibonsha.

Tanabe, George J., Jr. 1992. *Myōe the Dreamkeeper: Fantasy and Knowledge in Early Kamakura Buddhism*. Cambridge, MA, and London: Harvard University Council on East Asian Studies.

———. 2004. "Popular Buddhist Orthodoxy in Contemporary Japan." *Japanese Journal of Religious Studies* 31(2): 289–310.

———. 2007. "Playing with Religion." *Nova Religio* 10(3): 96–101.

Tanabe, Willa J. 1988. *Paintings of the Lotus Sutra*. New York: Weatherhill.

Tezuka Osamu. 1992. *Hi no tori*, vols. 1–12. Tokyo: Kadokawa Bunko.

———. 1992–1993. *Budda*, vols. 1–12. Tokyo: Ushio Press.

———. 1997. *Boku no manga jinsei*. Tokyo: Iwanami Shinsho.

Tezuka Production. 1994. *Tezuka Osamu no* Budda: *Sukuwareru kotoba*. Tokyo: Kōdansha.

Thomas, Jolyon Baraka. 2007. "*Shūkyō Asobi* and Miyazaki Hayao's *Anime.*" *Nova Religio* 10(3): 73–95.

———. 2009. "Religion in Japanese Film: Focus on *Anime.*" In *The Routledge Companion to Religion and Film*, ed. John Lyden, 194–213. London and New York: Routledge.

———. 2010. "Seiyō kara mita Nihon eiga no shūkyōsei." In *Kokusai kenkyū fōramu: Eiga no naka no shūkyō bunka: Hōkokusho*, ed. Inoue Nobutaka, 35–46. Tokyo: Kagaku Kenkyūhi hojokin/kiban kenkyū [A] "Daigaku ni okeru shūkyō bunka kyōiku no jisshitsuka o hakaru shisutemu kōchiku," dai 2 gurūpu [Kokugakuin University].

Tokyo National Museum Online Gallery. n.d. http://www.tnm.jp/modules/r_collection/index.php?controller=dtl&colid=A10942&t=type&id=11.

Tsukada Hotaka. 2009. "Shinshūkyō kyōdan sakusei no eiga." In *Eiga de manabu gendai shūkyō*, ed. Inoue Nobutaka, 102–103. Tokyo: Kōbundō.

———. 2010. "Kōfuku no Kagaku no eizō media riyō: Kōfuku Jitsugen Tō, eiga *Budda saitan* o chūshin ni." In *Gendai to shūkyō ga wakaru hon 2010*, ed. Watanabe Naoki, 74–79. Tokyo: Heibonsha.

Tsutsui Yasutaka. 1997. *Papurika*. Tokyo: Chūkō Bunko.

Uchiyama Hiroki and Fukui Yōhei. 2004. "Nijūdai no 'gachi' nashonarizumu." *AERA* (*Asahi Shinbun Extra Report and Analysis*) 17(30): 12–15.

Umezu Kazuo. 1997. *Kami no hidarite akuma no migite*, vol. 1. Tokyo: Shōgakukan Bunko.

Urasawa Naoki. 2000–2007. *Nijū seiki shōnen*, vols. 1–22. Tokyo: Shōgakukan.

———. 2007. *Nijūisseiki shōnen*, vols. 1–2 Tokyo: Shōgakukan.

Vintacelli, Elisabeth. 1999 (27 October–2 November). "Bittersweet Symphonies." *The Village Voice*, New York. http://www.villagevoice.com/film/9943,vincentelli, 9453,20.html.

Watanabe Manabu. 2001. "Opposition to Aum and the Rise of the Anti-Cult Movement." In *Religion and Social Crisis in Japan: Understanding Japanese Society through the Aum Affair*, ed. Mark R. Mullins and Robert J. Kisala, 87–106. New York: Palgrave.

Watanabe Naoki. 2007. "Washi no naka no shūkyōshin to kindaishugi o dō secchū suru ka ga mondai da [Kobayashi Yoshinori Interview]." In *Shūkyō to gendai ga wakaru hon 2007*, ed. Watanabe Naoki, 66–77. Tokyo: Heibonsha.

Watkins, Gregory J. 2008. *Teaching Religion and Film*. Oxford and New York: Oxford University Press.

Whelan, Christal. 2007. "Shifting Paradigms and Mediating Media: Redefining a New Religion as 'Rational' in Contemporary Society." *Nova Religio* 10(3): 54–72.

Whipple, Charles T. 1994. "The Power of Positive Inking." Text of a 1994 article of the same title provided by the author.

Winge, Theresa. 2006. "Costuming the Imagination: Origins of Anime and Manga Cosplay." In *Mechademia 1: Emerging Worlds of Anime and Manga*, ed. Frenchy Lunning, 65–76. Minneapolis: University of Minnesota Press.

Wright, Lucy. 2005. "Forest Spirits, Giant Insects, and World Trees: The Nature Vision of Hayao Miyazaki." *The Journal of Religion and Popular Culture* 10 (Summer). http://www.usask.ca/relst/jrpc/art10-miyazaki-print.html.

Wright, Lucy, and Jerry Clode. 2004. "The Animated Worlds of Hayao Miyazaki: Filmic Representations of Shinto." *Metro Magazine* 143: 46–51.

Yamagishi Ryōko. 1994. *Hi izuru tokoro no tenshi*, vol. 1. Tokyo: Hakusensha Bunko.

Yamamoto Naoki. 2000. *Birībāzu*, vols. 1–2. Tokyo: Shōgakukan.

Yamamoto Sumika. 2002. *Ēsu o nerae!* vol. 1. Tokyo: Hōmusha.

Yamamoto Sumika Fan Site. n.d. http://www.cosmo.ne.jp/~sumihime/.

Yamamura Hajime. 2007. *Kamisama dōruzu*, vol. 1. Tokyo: Sunday GX Comics, Shōgakukan.

Yamanaka Hiroshi. 1996. "Manga bunka no naka no shūkyō." In *Shōhi sareru "shūkyō*," ed. Shimazono Susumu and Ishii Kenji, 158–184. Tokyo: Shunjusha.

———. 2008. "The Utopian 'Power to Live': The Significance of the Miyazaki Phenomenon." In *Japanese Visual Culture: Explorations in the World of Manga and Anime*, ed. Mark W. MacWilliams, 237–255. Armonk, NY: M. E. Sharpe.

Yamaori Tetsuo. 1990. "Yamiya no saihyōsen: Wakaki hi no Shinran." In Baron Yoshimoto and Yamaori Tetsuo, *Shinran*, vol. 1. Tokyo: Kadokawa Comikkusu.

Yonei Teruyoshi. 1999a. "Ichirei shikon." In *Shintō jiten*, ed. Inoue Nobutaka, 379. Tokyo: Kōbundō.

———. 1999b. "Kitano tenjin engi." In *Shintō jiten*, ed. Inoue Nobutaka, 571. Tokyo: Kōbundō.

Yoneyama Yoshio. 1995. "Subikari kōha sekai shindan: Su no hikari to gekiga media." In *Shinshūkyō jidai 3*, ed. Shimizu Masato, 53–95. Tokyo: Daizō shuppan.

Yoshida Daisuke. 2005. "Mori Tatsuya, Takekuma Kentarō taidan: Urasawa Naoki: ima mo owaranai nijū seiki." *Quick Japan* 59: 50–53.

Yoshioka Shiro. 2008. "Heart of Japaneseness: History and Nostalgia in Hayao Miyazaki's *Spirited Away*." In *Japanese Visual Culture: Explorations in the World of* Manga *and Anime*, ed. Mark W. MacWilliams, 256–273. Armonk, NY: M. E. Sharpe.

Yumiyama Tatsuya. 1994. "Gendai nihon no shūkyō." In *Gendai nihon no shūkyō shakaigaku*, ed. Inoue Nobutaka, 93–130. Tokyo: Sekaishisō Press.

———. 2004. "Kachi sōtai shugi e no ōtō: Oumu Shinrikyō to nyū eiji undo." In *Supirichuaritī no shakaigaku: Gendai sekai no shūkyōsei no tankyū*, ed. Itō Masayuki, Kashio Naoki, and Yumiyama Tatsuya, 249–267. Tokyo: Sekaishisō Press.

———. 2005. "Anime to shūkyō." In *Gendai shūkyō jiten*, ed. Inoue Nobutaka, 6–8. Tokyo: Kōbundō.

Yumiyama Tatsuya, Sasaki Ryūtomo, Kamata Naoki, Fujiki Fusanobu, and Naitō Yoshiyo. 2003. "Anime ni miru shūkyōsei: Osusume anime 'gekiron' zadankai." *Pippara* 472: 12–17.

Jolyon Baraka Thomas, a doctoral candidate in the Department of Religion at Princeton University, conducted the fieldwork for this book in Tokyo between 2005 and 2007. His previous publications include *"Shūkyō Asobi* and Miyazaki Hayao's *Anime," Nova Religio* 10, no. 3 (2007); "Manga to shūkyō no genzai: Nijū seiki shōnen to nijūisseiki no shūkyō ishiki," *Gendai shūkyō* (2008); and "Religion in Japanese Film: Focus on Anime," John Lyden, ed. *The Routledge Companion to Religion and Film* (London: Routledge, 2009).